INSIDE THE
GEMSTONE FILE

Kenn Thomas &
David Hatcher Childress

The Mind Control/Conspiracy Series:
Mind Control, World Control
NASA, NAZIS & JFK: The Torbitt Document
Mind Control, Oswald & JFK
HAARP: The Ultimate Weapon of the Conspiracy
Inside The Gemstone File
Liquid Conspiracy

The Lost Science Series:
The Anti-Gravity Handbook
Anti-Gravity & the World Grid
Anti-Gravity & the Unified Field
The Free-Energy Device Handbook
The Energy Grid
The Bridge to Infinity
The Harmonic Conquest of Space
Vimana Aircraft of Ancient India & Atlantis
Ether Technology
The Fantastic Inventions of Nikola Tesla
Man-Made UFOs: 1944-1994

The Lost Cities Series:
Lost Cities of Atlantis, Ancient Europe & the Mediterranean
Lost Cities of North & Central America
Lost Cities & Ancient Mysteries of South America
Lost Cities of Ancient Lemuria & the Pacific
Lost Cities & Ancient Mysteries of Africa & Arabia
Lost Cities of China, Central Asia & India

The Mystic Traveller Series:
In Secret Mongolia by Henning Haslund (1934)
Men & Gods In Mongolia by Henning Haslund (1935)
In Secret Tibet by Theodore Illion (1937)
Darkness Over Tibet by Theodore Illion (1938)
Danger My Ally by F.A. Mitchell-Hedges (1954)
Mystery Cities of the Maya by Thomas Gann (1925)
In Quest of Lost Worlds by Byron de Prorok (1937)

Write for our free catalog of exciting books and tapes.

INSIDE THE
GEMSTONE FILE

Adventures Unlimited Press

For Acharya S and Len Bracken

INSIDE THE GEMSTONE FILE

ISBN 0-932813-66-6

Printed in the United States of America

**Published by
Adventures Unlimited Press
One Adventure Place
Kempton, Illinois 60946 USA
auphq@frontiernet.net**

Permission is given to quote freely from this book.

TABLE OF CONTENTS

Other books by Kenn Thomas:

Flying Saucers Over Los Angeles
Maury Island UFO
Mind Control, Oswald & JFK
NASA, Nazis & JFK: The Torbitt Document
The Octopus: Secret Government and the Death of Danny Casolaro
Popular Alienation: A Steamshovel Press Reader

(Steamshovel Press is available from POB 23715, St. Louis, MO 63121
$6 per issue; $23 four issue subscription. www.umsl.edu/~skthoma)

1.
INTRODUCTION

by
David Hatcher Childress

"Only the small secrets need to be protected.
The big ones are kept secret by public incredulity."
—Marshall McCluhan

It was early in 1983, while visiting a friend in London, that I was given a copy of The Gemstone File. Fascinated by its revelations, I devoured the document in one sitting, unable to put it down.

A few years later, while in Australia, I was given another copy of The Gemstone File. "Here, take this, make another photocopy of it, and pass it on," the person told me. I took their copy (of a copy of a copy) and passed it on to someone else.

"Pass it on," I repeated, as many had before.

And now, after more than 20 years since the author, Bruce Roberts, died on August 1, 1976, his manuscript has become legendary. The Gemstone File is perhaps the world's best known circulated document, one that is mentioned in dozens of books on the Kennedy Assassination and the role of the Mafia in the affairs of the United States and other countries throughout the 40s, 50s, 60s and 70s.

The mysterious Bruce Roberts, as he claimed, was the inventor of the synthetic ruby and was an expert in synthetic jewels of many kinds. This sort of knowlege would seem to lead one into a natural career as a costume jeweler,

particularly in Los Angeles, where Roberts resided for a time. Few photographs are known of Roberts. One that was discovered by Gemstone researcher Gerald A. Carroll, which appeared in the *Los Angeles Times* in 1952, is of Roberts fitting actress Carmen Miranda with synthetic jewelry.

Hughes Aerospace was located in Los Angeles as well. In the late 40s and through the 50s, Roberts claimed that he was employed by Hughes. He brought the technology for making synthetic rubies—the basis for laser beam research, laser bombs, etc.,—to Hughes Aircraft, where it was stolen because of the optical quality of the rubies.

Later he moved to San Francisco and began writing his "Gemstone Letters." These letters, sent with accompanying synthetic rubies, were addressed to important people around the world. Roberts hoped that these people would pay him handsomely for the insider information that he passed on to them.

Thus began The Gemstone File, a file of Robert's personal letters of which he had kept copies. These letters ultimately made it to Mae Brussell in Carmel, California. She commissioned the Skeleton Key (a chronological outline of the most important points of the letters) to be written, as the number of handwritten pages that were given to Brussell is said to have been well over a thousand. Parts of the file were released to certain Americans beginning in 1969, and the Skeleton Key began to be widely circulated underground in the mid 70s.

The Gemstone File gives a very different tale of the lives of Aristotle Onassis, Joseph Kennedy, Sr., Howard Hughes and other famous figures than the mainstream media and official biographers would have us believe. Where did Roberts get the fantastic information contained in his letters?

According to the Skeleton Key, Roberts was married to the daughter of the former French consul in Indochina, and, in fact, the Golden Triangle area was a possible source for one of the ingredients in his synthetic gemstones. In that area, Onassis's involvements in the Golden Triangle dope trade was

no secret. Roberts' investigation of Onassis revealed some incredible information. He began selling or giving away "Gemstones"—synthetic rubies and sapphires with accomplished "histories" (gemstone papers)—to consulur offices in return for information. A world-wide information network was gradually developed, trading in the intelligence activities of many countries. This intelligence network is the source for much of the information in The Gemstone File.

Was Aristotle Onassis really the kingpin of the Mafia during his life, as Bruce Roberts and The Gemstone File assert? Evidence gathered from newspaper articles lends credence to this theory. Was Howard Hughes kidnapped and his empire controlled by Onassis and the Mafia for over 10 years? By all accounts, both Onassis and Hughes were highly eccentric and powerful men.

This kidnapping of Hughes and holding him hostage in Las Vegas and other mob controlled cities in order to wrest control of his vast empire is one of the most interesting facets of The Gemstone File scenario.

Howard Hughes' various corporations (Hughes Tool and Die, Hughes Aviation, etc.) were different from other large corporations in that they were totally controlled by one person, rather than by a board of directors. While most corporations would have to have periodic meetings of the directors and stockholders, the various elements of the Hughes empire had no such annoying committees. Indeed, these giant corporations, including a world-wide airline, TWA, were all controlled by a single eccentric dictator who made all decisions.

By controlling Howard Hughes, one could control a vast commercial empire without having to share executive decisions with anyone else. However, the socialite playboy Howard Hughes had to be retired permanently. A reclusive, rarely to be seen Howard Hughes had to take his place. This required a highly clever plot that would take a certain amount of *cajones* to pull off.

But pull it off they did (according to Roberts), and more than that. With the help of their oil company CIA and FBI buddies,

Onassis and the Mafia ran their own world-wide empire of super-tankers, arms deals, drug smuggling and gambling. Entire countries were under their control: Cuba, Monaco, Greece, Panama, Liberia, even (*gasp!*), the United States of America!

When looked at carefully, The Gemstone File is not just believable, it is downright scary. When one holds a gemstone carefully and turns it in the light, one can see the refractions that ripple off into the shadows of history...

—David Hatcher Childress, Room 23, Templar Castle, New Scotland

2.
GEMSTONED
AGAIN

by Kenn Thomas

Here it is again, the Gemstone File, a 24-page rant that many believe deserved an early death on the conspiracy circuit, but one that shows a remarkable durability of interest.

Readers unfamiliar with the Gemstone File should know that a document dated May 1, 1975 began circulating in the middle of that year purporting to summarize over a thousand pages handwritten "in many segments over a number of years" by an American named Bruce Roberts. The document is called "The Skeleton Key to the Gemstone File," and it was written by Stephanie Caruana. Caruana had been assigned by *Playgirl* magazine to interview Mae Brussell, the woman who served as the model for conspiracy researchers until her death in 1988. Brussell became somewhat of a celebrity after the JFK assassination transformed her housewife existence into that of an almost compulsive collector of little-known facts and hidden perspectives on current affairs. Her radio programs, "World Watchers International" and "Dialogue Conspiracy," ran for sixteen years on stations in Pacific Grove and her home town of Carmel, California. Today, many writers who concern themselves with parapolitical issues—activist John Judge, for instance, and mind control expert Alex Constantine—still acknowledge great debt to Mae Brussell, and are sometimes referred to affectionately as Brussell sprouts.

In 1969 Brussell became one of a number of Americans who began receiving letters from the mysterious Bruce Roberts. She

had accumulated quite a file by the time she introduced Caruana to the Roberts letters.

Caruana claimed to have only gone through about four hundred letters before beginning her Skeleton outline. Brussell claimed that she only had possession of about three hundred letters.

The Skeleton Key tells the story of internecine corporate warfare between Aristotle Onassis and Howard Hughes. According to the Gemstone, Onassis and the International Mafia kidnapped and held Hughes captive for ten years in his own hotels, stopping his high-profile movie star chasing and removing him from public view. As sole owner of Hughes Aircraft and related industries, the Mafia could exploit Hughes' empire without a company board meeting ever taking place.

Gemstone goes down many ancillary avenues, of course, not the least of which is the role Onassis played in the assassinations of the Kennedy brothers and his subsequent marriage to JFK's widow. It also examines the still dimly understood machinations of the Watergate break-in and scandal, Ted Kennedy's disaster at Chappaquiddick and a plethora of mob interactions with Rockefeller, Kissinger, Nixon—the whole sick conspiracy crew of the 1970s, including the Bay of Pigs/Plumbers spookreeps E. Howard Hunt, James McCord, Frank Sturgis, G. Gordon Liddy.

When Roberts' synthetic rubies were stolen from him by Hughes Aircraft his investigation of the theft led him to the Gemstone story. Roberts' connection to the French consulate allowed him to develop a global network underground information exchange to track Onassis-Hughes related events.

Two dozen years on, conspiracy researchers still pattern their activity after Roberts' network, now with the help of the internet, filling in the gaps left by the standard news and information sources to get at the deeper parapolitical dynamics of current affairs. In addition to the pattern of its existence as pass-around samizdat, emerging in over a dozen photocopied formats, Gemstone became the subject of three

major studies: *The Gemstone File* by Jim Keith (IllumiNet, 1992); *The Gemstone File: Sixty Years of Corruption and Manipulation* by Richard Alan (Crown, 1992); and *Project Seek: Onassis, Kennedy and the Gemstone Thesis* by Gerald Carroll (Bridger House, 1994). The first of these books discusses the early Gemstone incarnations, as does an apparently non-locatable fourth book called *Beyond the Gemstone File,* and the last expanded on the historic facts and speculation set out by Bruce Roberts.

Gerald Carroll was the first to discuss Gemstone in the context of other samizdat documents and conspiracy circuit information similar in style, but providing revelations about the covert world up to the present.

Many of these other documents are reproduced for the first time in the current volume. This book also reproduces the Skeleton Key and presents for the first time ever in its entirety, the Gemstone downunder counterpart, the Kiwi Gemstone File. We also include an essential outline of events surrounding Danny Casolaro's Octopus research, and the Com-12 Briefing, a much clamored-for report corroborative of Casolaro circulated after his death. Readers will also find for the first time previously unknown Gemstone artifacts, such as stationery from the Watergaters' Gemstone plan, and, another publishing first, an actual Bruce Roberts letter.

This book makes no claim to be the final word on The Gemstone File,.

Rather, it presents this material again for purposes of continued debate and discussion. A section of commentary reflects the full range of response to Gemstone: amusement, derision, critical outrage, but also the discovery of new information, new questions to ask, and a renewed understanding that few world events are as simple as the newspapers explain.

Kenn Thomas *Steamshovel Press*, April 1, 1999

gets, "easter figures" – Liz Dale, an unnamed amount from Francis L. Dale. [illegible] and [illegible] that time, 1972, the massive economic shift of tredion dollar economies of governments and presidents and Bingo and geographical boundaries was still to come. Said Kissinger: "We will wage Arabia because of economic strangulation." Economic strangulation is a CIA project on me – as my CIA cousin Kincaid will strangle Africa – from Lagos, Nigeria; my father's "friend", Maillard, strangles South America from his Nixon appointed OAS office; and Francis L. Dale, appointed by Nixon, strangles the U.N. in Geneva, from an Onassis Swiss bank. In view of these things, what is the collector value of that Dallas Dime?

My means of livelyhood have been strangled by the Mafia. My father is dead and a son, your brother is dead. And another good friend, Ismail. On their honor, I propose a check from the President of Egypt – for a "Dallas dime, with history." A personal matter. Now to me, if your appraisal of the value of that collector's coin – on a signed check – would help to establish a base price on the value of those coins – just as the 72 check for a "gemstone, with history" and other bid offers have done for gemstones – rising now – as Onassis dimes did at Sotheby's.

I noted your statement that if your lands were not returned soon you would "explode it all in the United Nations." And our CIA Pentagon Schlesinger's response: "SS 18's can now launch a limited strategic strike on us – kill 6 million in 6 minutes – but 99% of our economy would still be intact – so that isn't bad. Survivors would show a brief loss of confidence in our government – but they would get over it – and soon resume their normal social relations in our society – sucking on the radioactive asshole of Aleste." Yet the million in San Francisco are the prime target – strategic, or massive – the hub of the Mafia universe. Proof has been furnished. It is difficult to sell or give away – gemstones or coins – with history – here. All of the history is burned, along with their own future. That's cancer, Schlesinger admits it – 6 million – expendable – to hide Project Star, the Rand version of Dallas, over which those dimes were doubled. Brandon London: "The JFK murder was known to 90% of the world within 48 hours. It's solution will become known to 100% within a few hours – unless the missiles get here first!" Not true. The solution has been out around the world for a long time – in the gemstone papers. Your statement speaks of Peace – by that exposure. Schlesinger speaks of nuclear war – murder – to hide it. The moral variance is obvious – the difference between a doctor and a cancer. In view of this consideration – life, or death – what is the value of that dime?

Please inform me of your judgement. If missiles don't get here first – there are other projects – and a solid performance record. My radioactive ass is at stake too, & live here.

Best wishes –

Sincerely – Bruce P. Roberts

One of Roberts' Gemstone letters.

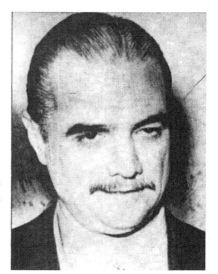

Right: This is the last photograph taken of Howard Hughes before he went into hiding in 1957.

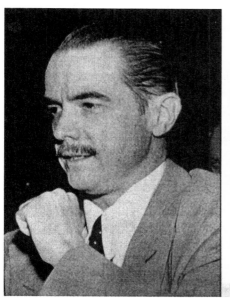
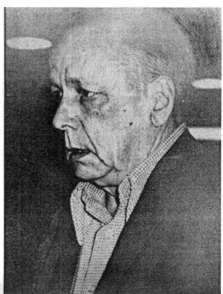

Above: Gerald Carroll found these photographs taken of Howard Hughes. Left: A 1947 file photo of Hughes. Right: Photograph taken in March, 1972 in Vancouver, British Columbia, alleged to be an elderly Hughes. The Skeleton Key suggests that this man is instead L. Wayne Rector, a Hughes double.

The Gemstone file

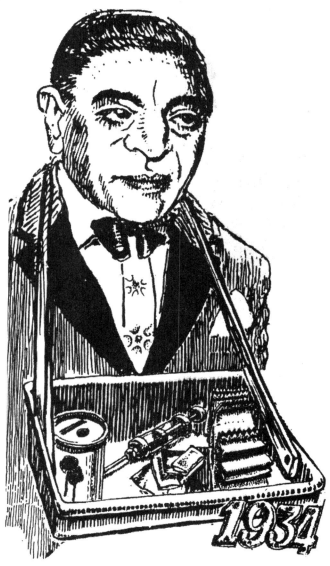

Above: Cartoon of Onassis and The Gemstone File that
appeared in the *International Times* in 1978 (Vol. 4, No. 4).

3.
A SKELETON KEY
TO THE
GEMSTONE FILE

The following transcript of the Skeleton Key to the Gemstone File comes from a copy given to Paul Krassner, humorist and editor of *The Realist*, by Bruce Roberts, beginning with the date below:

May 1, 1975

The Gemstone File was written in many segments over a period of years by an American man named Bruce Roberts.

Parts of the file were released to certain Americans beginning in 1969. The number of handwritten pages is well over a thousand, of which I have read about four hundred. I do not have the time or the research facilities to verify the entire story. Perhaps others can help. Since the scope of the work is so large, and the events described so complex and interlocking, it may be more easily understood with this skeleton outline of the Gemstone thesis. Individual papers can then be read with greater comprehension.

•1932: Onassis, a Greek drug pusher and ship owner who made his first million selling "Turkish tobacco" (Opium) in Argentina, worked out a profitable deal with Joseph Kennedy, Eugene Meyer, and Meyer Lansky. Onassis was to ship booze directly into Boston for Joseph Kennedy. Also involved was a heroin deal with Franklin and Elliott Roosevelt.

•1934: Onassis, Rockefeller and the Seven Sisters (major oil

17

companies) signed an agreement, outlined an oil cartel memo: Beat the Arabs out of their oil, ship it on Onassis's ships; Rockefeller and the Seven Sisters to get rich. All this was done. Roberts, studying journalism and physics at the University of Wisconsin learned these things via personal contacts. His special interest was in crystallography -- and the creation of synthetic rubies, the original Gemstone experiment.

•1936-1940: Eugene Meyer buys the Washington Post, to get our news Media; other Mafia buy other papers, broadcasting, T.V., etc. News censorship of all major news goes into effect.

•1941-1945: World War II; very profitable for Onassis, Rockefeller, Kennedys, Roosevelts, I.G. Farben, etc. Onassis selling oil, arms and dope to both sides went through the war without losing a single ship or man.

•1949: Onassis buys U.S. surplus "Liberty Ships" in questionable (illegal) purchase. Lawyer Burke Marshall helps him.

•1956: Howard Hughes, Texas millionaire, is meanwhile buying his way toward his own personal gain. He buys senators, governors, etc. He finally buys his last politician: newly elected V.P. Nixon, via a quarter-million dollar non-repayable loan to Nixon's brother Donald.

•Early 1957: V.P. Nixon repays the favor by having IRS Treasury grants tax-free status (refused twice before) to "Hughes Medical Foundation", sole owner of Hughes Aircraft, creating a tax-free, non-accountable money funnel or laundry, for whatever Hughes wanted to do. U.S. Government also shelved anti-trust suits against Hughes' T.W.A., etc.

•March 1957: Onassis carried out a carefully planned event: He has Hughes kidnapped from his bungalow at the Beverly Hills Hotel, using Hughes' own men (Chester Davis, born Cesare in Sicily, et al). Hughes" men either quit, get fired, or stay on in the new Onassis organization. A few days later, Mayor Cannon of Nevada (now senator Cannon) arranges a fake "marriage" to Jean Peters, to

explain Hughes' battered and brain damaged in the scuffle, is taken to the Emerald Isle Hotel in the Bahamas, where the entire top floor has been rented for thirty days and later dragged off to a cell on Onassis's island, Skorpios. Onassis now has a much larger power base in the U.S. (the Hughes empire), as well as control over V.P. Nixon and other Hughes purchased politicians. L. Wayne Rector "Hughes" double since 1955, becomes "Hughes."

•September, 1957: Onassis calls the Appalachian meeting to announce to U.S. Mafia head his grab of Hughes and his adoption of Hughes game plan for acquiring power: buying U.S. senators, congressmen, governors, judges to take control legally of the U.S. government. Onassis's radio message to Appalachia from a remote Pennsylvania farmhouse intercepted (reluctantly) by FBI's J. Edgar Hoover, on the basis of a tip-off from some Army Intelligence guys who weren't in on the plan.

•Also in 1957: Joseph Kennedy takes John F. and Jackie to see Onassis on his yacht, introduced John and reminds Onassis of an old Mafia promise: the presidency for a Kennedy. Onassis agrees.

•1958: Hordes of Mafia-selected, purchased and supported "grass roots" candidates sweep into office.

•1959: Castro takes over Cuba from dictator Battista, thereby destroying cozy and lucrative Mafia gambling empire run for Onassis by Meyer Lansky. Castro scoops up 6$ million in Mafia casino receipts. Onassis is furious, V.P. Nixon becomes operations chief for CIA-planned Bay of Pigs invasion, using CIA Hunt, McCord, etc., and Cuban ex-Battista strong-arm cops (Cuban freedom-fighters) Martinez, Gonsalez, etc., as well as winners like Frank Sturgis (Fiorini).

•1959: Stirring election battle between Kennedy and Nixon. Either way Onassis wins, since he has control over both candidates.

•1960: JFK elected. American people happy. Rose Kennedy happy. Onassis happy. Mafia ecstatic. Roberts brings his synthetic rubies--the original gemstones to Hughes Aircraft in Los Angeles.

They steal his rubies -- the basis for Laser beam research, laser bombs, etc., because of the optical quality of the rubies. One of the eleven possible sources for one of the ingredients involved in the Gemstone experiment was the Golden Triangle area. Roberts was married to the daughter of the former French consul in Indochina. In that area, Onassis's involvements in the Golden Triangle dope trade was no secret. Roberts investigation revealed the Onassis-Hughes connection, kidnap and switch. "Gemstones"--synthetic rubies and sapphires with accomplished "histories"--gemstone papers—were sold or given away to consular offices-- in return for information. A world-wide information network was gradually developed-a trade of the intelligence activities of many countries. This intelligence network is the source for much of the information in the Gemstone File.

•January 1961: Joseph Kennedy has a stroke, ending his control over John and Bobby. The boys decide to rebel against Onassis's control. Why? Inter-Mafia struggle? Perhaps a dim hope of restoring this country to it's mythical integrity? They began committing Mafia no-no's: Arrested Wally Bird owner or Air Thailand, who had been shipping Onassis's heroin out of the Golden Triangle (Laos, Cambodia, Vietnam), under contract with the CIA (Air Opium): arrested teamster Mafia Jimmy Hoffa, and put him in jail. Declared the 73$ million in forged "Hughes" land liens, deposited with San Francisco Bank of America, as "security" for the TWA judgment against Hughes, to be what they are: Forgeries.

•April 1961: CIA Bay of Pigs fiasco. Hunt, McCord, CIA Battista's Cubans and Mafia angry about JFK's lack of enthusiasm. Mafia Onassis has his right-hand man "Hughes' top aid" former FBI and CIA Robert Maheu (nicknamed "IBM" for Iron Bob Maheu), hire and train a Mafia assassination team to get Castro. The team of a dozen or so includes John Roselli and Jimmy (The Weasel) Frattiano, expert Mafia hitmen, assisted by CIA Hunt and McCord and others. This was reported recently by Jack Anderson, who gets a lot of his "tips" from his friend, Frank (Fiorini) Sturgis--also on the Castro assassination team. The team tries five times to kill Castro with everything from long-range rifles to apple pie with sodium morphate in it. Castro survives.

•1963: Members of the Castro assassination team arrested at Lake Pontechartrain, La. by Bobby Kennedy's justice boys. Angered, Onassis stops trying to kill Castro. He changes target and goes for the head: JFK, who, according to Onassis, "welched" on a Mafia deal. JFK sets up "Group of 40" to fight Onassis.

•August 1963: Two murders had to occur before the murder of JFK, or people who would understand the situation and might squawk:

•Senator Estes Kefauver; whose crimes commission investigations had uncovered the 1932 deal between Onassis, Kennedy, Eugene Meyer, Lansky, Roosevelt, et al. Kefauver planned a speech on the senate floor denouncing Mafia operations; instead, he ate a piece of apple pie laced with sodium morphate (used in rat poison), and had a sodium-morphate-induced "heart attack" on the Senate floor.

•Phillip Graham: Editor of the Washington Post. Phillip had married Katherine Meyer, Eugene Meyer's daughter, who had inherited the Washington Post and allied media empire. Graham put together the Kennedy-Johnson ticket and was Kennedy's friend in the struggle with Onassis. According to Gemstone, Katherine Meyer Graham bribed some psychiatrists to certify that Phil was insane. He was allowed out of the nuthouse for the weekend and died of a shotgun wound in the head in the Graham home in Washington; death ruled "suicide."

•November 1, 1963: The hit on JFK was supposed to take place in true Mafia style: a triple execution, together with Diem and Nhu in Vietnam. Diem and Nhu got theirs, as scheduled. Onassis had invited Jackie for a cruise on the Christina, where she was when JFK got tipped off that big "O" planned to wipe him out. JFK called Jackie on the yacht, from the White House, hysterical: "Get off that yacht if you have to swim"' and canceled his appearance at a football stadium in Chicago, where this CIA-Mafia assassination team was poised for the kill. Jackie stayed on board, descended the gangplank a few days later on Onassis's arm, in Turkey, to impress the Bey, Mustapha. Madame Nhu, in the U.S. bitterly remarked whatever has happened

in Vietnam. One of the assassination teams was picked up in Chicago with a rifle and quickly released by the police. Three weeks later the Mafia's alternate and carefully arranged execution plan went into effect: JFK was assassinated in Dallas. A witness who recognized pictures of some of the people arrested in Dealey Plaza as having been in Chicago three weeks earlier told Black Panthers Hampton and Clark.

•The JFK murder: Onassis-Hughes' man Robert Maheu reassigned the Mafia-CIA Castro assassination team to the murder of JFK adding Eugene Brading a third Mafia hitman from the Denver Mafia Amaldones "family." Two months earlier Brading on parole after a series of crimes applied for a new driver's license explaining to the California DMV that he had decided to change his name to Jim Brading. Brading got his California parole the first time to look things over and the second time when JFK was scheduled for his Dallas trip. Lee Harvey Oswald CIA with carefully planned links to both the ultra right and to the Communists was designated as the patsy. He was supposed to shoot Governor Connally and he did. Each of the four shooters, Oswald, Brading, Frattiano and Roselli had a timer and a back up man. Back up men were supposed to pick up the spent shells and get rid of the guns. Timers would give the signal to shoot. Hunt and McCord were there to help. Sturgis was in Miami. Frattiano shot from a second story window in the Dal-Tex building across the street from the Texas School Book Depository. He apparently used a handgun-he is an excellent shot with a pistol. Frattiano and his back-up man were "arrested", driven away from the Dal-Tex building in a police car and released (without being booked). The Dallas police office is in the Dal-Tex building. Roselli shot Kennedy once hitting the right side of his head and blowing his brains out with a rifle from behind a fence in the grassy knoll area. Roselli and his timer went down a manhole behind the fence and followed the sewer line away from Dealey Plaza. The third point of the triangulated ambush was supplied by Eugene Brading shooting from Kennedy's left from a small pagoda at Dealy Plaza across the street from the grassy knoll. (Brading missed because Roselli's and Frattiano shot had just hit Kennedy in the head from the right and the rear nearly simultaneously). Brading's shot hit the curb and ricocheted off. Brading was photographed on the scene stuffing his

22

gun under his coat. He wore a big leather hat, its hatband marked with large conspicuous X's. (Police had been instructed to let anyone with an X-marked hatband through the police lines. Some may have been told they were Secret Service). After his shot, Brading ditched his gun with his back-up man and walked up the street toward the Dal-Tex building. Sheriff rushed up to Brading, assuming he was "Secret Service" and told him he had just seen a man come out of the Book Depository and jumped into a station wagon. Brading was uninterested. Brading walked into the Dal-Tex building to "make a phone call." There he was arrested by another deputy sheriff, showed his "Jim Braden" driver's license and was released without being booked. Oswald shot Connally twice from the Texas School Book Depository. He split from the front door. His back-up man was supposed to take the rifle out of the building (or so Oswald thought); instead he "hid" it behind some boxes, where it would be found later. Three men dressed as tramps picked up the spent shells from Dealey Plaza. One was Howard Hunt. Then they drifted over to an empty boxcar sitting on the railway spur behind the grassy knoll area, and waited. A Dallas police officer ordered two Dallas cops to "go over to the boxcar and pick up the tramps." The three 'tramps' paraded around Dealey Plaza to the Police Department in the Dal-Tex Building. They were held there until the alarm went out to pick up Oswald; then they were released, without being booked. In all, ten men were arrested immediately after the shooting; all were released soon after; none were booked; not a word about their existence is mentioned in the Warren Report.

•Regarding Lee Harvey Oswald: Officer Tippitt was dispatched in his police radio car to the Oak Cliff Section, where Oswald had rented a room. Tippett may have met Oswald on the street. He may have been supposed to kill Oswald, but something went wrong. Tippett was shot by two men using revolvers. The "witness", Domingo Benavides, who used Tippitt's police car radio to report "we've had a shooting here", may have been one of the men who shot him. (A Domingo Benavides" appears in connection with the Martin Luther King shooting also.) Oswald went to the movies. A "shoe store manager" told the theatre cashier that a suspicious looking man had sneaked in without paying. Fifteen assorted cops and FBI charged out to the movie theatre to look for the guy who

had sneaked in. Oswald had a pistol that wouldn't fire. It may have been anticipated that the police would shoot the "cop-killer" for "resisting arrest." But since that didn't happen, the Dallas police brought Oswald out for small- time Mafia Jack Ruby to kill two days later.

•Brading stayed at the Teamster-Mafia-Hoffa-financed "Cuban Hotel" in Dallas. Ruby had gone to the Cabana the night before the murder, says the Warren Report. The rest, as they say, is history. Onassis was so confident of his control over police, media, FBI, CIA, Secret Service and the U.S. Judicial System that he had JFK murdered before the eyes of the entire nation; then systematically bought off, killed off, or frightened off all witnesses and had the evidence destroyed; then put a 75 year seal of secrecy over the entire matter. Cover up participants included among many: Gerald Ford on the Warren Commission (a Nixon recommendation): CIA attorney Leon Jaworski, of the CIA front Anderson Foundation, representing Texas before the Commission to see that the fair name of Texas was not besmirched by the investigation; CIA-Dallas Chief John McCone, his assistant; Richard Helms; and a passle of police, FBI, news media, etc.

•WHERE ARE THEY NOW?

•Johnny Roselli received part of his pay off for the head shot on JFK in the form of a $250,000 "finder's fee for bringing "Hughes" (Onassis) to Las Vegas in 1967.

•Jimmy Frattiano's pay-off included $109,000 in "non-repayable loans", from the S.F. National Bank (President: Joe Alioto). Credit authorization for the series of loans from 1961 to 1965, came from Joe Alioto and a high Teamster official. Dun and Bradstreet noted this transaction in amazement, listing how Frattiano could explain so much "credit" as his only known title (listed in D&B) was "Mafia-Executioner." Frattiano went around for years bragging about it: "Hi there, I'm Jimmy Frattiano, Mafia Executioner...." A bank V.P. told the whole story to the California Crime Commission, where Al Harris, who later shot off his mouth a little too much--"Heart attacked." When last seen March, 1975, Frattiano was testifying

before a S.F. Grand Jury in regard to his participation, with East Coast Mafia Tony Romane, in the Sunol Golf Course swindle (which cost S.F. somewhere between $100,000 in "non-repayable loans" to start a trucking company in the Imperial Valley, where he engaged in a lot more swindling--involving U.S. Government member explained, "The Mafia is doing business directly with the U.S. Government now."

•Brading was questioned by the FBI two months after his arrest and released in Dallas as part of the Warren Commission's determination to "leave no stone unturned" in its quest for the truth about the JKF assassination. In spite of the fact that Brading was a known criminal with an arrest record dating back about twenty years, the FBI reported that Brading knew nothing whatsoever about the assassination. Brading became a charter member of the La Costa Country Club, Mafia heaven down near San Clemente. He also became a runner for the skim money from the Onassis "Hughes" Las Vegas casinos to Onassis' Swiss Banks.

•GERALD FORD; of the Warren Commission went on to become President by appointment of Nixon, then in danger of even further and more serious exposure--from which position of trust Ford pardoned Nixon one month later, for "any and all crimes he may have committed." That covers quite a lot but Ford is good at covering things up. McCONE; the head of CIA-Dallas, went on to become a member of the ITT Board of Directors sitting right next to Francis L. Dale, the head of CREEP.

•RICHARD HELMS; McCone's assistant at Dallas, ultimately has been rewarded with the post of CIA Director.

•LEON JOWARSKI; CIA Attorney, became the Watergate Prosecutor, replacing Cox, who was getting too warm. Jowarski turned in a startling performance in our "government-as-theatre" the honest, conscientious investigator who "uncovered" not a bit more than he had to and managed to steer everybody away from the underlying truth.

•Dr. "RED" DUKE; the man who dug two bullets out of Connelly

and saved his life was shipped off to a hospital in Afghanistan by a grateful CIA.

•JIM GARRISON; New Orleans D.A. who tried to get Eugene Brading out of L.A. (but used one of Brading's other aliases, Eugene Bradley, by mistake), had his witnesses shot out from under him, and was framed on charges of bribery and extortion. FBI officers "confiscated" photos of Brading taken on the scene, etc.

•After JKF's death, Onassis quickly established control over Lyndon Johnson through fear. On the trip back to Washington, Johnson was warned by radio relayed from an air force base; "There was no conspiracy, Oswald was a lone nut assassin. Get it Lyndon? Otherwise, Air Force might have unfortunate accident on flight back to Washington." Onassis filled all important government posts with his own men. All government agencies became means to accomplish an end: rifle the American Treasury, steal as much as possible, keep the people confused and disorganized and leaderless; persuade world domination. JFK's original "Group of 40" was turned over to Rockefeller and his man, Kissinger, so that they could more effectively take over South America (Onassis was one of the first to console Jackie when she got back from Dallas with JFK's body.) Silva, a S.F. private detective hired by Angelina Alioto to get the goods on philandering Joe, followed Joe Alioto to Vacaville, to the Nut Tree Restaurant, where Joe held a private meeting with other Mafioso to arrange the details of the JFK assassination pay off to Frattiano.

•1967: Onassis has always enjoyed the fast piles of money to be made through gambling (in Manaco, in the 50's and in Cuba under Battista). Onassis took over Las Vegas in 1967, via the "Hughes" cover. U.S. Government officials explained that it was all right because "at least Hughes isn't the Mafia."

•Mafia Joe Alioto had Presidential ambitions, shored up by his participation in the Dallas pay-off. Everyone who helped kill JKF got a piece of the U.S. pie. But J. Edgar Hoover, FBI head, blew his cover by releasing some of the raw FBI files on Alioto at the Democratic National Convention. Joe was out of the running for

V.P. and Humphrey had to settle for Muskie. Humphrey planned to come to S.F. for a final pre-election rally, sparked by Joe Alioto. Roberts threatened to blow the hit-run story plus its Mafia ramifications open if Humphrey came to S.F. Humphrey didn't come; Humphrey lost in San Francisco, California and the election.

•October 1968: Jackie Kennedy was now "free" to marry Onassis. An old Mafia rule: if someone welches on a deal, kill him and take his gun and his girl: in this case, Jackie and the Pentagon.

•July, 1969: Mary Jo Kopechne, devoted JFK girl, and later one of Bobby's trusted aides, was in charge of packing up his files after his assassination in L.A. She read too much, learned about the Kennedy Mafia involvement and other things. She said to friends: "This isn't Camelot, this is murder." She was an idealistic American Catholic. She didn't like murdering hypocrites. She died trying to get off Chappaquiddick Island, where she had overheard (along with everyone else in the cottage) Teddy Kennedy's end of the D.H. Lawrence cottage telephone calls from John Tunney and to Joe Alioto, and Democrat bigwigs Swig, Shorenstein, Schumann and Bechtel. Teddy's good friend John Tunney called to complain that Alioto's friend Cycil Magnin and others had tried to bribe Jess Unruh to switch from the Governor's race to run for the Senate for the seat John Tunney wanted so that Alioto would have an easier run for Governor. Teddy called Alioto, who told him to go to hell; then Teddy called the rest to arrange for yet another Mafia murder. Mary Jo, up to there with Mafia ran screaming out of the cottage on her way to Nader. Drunken Teddy offered to drive her to the ferry. Trying to get away from curious Sheriff look, Teddy sped off toward the Bridge, busted Mary Jo's nose when she tried to grab his arm from the back seat, and bailed out of the car as it went off the bridge. Mary Jo with a busted nose, breathed in an air bubble in the car for more than two hours waiting for help, while Teddy, assuming she was dead, to set up an alibi. Mary Jo finally suffocated in the air bubble, diluted with carbon dioxide. It took her 2 hours and 37 minutes to suffocate while Teddy called Jackie and Onassis on the Christina. Teddy also called Katherine Meyer Graham, lawyers, etc. Jackie called the Pope on Teddy's behalf, who assigned Cardinal Cushing to help. The next morning, the first person Teddy tried to

call after deciding he'd have to take the rap himself was a lawyer, Burke Marshall, Onassis's friend in the U.S. Liberty ships deal back in the forties and also the designated custodian for JFK's brains after Dallas (the brains have since disappeared).

•Cover-up of the Chappaquiddick murder required the help of Massachusetts Highway Patrol, which "confiscated" the plates from Teddy's car after it was fished out of the pond: the Massachusetts Legislature, which changed a 150 year old law requiring an autopsy (which would have revealed the suffocation and broken nose); Coroner Mills, who let Kennedy's aide K. Dun Grifford, supply him with a death certificate, already prepared for Hill's signature, listing cause of death as drowning: Police Chief Arenas: Cardinal Cushing's priest who appeared before the Kopechne's "direct from God" with personal instructions from Him that Mary Jo was not to be disturbed; a Pennsylvania mortuary where Mary Jo's broken nose was patched up, East and West phone companies, which clamped maximum security on the records of calls to and from the cottage. S.F. Police Chief Cahill was reassigned to a new job; Security Chief for Pacific Telephone. The U.S. Senate, who never said a word about Teddy's (required equipment) plug- in phone; the judge who presided over the mock hearing; James Feston, editor of Martha's vineyard's only newspaper, who never heard a word about Teddy's phone at the cottage, though residents called in to tell the newspaper; the New York Times, Washington Post, etc.

•John Tunney's sister, Joan, heard her brother's end of the phone call, made from her house in Tiburon, to the Chappaquiddick cottage. The next day, after Mary Jo died, Joan ran away to Norway, where she was kidnapped by Mafia hoods Mari and Adamo. They locked her up in a Marseille heroin factory. Joan's husband complained so she chopped his head off with an ax, and was subsequently locked up in a nuthouse belonging to the Marquess of Blandford, then Tina Livanos Onassis' husband. Mari and Adamo got pressed into scrap metal in a New Jersey auto junkyard. In the panic of trying to cover up Teddy's quilt at Chappaquiddick, many things came unglued. The JFK murder threatened to creep out of the woodwork again; Black Panthers Hampton and Clark were murdered (the Chicago cops fired over Attorney Charles Garry's because of

what they knew about the JFK murder squad's presence at Chicago on November 1,1963.

•September 1969: "Gemstones", with histories, had been released around the globe for several years. In 1969, Roberts gave a Gemstone with history to Mack, head of California CREEP, for Nixon, with the proposition: the Presidency in return for wiping out the Mafia. The "history" included Teddy's phone calls to and from the Lawrence Cottage on Chappaquiddick billed to Teddy's home phone in Havannisport. Nixon being Mafia himself, wasn't interested; but kept the information to use on Teddy whenever it seemed advantageous.

•May 4, 1970: Charlotte Ford Niarchos called her ex-husband Stavros, worried about the Ford Foundation's involvement in the Chappaquiddick cover-up. Eugenie Livanos Niarchos, in bed with her husband, overheard the conversation. Stavros was forced to beat her to death; he ruptured her spleen and broke the cartilage in her throat. Cause of death was listed as "overdose of barbituates," though autopsy showed these injuries.

•NOTE: L. Wayne Rector was hired around 1955 by the Carl Byoir P.R. Agency (Hughes L.A. P.R. firm) to act as Hughes double. In 1957 when Onassis grabbed Hughes, Rector continued to act as his stand-in. Rector was the Hughes surrogate in Las Vegas; Robert Maheu actually ran the show; Maheu got his orders from Onassis; the six "nursemaids", called the "Mormon Mafia", kept Rector sealed off from prying eyes.

•June 17, 1969: Bobby Kennedy knew who killed his brother; he wrote about it in his unpublished book, The Enemy Within. When he foolishly tried to run for President, Onassis had offed, using a sophisticated new technique hypnotized Sirhan Sirhan shooting from the front "security guard" (from Lockheed Aircraft). Thane Cesar shooting from two or three inches away from Bobby's head from the rear. Sirhan's shots all missed. Evelle Younger, then the L.A. District Attorney, covered it all up including the squawks of the L.A. Coroner Thomas Noguchi. Younger was rewarded with the post of California Attorney General later. His son, Eric Younger,

got a second generation Mafia reward; a judge-ship at age 30. (See Ted Charach, L.A. author and director, The Second Gun, a documentary film on the RFK murder, bought and suppressed by Warner Brothers for more details). After Bobby's death, Teddy knew who did it. He ran to Onassis afraid for his life and swore eternal obedience. In return, Onassis granted him his life and said he could be President, too, just like his big brother, if he would behave himself and follow orders.

•September 16, 1968: Hit and run accident on Robert's car parked in front of the Russian consulate on S.F. who routinely takes pictures of everything that goes on in front of the consulate. Their photos showed the license plate of the hit and run car UKT-264, on a blue Cadillac belonging to Angela Alioto, Joe's daughter, being driven by Tom Alioto, Joe's son whose driving license had been revoked. His license and the cars license were both fraudulent. To cover up the hit and run circumstances, B.F. MPJ's from the Presido quickly staged a few more hit and runs on the same corner all duly filmed by the Russians. Katheryn Hollister, the Alioto family nurse was "persuaded" to take the rap for the hit and run. Roberts threatened to spill the whole story in court with photos. Next evening Brading and Frattiano showed up in the Black Magic Bar, Brading wearing his x-marked hat from Dallas to see whether Roberts recognized it, how much he knew, etc. A S.F. MP from the Presidio piped up from the end of the bar, "I heard they let everyone with an X-marked hatband through the police lines at Dallas."

•Cover up support for Alioto in the hit and run was completed.

•End of 1970: Howard Hughes presence on earth no longer required. His handwriting could be duplicated by a computer. His biography all the known facts about his life had been compiled and a computerized biography issued to top Hughes executives. His double—Rector—had been doing "Hughes" for years. And Hughes was ill.

•Clifford Irving, author of Hoax, about an art forger, became interested in "Hughes." Living on Ibazza, he heard the Mediterranean gossip that "Hughes" was a hoax, too. He went to

"Hughes" so-called "Mormon Mafia", the six nursemaids for information. One of them, Merryman perhaps, tired of the game, gave Irving the computerized Hughes biography and from it Irving wrote his "autobiography." Hughes' death was expected shortly. Preparations were being made so that it would not interfere with the orderly continuation of his empire. Irving wrote his book and the publishers announced it. Onassis knew someone had given Irving the information. He thought it was Maheu and fired him in November, 1970. On Thanksgiving Eve, 1970, in the middle of the night "Hughes" (Rector made a well-publicized "secret departure" from Las Vegas to the Bahamas).

•December 1970: Onassis discovered his mistake and had Merryman killed. Robert Maheu accidentally deprived of his half-million dollars annual salary, sued "Hughes" for millions mentioning "Hughes" game plan for the purchase of Presidents, governors, Senators, judges, etc. Onassis paid off cheap at the price to maintain his custodianship of "American democracy" and the "free world" and keep from hanging for multiple murders. The "Hughes" Mormon Mafia party, plus Rector, fled around the world from the Bahamas where they murdered an uncooperative Governor and Police Chief, to Nicaragua, where they shot the U.S. Ambassador between the eyes for noticing that there wasn't really any Hughes; and then to Canada, where Mormon Mafia nursemaid Sckersley looted a goodly sum in a swindle of the Canadian Stock Exchange; and on to London to Rothschild's Inn of the Park.

•April 18, 1971: Howard Hughes, a human vegetable as the result of serious brain damage during his 1957 hustle, plus fourteen years of heroin, grew sicker and sicker. A final overdose of heroin did him in. His coffin was lowered into the sea from a rocky headland off the coast of Skorpios. Present at the funeral were: Jackie Kennedy Onassis, Teddy Kennedy, Francis L. Dale, Director of CREEP, and a South Vietnamese cardinal named Thue. Onassis allowed some pictures to be taken from a distance; he himself did not appear. The pictures were published in Midnight, a Canadian tabloid. Albanian frogmen, tipped off, were waiting under the water. They seized the coffin and took the corpse off to Yugoslavia, then to China, Russia and then perhaps to Boston in a foot locker. The

corpse's dental work was compared to Hughes's very own dental records and they matched. News of Hughes death, the U.S. take-over by Onassis and the facts surrounding the murders of JFK, RFK, Martin Luther King, Mary Jo Kopechne, and many more and the subsequent cover-ups (involving still more murders) had been circulating around the globe for several years. Any country with this information can blackmail the U.S. Mafia government, which has no choice but to pay up. The alternative: be exposed as a bunch of treasonous murderers. This is why China-hating red-baiting Nixon was forced to "recognize" China (which he now claims as his greatest accomplishment); and why the U.S.S.R. walks off with such good deals in U.S. loans, grains, and whatever else it wants. All they have to do is mention those magic words: "Hughes", JFK, RFK, MLK, Mary Jo-words to conjure by-and the U.S. Mafia government crawls into a hole. Information once leaked can't be unleaked. The only way to end the dilemma is through a nuclear war and that wouldn't be one-sided. The other way would be to throw the Mafia out of the United States. Starting at the top-with Ford, Rockefeller and Kissinger. Super-patriots, please note: No one-not all the radicals a On the day Hughes was buried, Clifford Irving's wife presented a publisher's check made out to "H. Hughes" to Onassis' Swiss Bank, for payment. Onassis paid off-cheap at the price. "Gemstone" papers rolling around the world, here and abroad, kept the situation hot. Everyone was nervous. Rockefeller gave Kissinger $50,000 for Carlson and Brisson to write their "expose", "The Alioto Mafia Web' for Look. Their mission: find out everything that was public record about Alioto's connection with the JFK murder (His pay-offs to Frattiano, listed in D&B)-and explain it away-in any way that didn't lead back to Dallas. The idea was to get Alioto to quietly go away but still keep the lid on everything.

•May 1971: Tina Livanos Onassis married Stavros Niarchos, her former brother-in-law-until he lolled her sister, Eugenie.

•May 1971: "Folk hero" Daniel Ellsberg, a well-known hawk from the Rand Corp., who had designed the missile ring around the Iron Curtain countries (how many missiles to aim at which cities), was told to release the faked-up "Pentagon Papers," to help distract people from Hughes, JFK, RFK, MLK, etc. The papers were

carefully designed by Ellsberg and his boss, Rand Chief and new World Bank Chief Bob ("Body Count") McNamara, to make the Vietnamese War look like "Just one of those incredibly dumb mistakes". This helped to cover up the real purposes of the war: Continued control, for Onassis and his friends, of the Golden Triangle dope trade (Vietnam, Laos, and Cambodia); and for Onassis and the oil people, of Eastern oil sources. To say nothing of control over huge Federal sums, which could be siphoned off in profitable arms contracts, or conveniently "disappear" in the war effort. McNamara's "World Bank"—handing out American money to "starving nations"-actually set up huge private bank accounts for various dictators in the Onassis-controlled Swiss banks. The money could be used as needed to support and extend Mafia operations. Example: $8 billion in World Bank funds for "starving Ethiopians" wound up in Emperor Haile Selassie's personal Swiss bank accounts. This would make him the richest individual in the world-but other dictators have Swiss accounts, too. Maybe even larger. The money drained from America and other captive Mafia nations to feed a greed that can never be satisfied. (Rand Corp., one of our major "think tanks" has another goody in store for the public: "Project Star," Rand's cover-up fall-back version of the JFK murder-held in reserve should public restlessness over the Warren Commission Report cover-up ever threaten to get out of hand. That ought to confuse the people for at least another twelve years, and by that time most of us will be dead, anyway ...) Note in passing: The dope trade routes are: Golden Triangle to Taiwan to San Francisco. Heroin from the Golden Triangle was sometimes smuggled into S.F. in the bodies of American G.I.'s who died in battle in Vietnam. One body can hold up to 40 pounds of heroin, crammed in where the guts would be. Some dope gets pressed into dinner plates, and painted with pretty patterns. One dope bust in S.F. alone yielded $6 billion in heroin "china plates"-the largest dope bust in history-quickly and completely hushed up by the S.F. press Mafia. The dope sat in the S.F.P.D. for a while, then was removed by FBI men and probably sent on its way-to American veins. All of this dope processing and shipping is controlled and supervised by the Mafia, for the Mafia. Dope arrests and murders are aimed at independent pushers and maverick peddlers and smugglers who are competing with, or holding out on, the Mafia. While Nixon was conducting his noisy

campaign against dope smuggling across the Mexican border, his dope officer in charge of protecting the Mafia dope trade was E. Howard Hunt. Lots of heroin gets processed in a Pepsi Cola factory in Laos. So far, it hasn't produced a single bottle of Pepsi Cola. Some dope gets processed in heroin factories in Marseilles (see The French Connection). Still more dope comes from South America-cocaine, and now heroin. U.S. Aid went to build a highway across Paraguay (Uruguay?). Useless for the natives, who have no cars; they use it for sunbathing in the day. All night, airplanes loaded with cocaine take off from the longest landing strip in the world-financed by U.S. tax money for the benefit of international Mafia dope pushers. And then there is opium from Turkey-morphine. This was the starting point of Onassis' fortune. In case one is still wondering whether the Mafia can actually get away with such things, consider the benefits derived from controlling the stock market, the courts, the police, etc., in one swindle alone: the 1970 acquisition by "Hughes" of "Air West", which involved swindling Air West stockholders of $45 million. Recently indicted for that swindle by the S.E.C. (in a civil suit) were "Howard Hughes" and Jimmy (the Greek) Snyder, "not usually associated with the Hughes crowd," and others.

•June, 1971: New York Times began publishing the Pentagon Papers, Rand Corp.'s prepared cover-up of the real reasons for the Vietnamese War. Nixon had gotten a copy of the first Gemstone Papers, circulated in the U.S. back in 1969. He was now wondering how much information Democratic chairman Larry O'Brian had about Hughes, Onassis, JFK, RFK, et al., and more specifically, how much of the dirt the Democrats planned to use. Nixon set up the "plumber's unit" to "stop security leaks, investigate other security matters." Ehrlichman, Krogh, Liddy, Hunt, Young, etc. Hunt as "White House consultant" supposedly worked for the Mullen Corp. - a CIA cover. Mullen's chief client was "Howard Hughes". Robert Bennett was the head of the Mullen Corp.

•June 28, 1971: Ellsberg indicted for leaking the Pentagon Paper's.

•September 3, 1971: The Watergate team broke into Ellsberg's

doctor's (Fielding's) office to get Ellsberg's psychiatric records. Team members: CIA Hunt and Liddy; Cuban "Freedom Fighters" De Diego, Martinez, Bernard Barker. All except Liddy had worked together back at the Bay of Pigs. Question: Why the intense battle between Mafia forces? Answer: While Onassis was the recognized crowned head of the Mafia, intense, no holds barred scuffling for the lucrative second spot (control of U.S. presidency, government, and so on) was permissible and encouraged under the Mafia code of rules. The only stipulation: outsiders mustn't know about it. "Hughes" contributed liberally-and equally-to both Democratic and Republican parties for the 1972 election. The winner would get even more money from "Hughes".

•September 23, 1971: E. Howard Hunt spliced up the phony cables implicating JFK's administration in the Diem assassination.

•October 1971: Look magazine apologized to Alioto for their "Alioto Mafia Web" article--and folded. The sticking point: they couldn't prove Alioto's Mafia Nut Tree meeting back in '63-re: the JFK murder.

•November 1971: Alioto re-elected S.F. mayor.

•December 1971: Roberts applied for a "Gemstone" visa from the Russian Consulate-on a tapped phone. Phone was tapped by Hal Lipset, S.F. private investigator, who worked for Katherine Meyer Graham, and others, and routinely monitored Consulate phone calls..

•January, 1972: The Watergate team showed up at the S.F. Drift Inn, a CIA-FBI safe-house hangout bar, where Roberts conducted a nightly Gemstone rap, for the benefit of any CIA or FBI or anyone who wandered in for a beer. James McCord, Martinez, Bernard Baker, Garcia, and Frank Sturgis showed up-along with a San Francisco dentist named Fuller. James McCord remarked: -Sand and oil with hydrogen heat makes glass brick-threat of war to Arab nations. The event, like the other nightly raps, was taped by the Drift Inn bartender, Al Strom, who was paid to do so by his old friend, Katherine Meyer Graham-but told his other friend, Roberts, about it. The bar was also wired for sound by Arabs, Russians and

Chinese.

•January 27, 1972: Liddy and Dean met in Mitchel's office, with Liddy's charts for his $1 million 'plan' of spying, kidnapping, etc. The plans included breaking into Hank Greenspun's Las Vegas office safe, in hopes of recovering Greenspun's file on the Hughes kidnapping and Onassis' Vegas operations, which Greenspun had successfully used to blackmail Onassis out of $4 million or so. A "Hughes" get-away plane would stand by to take the White House burglars to Mexico.

•February, 1972: Liddy and Hunt traveled around a lot, using 'Hughes Tool Co." calling cards, and aliases from Hunt's spy novels. Liddy, Hunt and other Watergaiters dropped by for a beer at the Drift Inn, where they were photographed on bar stools for Katherine Graham. These photos were later used in the Washington Post, when Liddy, Hunt, and the others were arrested at Watergate-because CIA men like Liddy and Hunt aren't usually photographed. Roberts quoted to Liddy the "Chinese stock market in ears"-the price on Onassis' head-by the ear-in retaliation-for a few things Onassis had done; on Wayne Rector, the Hughes double; Eugene Wyman, California Democratic Party Chairman and Mafla JFK pay-off bagman; and on Lyndon Johnson: 'four bodies twisting in the breeze'. Roberts: "Quoting the prices to Liddy at the Drift Inn made their deaths a mortal cinch. Liddy's like that-and that's why the murdering slob was picked by the Mafia." "Gemstones rolling around the Drift Inn in February inspired Liddy's 'Gemstone plan' that became Watergate."

•February, 1972: Francis L. Dale, head of CREEP and ITT Board of Directors member, pushed Magruder to push Liddy into Watergate. In a Mafla-style effort to shut Roberts up, his father was murdered by "plumbers" team members Liz Dale (Francis L. Dale's ex-wife), Martinez, Gonzalez, Barker; in Hahnemann"S hospital, S.F.—where Mr. Roberts had been taken after swallowing a sodium morphate "pill" slipped into his medicine bottle at home by Watergate locksmith (Miama's "Missing Link" locksmith shop) Gonzalez. The pill didn't kill him; he had a weak digestion, and vomited enough of the sodium morphate up (it burned his lips and

tongue on the way out)-but he had emphysema, and went to the hospital. In the hospital, "nurse" Liz Dale and "doctor" Martinez assisted him to sniff a quadruple-strength can of aerosol medicine-- enough to kill him the next day. The day before, Tisseront, head of the College of Cardinals at the Vatican, was pushed out of a Vatican window. Tisseront had followed the career of the present Pope, Montini (whose mother was Jewish). Montini sodium-morphate-murdered Pope Pius XI; was banished from Rome for it by Pius XII; became Pope in 1963. Tisseront wrote it all down; called the Pope "The Deputy of Christ at Auschwitz," and the fulfillment of the Fatima 3 prophecy: that "The anti-Christ shall rise to become the head of the Church." Tisseront also wrote about all the suppressed secrets of the Roman Catholic Church: ie., that Jesus Christ was an Arab, born April 16, 6 BC, at the rare conjunction of Saturn and Jupiter. Arab (Persian) astronomers(the Magi) came to Bethlehem to look for their king-an Arab baby-and found him in a stable, because the Jews wouldn't let Arabs Mary and Joseph into their nice clean inns, even then. When Jesus overturned the tables of the money-lenders at the Temple, the Jews had the Romans n Mary a virgin, and work out a church-state deal to fuck the people in the name of God and country that has been operating ever since. Around 300 AD-at the Council of Nicasa—the Christian Orthodoxy was established; a dissenting bishop had his hands chopped off, another bishop was assigned to round up all the old copies of the Bible and destroy them, in favor of the "revised", de-Arabized version. Cleaned up Matthew, Mark, Luke and John were declared "it"; the other Gospels were declared Apocryphal and heretical. Roman Emperor Constantine became the first "Christian" emperor. Later-during the 'Holy crusades'-the Bible was again rewritten-to include Jesus's warning against the "yellow race." "27 Gemstones, with histories, to 27 countries, brought Red China into the U.N. and threw Taiwan out."

•April 1972: Money pours into CREEP: "Gulf Resources and Chemicals Corp., Houston, Texas' contributes $100,000; illegal, laundered through Mexico, comes back through Liedtke of Pennzoil Corp., Houston. (59) Robert Vesco gives Maurice Stans $200,000 'campaign contribution,' etc., etc. Liddy gives McCord $76,000; McCord buys $58,000 worth of bugging equipment, cameras, etc.

•May 1972: J. Edgar Hoover had the Gemstone File; threatened to expose Dallas-JFK in an 'anonymous" book, The Texas Mafla. Instead, someone put sodium morphate in his apple pie. The corpse was carted away from his home in the back seat of a VW-and his files were "burned" but some of them got away.

•May 28, 1972: First break-in at Watergate: McCord, Barker, Martinez, Garcia, Gonzalez, Sturgis. De Diego and Pico stood guard outside. Hunt and Liddy directed the operation from a (safe?) distance- across the street. The object was to check on Onassis's two men at Democratic Party HQ: Larry O'Brien and Spencer Oliver. (O'Brien's chief PR; client had been 'Hughes'; Oliver's father worked for Onassis). McCord wiretapped their phones. But!!! Little did McCord know that the Plumbers were being observed by Hal Lipset, Katherine Graham's S.F. detective who had followed two of the Plumbers from Liz Dale's side in S.F. to Watergate. Lipset 'watched in amazement' as the Plumbers broke in and bugged the phones; then reported back to his boss, Katherine Graham. Lipset and Graham set the trap for the Watergaiters when they returned to remove their bugs and equipment.

•June 17, 1972: Bernard Barker was wearing his Sears, Roebuck deliveryman costume-the same one he wore at the Dr. Fielding break-in and at the Hahnemann's Hospital murder of Mr. Roberts. Hal Lipset, Graham's spy, was dressed as a mailman. He left his mallsack behind when he taped the door at Watergate, watched security guard Frank Wills remove it and walk on; retaped the door, and as a result, Frank Wills went across the street and called the police, and McCord, Martinez, Sturgis, Barker and Gonzalez were caught in the act. (Graham had them on tape and film, too, every minute of the time.) Liddy and Hunt, across the street, supervising via walkie-talkie, were not. Liddy called Magruder in California re: the Watergate arrests. Magruder told Mitchell, LaRue and Mardian. Time to bum files. Liddy shredded the Gemstone files at CREEP. Dean cleaned out Hunt's safe at the White House, and gave Hunt's copy of the Gemstone file to L. Patrick Gray, acting FBI head: "Deepsix this-in the interest of national security. This should never see the light of day.' Gray burned the file.

•June 20, 1972: DMC Chairman Larry O'Brien filed a $1 million suit against CREEP-naming Francis L. Dale, the head of CREEP. This was a big Mafia mistake-for Dale led directly back to Onassis.

•June 21, 1972: The 18-112 minutes of accidentally erased White House tape: Nixon, furious over the Watergate Plumbers' arrests, couldn't figure out who had done it to him: who had taped the door at Watergate that led to the arrests? Hal Lipset, whose primary employer at the time was Katherine Graham, couldn't tell him. Nixon figured that it had to do somehow with Roberts's running around in Vancouver tracing the "Hughes" Mormon Mafia nursemaid's (Eckersley) Mafia swindle of the Canadian stock exchange; and Trudeau. The 18 1/2 minutes was of Nixon, raving about Canada, "asshole Trudeau", "asshole Roberts", Onassis, "Hughes" and Francis L. Dale. It simply couldn't be released. Stephen Bulrs secretary, Beverly Kaye, later heard the "erased" tape, stored in a locked room in the White House. She was horrified. She sent out some depressed Christmas cards and notes to friends, and sodium morphate 'heart attacked' at age 40 in a White House elevator outside the locked safe room where the tapes were stored.

•January 1973: Tisseront was dead-but as the Church rushed to destroy every copy of his papers, Roberts received one-and wrote a few of his own, released over New Years': 1. "The Cover-up of the Murder of Christ"; 2. "The Yellow Race is not in China-The Yellow Race Dead-Fucks Mary Jo Kopechne"; 3. "Mrs. Giannini's Bank of America financed the murder of JFK at Dallas via Alioto's Frattiano, Brading and Roselli"; 4. "Vietnam-Fatima 3-Holy Crusade." "Four documents; four bodies twisting slowly in the breeze." Lyndon Johnson: Sodium Morphate "heart attack" at his ranch on the Perdernales River. Among his last words: "You know, fellows, it really was a conspiracy..." Alexander Onassis's plane crash at the "1000 foot Walter Reuther Level," via a fixed altimeter, at Athens airport. Eugene Wyman, California Democratic Party Chairman, and JFK assassination pay-off bagman: heart attack. L. Wayne Rector, Hughes double: killed at Rothschild's Inn on the Park, in London. "Started the shattering of the Mafia economy."

•March 18, 1973: Roberts called Hal Lipset, discussing all these

matters publicly-over a tapped phone. Lipset reported to Dean, who had hired him away from Graham after they figured out who had taped the door at Watergate. (Mitchell: "Katie Graham's liable to get her tit caught in a wringer.")

•March 19, 1973: Dean to Nixon, nervously: "There is a cancer growing on the Presidency."

•March 21, 1973: Nixon said that on this date he "received new evidence on Watergate.' Lipset later bragged on TV that he had been the one to bring the 'new evidence' to Nixon. Meanwhile, back at the Washington Post, Katherine Meyer ("Deep Throat") Graham had been feeding Woodward and Bernstein information for their articles.

•May 10, 1973: (64) The first witness at the Watergate hearing, running down the names on the CREEP organizational chart, mentioned the name at the top: Francis L. Dale, Chairman. Dale was never mentioned again during the rest of the trial.

•July 9. 1973: Roberts had used Al Strom's Drift Inn Bar as an "open lecture forum" for any and all-and Al Strom taped it, for his boss Katherine Graham. But "Al was fair"-and told Roberts he was doing it-for which he was murdered on this date.

•August 1973: Murder of Chile, by Group of 40: (Rockefeller and his man, Kissinger), working with the CIA and $8 million. Allende's Chile had nationalized ITT. Admiral Noel Gaylor, Naval Intelligence, told Roberts 1 1/2 years earlier that Chile would get it; Roberts warned the Chilean consul in advance: Allegria, now 'teaching' at Stanford. ITT has now exacted $125 million payment for its Chilean plants-a good return for their $8 million. Mafia-controlled Chile's annual inflation rate has set a world's record. In the style of the old Holy Roman Empire: a slave nation paying tribute to the conqueror.

•October 1973: Another "Holy War"—Israelis vs. Arabs.

•January 1974: Joe Alioto grants Sunol Golf Course lease to Mafioso Romano, Frattiano, Muritz, Madeiros, Abe Chapman, and

Neil Neilson. Alioto sets up the Dallas murder squad in S.F. for more murders.

•January 26, 1974: "Hughes" extradition trial canceled in Reno, "Alioto Mafia Web" Mafia Judge Thomson, after Moses Lasky, from Mafia Alioto's California Crime Commission, waves the forged 'Howard Hughes' signature under his nose. Maheu "wins" his damage suit against "Hughes"-his blackmail pay-off-after discussing Hughes's "game plan" for buying control of the U.S. by buying politicians: Governors, judges, senators, and presidents.

•February 1974: Mafia Hearst's daughter Patty 'kidnapped' by Lipset's SLA-in a fake terrorist action. Martin Luther King's mother was murdered by a black student, a self-declared 'Israelite'--acting alone," who was escorted to the church by somebody-and who had a list of other mothers as targets. Next day, the target, Shirley Chisholm, got the message, and rushed to sign off on the DNC suit against CREEP, naming Francis L. Dale; she had been the last hold-out.

•April 4, 1974: Mary McCarthy, a writer who had been given a copy of the Gemstone File, said in an article in the New York Review of Books that the key to the formation of Liddy's Gemstone plan lay in the whereabouts and activities of the Plumbers between December, 1971 and February, 1972. Answer: They were in the Drift Inn, watching Gemstones rolling around on the bar top.

•August 6, 1974: Nixon and Ford signed a paper at the White House. It was an agreement: Ford could be President; Nixon got to burn his tapes and files, and murder anyone he needed to, to cover it all up.

•August 7, 1974: Roberts passed information to Pavlov at the S.F. Russian consulate which led directly to Nixon's resignation: the "More" journalism story reviews story about Denny Walsh's "Reopening of the Alioto Mafia Web" for the New York Times, killed in a panic; plus a long taped discussion of who and what the Mafia is. Hal Lipset, listening to the conversation in the bugged consulate room, had phone lines open to Rockefeller and Kissinger,

who listened, too. Rockefeller sent Kissinger running to the White House with Nixon's marching orders. "Resign right now." Nixon and Julie cried. But there was still some hope, if Nixon resigned immediately, of drawing the line somewhere-before it got to the King of the Mountain himself-Onassis. Nixon, on trial, would blurt out those names to save himself: Onassis, Dale, "Hughes". Even "JFK".

•August 8, 1974: Nixon stepped down, and Ford stepped up to keep the cover-up going.

•August 23, 1974: Frattiano in San Francisco, staying at the Sunol Golf Course. More murders scheduled re: Gemstone cover-up.

•August 30, 1974: Ford hires Mafia lawyer Becker to work out a pardon deal for Nixon, who might otherwise name Onassis, Graham, and Pope Montini to save himself.

•San Francisco Zebra Murders: A series of 'random' killings, dubbed "Zebra Murders' by the police because, supposedly, blacks were killing whites. The real target was Silva, the witness to Alioto's Mafia Nut Tree meeting. Silva was shot to death in an alley. Careful Mafia planning went into this series, to kill several birds with one stone: 1. Get witness Silva out of the way, without being too 'obvious" about it; 2. Spread fear of "black terrorists," and convince people that the Police Department needed more money, and more repressive power. 3. Blame-and frame-Black Muslims-knock off leaders of the opposition.

•September 7, 1974: Roberts had made an agreement with a friend, Harp, of Kish Realty, over a bugged phone. Harp was to buy a Gemstone-with history-for $500, the price of a trip to Canada for Roberts to check into the "Hughes" Mormon Mafia Canadian stock market swindle, and other matters. But Harp was sodium-morphate poisoned before the deal could go through-on this date.

•Note: Sodium-morphate: a favorite Mafia poison for centuries. Smells like apple pie, and is sometimes served up in one, as to J. Edgar Hoover. Sometimes In a pill or capsule. Symptoms: Lethargy,

sleep, sometimes vomiting. Once ingested, there is a heart attack-and no trace is left in the body. Proof is in the vomit, which is usually not analyzed. Not mentioned in your standard medicine books on poisons, etc. It is a common ingredient in rat poison.

•September 8, 1974: Ford pardons Nixon for "all crimes committed from June 20, 1969 (oops, make that January) through August, 1974." Gemstone papers still floating around the world. Gandhi talks about the "U.S.'s bloody deeds."

•October 1974: Ford drops 'extradition" of Hughes from the Bahamas. Explanation: "We dropped it because we knew he wouldn't come." That's for sure!

•October 3, 1974: The Watergate Trial-the cover-up of the cover-up- got under way, starring Montini's, Ben Veniste, Onassis's Neal, Graham's Jill Volner. In the White House, Mafia Mayors Alioto, Daley, and Beame met with the "truth squad"-Ford, Scott, and Griffin-and Mike Mansfield, in secret.

•October 10, 1974: Tina Livanos Onassis Blandford Niarchos, sodium-morphate poisoned by hubby Stavros; puked, slept, and died of "heart attack." Losing his son, Alexander, took all the fun out of killing for Onassis. Who was there to inherit the world empire he had dreamed of handing to his son?

•December 1974: Brezhnev had scheduled a meeting with Sadat, of Egypt. The outcome wouldn't help the U.S. -no matter how many trips Henry made to the Mid-cast with clean socks and blank checks. A new U.S. 'secret weapon' was apparently used: a tiny speck of metal, introduced somehow into Brezhnev's lymph system. It lodged in the cluster of lymph nodes over his heart, and there it was coated with layers of phlegm-much as an oyster creates a pearl around an irritating grain of sand. Brezhnev's lymph system clogged up; he got the flu and the meeting with Sadat was canceled. Russian doctors x-rayed him and found a huge lump in his chest. Then they put him before a Kirlian camera and checked Ws aura for cancer. No cancer. Note: Kirlian photography is the latest Russian diagnostic tool. It reveals the presence of disease-physical or moral (it also detects

lies). Brezhnev's "lump" had to be treated with radiation therapy-hence the rumors he had cancer. It took six weeks to clear up.

•March 1975: Onassis died. The Mafia organization regrouped itself. Prince Faisal watched his uncle, King Faisal, silently watch the shift of Mafia power- and couldn't stand it. He shot his uncle, the spiritual leader of 600,000,000 Moslems, who had played ball with Onassis all along. South Vietnam's Thieu, dubious about which way the Mafia cookie would crumble now that Onassis was dead, decided the time was right for him to split. He abandoned the War Effort, cursed the U.S., and split for Taiwan, his plane so overloaded with gold bullion that he had to dump some of it overboard.

•March 15, 1975: Roberts got the "Brezhnev Flu," and spent 2 weeks at U.C. hospital. Doctors there, without the Kirlian photography diagnostic technique, assumed the softball-sized lump over his heart was cancer. It wasn't..

•April 1975: The Cambodian domino was no fun at all—it fell right over. Premier Lon Nol fled to exile in a Hawaiian suburb. CIA Chief Colby, in a fit of spite, "leaked" the "stolen" story of CIA-Hughes Glomar Explorer's raising of the bodies of drowned Russian sailors from their sunken nuclear submarine. Purpose: To bug the Russians, and also to halt criticism of the CIA by pointing out how noble, brave, and self-sacrificing they are in their efforts to save us. The Russians are funny about their dead. They bitterly resented Colby's game. They quietly went through a massive naval "war game"—the rehearsal of a nuclear attack of the U.S. Which brings us almost to the present time. Ford, Kissinger and Rockefeller squat like toads on the corpse of America. By the time of the Bicentennial, the stink may be unbearable. Ford now plans a propaganda movie version of his book, "Portrait of an Assassin." which will reiterate the exploded cock and bullshit notion that Oswald was JFK's "lone assassin." With singularly inept misunderstanding of the times, he seems to think Americans will take his word for it, and be "reassured" in the face of those "crackpot conspiracy theories." He doesn't seem to realize that he will be reminding, or informing, Americans, of his role on the infamous Warren Commission. I hope this outline will make individual Gemstone papers easier to

understand.

•IF YOU FOUND THIS OUTLINE INTERESTING:

•You won't be reading it in the papers for quite some time. At present, the only way to spread this information here In America is via hand-to-hand. Your help is needed. Please make 1, 5, 10, 100, copies, or whatever you can, and give them to friends or politicians, groups, media. The game is nearly up. Either the Mafia goes-or America goes.

(End of the original Skeleton Key to the Gemstone File as it appeared in 1975.)

Above: Robert Maheu.

Above: Hughes Aircraft Company employee Dr. Theodore Maiman working with a cube of synthetic ruby crystal during the development of the modern laser, circa 1960. Right: A synthetic ruby crystal from a State Department brochure. The United States is the number one producer of these synthetic gems.

4.

THE NEWSPAPER
ARCHIVES
PART ONE

| # IISSION IT UNIT | | # MAN HERE RULES MONTE CARLO SIT |

IISSION IT UNIT

Free From
ild Adjust
iradually

· solving the
was offered
zens Budget

transit au-
ansportation
itical arena,
nended by
l others, the
he proposed
ved a transi-
vhich to ad-
iolicies.
rinciple as
Riegelman,
nission and
serted:
ld create a
olitical pres-
ed to enable
ems realisti-
·rating econ-
vith the fare
: facts rather

ision, a pri-
i, said it had
rnor Dewey,
public offi-
t authority
; the follow-

by contract
es and with

rational pol-
act. Explore
iolicies with
t to approval
mate.
he city of a

(ie New York Times

**WINS BIG CASINO: Aristotle
Socrates Onassis, who has
bought the controlling interest
in the syndicate that operates
the gambling concessions and
resort hotels at Monte Carlo.**

SCHOOLS CALLED TRUE TO AIMS OF RELIGION

Special to The New York Times
WASHINGTON, Jan. 15 — In an-
swer to widespread criticism that
the public schools of the country
are irreligious, Hollis L. Caswell,
dean of the Teachers College, Co-
lumbia University, declared here
today that after twenty years of
close observation he could find
nothing to support the charge. In-

MAN HERE RULES MONTE CARLO SIT

Continued From Page 1

Important part of Mr. Onass'
shipping business, but whaling e
peditions are his biggest gambl
although they are conducted on
scale of efficiency undreamed of
the days of Moby Dick.

"Poor old Moby Dick," M
Onassis said. "In those days
whaler would be gone two or thr
years and had to go through ho
rors. Today my whaling fleet h
nineteen units: a 'mother ship,' si
teen chasers, two tankers to supp
fuel. It also has a helicopter to sp
the whales, radar, and, for th
men, a hospital, dentist, swimm!n
pool and movie."

"That," Monte Carlo's new pr
prietor said, "is what I call gam!
ling. To spend $57,000 a day fo
six months to go fishing. If yo
catch whales, that's just the fir
thing. What about the price o
whale oil that year?"

If the sound of the whirrin
roulette wheel or the rattling di
carry from the casino to M
Onassis' new office in Monte Carl
he won't mind. With, or withou
those red and blue chips aroun
the international shipping execu
tive is sure to fit into the spir
of the community like a native.

L. I. TRAINS MOVE BETTE

Road Reports 98.64 On-Tim Index for December

The Long Island Rail Road re
ported yesterday that 992 train
were late last month out of 17,327
run. This compared with 1,254 late
in December, 1951. The late train
last month lost an aggregate of
1,146 minutes out of scheduled

Gemstone skips over the period of Onassis' life when, as a whale poacher, he got in troub
with the Peruvian government. Shortly thereafter, he purchased majority shares of t
gambling concession in Monte Carlo.

1947

y of
Be
e of

—/P—
told
Great
her
a lim-
r and
ses in
ent to
g eco-

rs "in
ustries"
er and
e asked
y addi-

in also
rts in a
"hard-

ates, at
reed to
ertibility
n trade
0 000 000

Hughes Arrives in Washington —— Howard Hughes, millionaire plane builder, is questioned by reporters after landing at national airport in Washington, D. C., today to testify before the Senate

Hughes consolidated his power over international air travel in 1947.

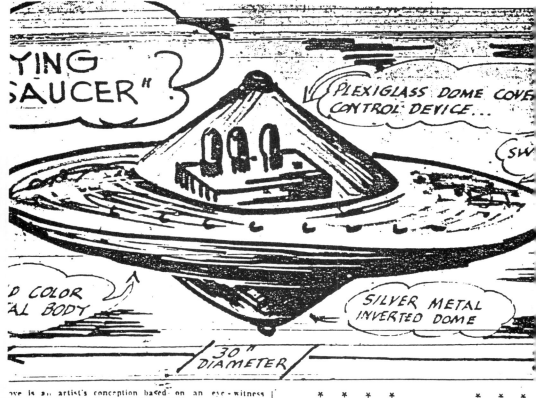

Guy Banister recovered this flying saucer in 1947, at the time of the Maury Island case. his book *Double Cross,* Sam Giancana linked Banister to Howard Hughes.

A General Links Kennedys To Plan to Depose Castro

By NICHOLAS M. HORROCK
Special to The New York Times

WASHINGTON, May 30—Retired Maj. Gen. Edward G. Lansdale said tonight that in late 1961, Attorney General Robert F. Kennedy, acting on behalf of President Kennedy, ordered him to prepare contingency plans to depose Premier Fidel Castro of Cuba.

In a telephone interview, General Lansdale said that at no time did he receive orders from either of the Kennedy brothers to plan an assassination of the Cuban leader. But he said that in the later operational planning the matter of assassination as one means of removing Mr. Castro from power may have been contemplated.

He said that to his knowledge no plan to assassinate Mr. Castro had ever been approved by any high member of the Kennedy Administration. The general said that in November or December, 1961, he was asked by Robert Kennedy to prepare a contingency plan to remove a leader whose actions "might endanger millions of Americans."

The leader, he acknowledged, was Mr. Castro. He said that the planning had centered on selecting a tight cadre of Cubans from the exile groups coming into the United States who were politically cohesive and might be able to start a popular uprising against Mr. Castro in Cuba.

General Lansdale said that he believed "Americans could not do this—you had to find natives of the country who had

Continued on Page 55, Column 1

U.S. Plan to Airlift Saigon Police Failed

By ALAN DAWSON
United Press International

SAIGON, South Vietnam, May 30—The United States Ambassador to South Vietnam, Graham A. Martin, promised helicopter evacuation last month for 150 top South Vietnamese policemen, but the aircraft never arrived, sources directly involved in the operation said today.

As a result of the missed evacuation, the former police chief committed suicide and a records of the police department fell into the hands of the new government, the source said.

Included in the computer records are names and details on police informers, undercover agents and double agents used by the Americans in South Vietnam, they said.

The sources said the main

Continued on Page 10, Column

Son
ked
De-
erts

Æ—
d at
Hills
lants
l the
erve
ding
gton
s in-
sub-
ance
ghes
iness
going

1.—
P.
it El-
How-
best

hoto-

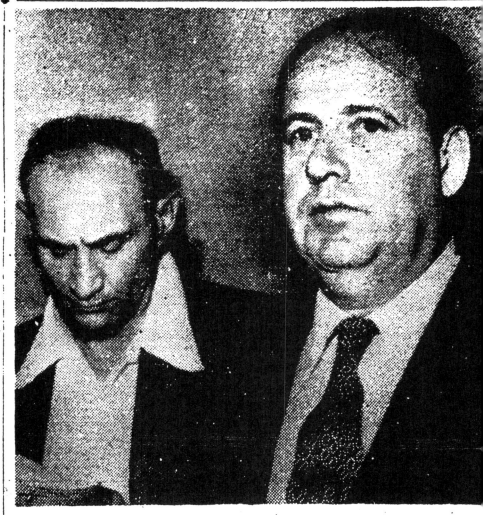

Declines to Discuss Hughes Probe—John W. Me
(right), publicity man for Howard Hughes, talks to reporters at
Guardia Field Friday morning on his arrival from Paris. In his b
interview with newsmen he said he had no comment on his schedu
appearance in Washington before the Senate committee investigat
war profits concerning Hughes' plane building activities.—(Æ w
photo)

Alexander Onassis, Only Son
Of the Magnate, Dies of Injuries

Special to The New York Times

ATHENS, Jan. 23 — Alexander Onassis, the 24-year-old only son of Aristotle Onassis, the multimillionaire, died in a hospital here of a brain hemorrhage tonight, 27 hours after his plane crashed at the Athens airport.

His father and stepmother, Mrs. Jacqueline Onassis, flew in from New York with a leading Boston surgeon. Also present at the bedside were his mother, who recently married her sister's widower, Stavros Niarchos, regarded as Mr. Onassis's chief business and social rival, and his sister Christina, 22, who flew in from Brazil.

The two-engined amphibian Piaggio crushed during take-off yesterday. Alexander was planning to try out a new American pilot, Donald McCusker, for the fleet or air taxis he operated in Greece. Mr. McCusker was seriously injured, but the third occupant of the four-seater, Donald McGregor, the 58-year-old pilot whom Mr. McCusker was to succeed, was reported to be recovering.

Alexander was born in New York April 30, 1948, the day his father launched an 18,000-ton tanker, the biggest then built in the United States. Five years later the youth launched in Germany a 45,000-ton tanker, the Tina Onassis, named after his mother.

Alexander, who retained his American citizenship, attended a private school in Paris. When his parents were divorced in 1960, he was said to have been deeply hurt. He spent his time traveling between them—his mother having married Britain's Marquess of

Associated Press
Alexander Onassis

Blandford, and his father Mrs. John F. Kennedy in 1968.

Alexander attended his father's wedding but did not see his mother after she married his uncle, Stavros Niarchos, following her divorce from Lord Blandford.

Alexander was president of Olympic Aviation, a subsidiary of his father's Olympic Airways, which owns a fleet of light aircraft and helicopters for rent to tourists and businessmen. Since he took his first flying lesson in 1968 he had put in 1,500 flying hours and had a professional pilot's license.

He often piloted aircraft on medical emergency missions, mostly to rugged islands or mountainous villages to transport patients needing hospital care.

ROBERT HELLER, 7
MANAGEMENT AID

Efficiency Expert, Who C
Federal Units' Costs, Die

Robert Heller, a management engineer and efficiency exp who helped reorganize pro dures for Congress, the Pen gon and some of the countr largest corporations, died M day at Delray Beach, Fla. was 74 years old and lived Bratenahl, Ohio.

Word of his death was ceived yesterday by a s Charles, of Chatham, N. J., w said Mr. Heller had died o stroke while on a trip.

Mr. Heller, until his reti ment in 1963, was president Robert Heller & Associates Cleveland. One of the concer largest reorganization proje was for the United States St Corporation, from 1935 to 19

Others included the F Motor Company, E. I. du P de Nemours & Co., the Ba more & Ohio Railroad, Pennsylvania Railroad and Columbia Broadcasting Syst

In 1944, Mr. Heller publis a plan for reorganizing Congr — "Strengthening the C gress." Many of its suggesti were later incorporated i the La Follette-Monroney and passed by Congress as Legislative Reorganization of 1946. One of the import features of the Heller plan v the reduction in the number standing committees

Led Committee on Congres

Mr. Heller was named cha man in 1946 of the Natio Committee for Strengthen Congress. Its members, lead

Mrs. Kennedy to Visit Greece For Two-Week Rest in October

President's Wife Will Stay With Sister Near Athens on Private Vacation

WASHINGTON, Sept. 17 (AP) — The President's wife will spend the first two weeks of October in Greece, vacationing and convalescing, the White House announced today. Mrs. John F. Kennedy is scheduled to leave on the private trip abroad Oct. 2.

The First Lady plans to stay near Athens, where her brother-in-law and sister, Prince and Princess Stanislas Radziwill, have rented a house.

The temperature there usually averages about 67 degrees at that time of year.

Mrs. Kennedy will fly to Athens by commercial airliner, her press secretary, Pamela Turnure, said. Two Secret Service men will be her only traveling companions.

This will be the second time since the Kennedys moved into the White House that Mrs. Kennedy has taken a private vacation in Greece. She joined the Radziwills there for a nine day visit in June, 1961, after accompanying the President on state visits to Paris, Vienna and London.

At the time, Mrs. Kennedy was the guest of then Premier and Mrs. Constantine Caramanlis.

This time, the White House said, the visit will be "wholly private."

Mrs. Kennedy spent the early part of the summer at Cape Cod in Massachusetts, while awaiting the birth of her third child, Patrick Bouvier Kennedy, who was born Aug. 7 and lived less than two days. Since then,

Associated Press
Mrs. John F. Kennedy

she has remained at the Kennedys' rented home at Squaw Island in Hyannis Port, Mass., moving only recently to her family's seaside estate at Newport, R. I.

Although the birth of her third child by Caesarean section was premature, Mrs. Kennedy is reported to be making a fine recovery with no complications.

Her doctor has advised that she rest and engage in no official activities until after the first of the year.

Parade Hails Rescued Miners

MEDIA, Pa., Sept. 17 (AP) — David Polin and Henry Throne, the two miners who were rescued from a cave-in three weeks ago, were honored here today with a parade, a luncheon and a dinner. The celebration was sponsored by the Media Lions Club.

5.
HOWARD HUGHES
& ONASSIS

by Kenn Thomas

Then as now, world affairs turned on the machinations of oil and the defense industry. The Gemstone file reflects speculation and rumors about the real flows of power as opposed to the dribs, drabs and distortion that came with the daily news. The principal players, however, Aristotle Onassis and Howard Hughes, have conventional biographies. These are the products of their own publicists, of course, and a willfully naive media, but they nevertheless constitute the foreground for which Gemstone provides the parapolitical backdrop, and thus deserve critical scrutiny.

Today oil gluts from Russia and Iraq fuel US bombings, and thus its military expenditures in the Middle East. In the 1950s, the Iraqi pipeline was cut, the Suez Canal blocked, Britain and France rationed gas and the US used its clout to increase the number of oil tankers coming from the region. This helped Onassis build considerably on his already considerable fortune, having bought every tanker he could in 1947 and again in the mid-1950s, when he took advantage of a US subsidy program through trusts established for his two US born children. This happened before anyone could guess the Mideast emergency. The Gemstone file has Onassis selling oil, arms and drugs to the Allies and the Axis during World War II, and then illegally purchasing US "Liberty" war ships for the purpose. The mainstream had it that it all came about from healthy competition with his brother Stavros Spyros Niarchos, both

defying experts and fortuitously investing heavily in the tankers—but both, of course, being rather sleazy profiteers of war.

Through the sheer self-confidence and friendly competition of these brothers, insurance companies and banks also invested close to a half-billion 1950s dollars in new super-tankers. The closing of the Suez canal and the attendant windfall of demand for tankers in the shipyards around Europe and the US came as an utter surprise. Aristotle Onassis and Stavros Spyros Niarchos were on hand with the two largest tanker fleets in private hands. These fleets moved over five billion gallons of crude oil, a fifth of all oil imported from the Mideast to western Europe by 1956.

Thereafter each of the brothers became almost immeasurably rich and powerful. They continued to reinvest, of course, and carried on their brotherly rivalry. They raced to build bigger fleets of super-tankers, and tried to outdo each other in real estate purchases—along the Riviera, in Montevideo and Antibes, Buenos Aires, Monte Carlo, Bermuda, Athens, Paris, London and New York. Onassis converted a Canadian Destroyer escort into the most lavish yacht in the world, named "Christina," either after his wife or after a mythological Greek island, depending on the report—and docked it at Monaco reportedly to infuriate Prince Rainier, with whom he had a feud. Niarchos commissioned the world's largest sailing vessel, the 43 cabin, 190 foot "Creole." The two men were art connoisseurs, of course, each keeping paintings by El Greco on their respective ships.

Onassis married 17 year old Tina Livanos at the same time he got the US Liberty ships. She was the daughter of Spyros Livanos, another Greek shipping magnate. Niarchos also married a daughter of Livanos, hence the family basis of the friendly rivalry that made both so rich and powerful, according to standard biographies. "We're always trying to cut each other's throats," Onassis told the papers, "but every now and then we sit down together and act civilized on account of the ladies." At the time, Onassis owned Greek National Airlines,

controlled over thirty corporations and $300,000,000 plus fortune, and had a tax-free base in Monaco, where he owned three hotels and the Monte Carlo Casino.

Onassis was born to a wealthy tobacco merchant in Izmir, Smyrna, Asia Minor on January 15, 1906. His family fled to Greece in 1922 , during war that prevented Greeks from extending themselves into Asia minor. Stateless, he emmigrated to Argentina, where he transformed a 25 cent per day job as a telephone lineman into an export empire by eavesdropping on business deals.

According to Onassis lore, his tough-but-fair business attitude and the fact that he always "bought Greek" endeared him so to politicians in Athens that he was appointed Greek consul and remained in that position until 1935.

Through a network of shipping tycoons and sea captains, he picked up the inside scoop on a deal to buy six Canadian cargo ships for $120,000. According to Gemstone, he was a Greek drug pusher who cornered the Argentinean opium market in deals with Joseph Kennedy, Eugene Meyer and Meyer Lansky. Gemstone also claims he swung a heroin deal for FDR and shipped booze directly into Boston.

He did make some kind of deal with the Roosevelt administration, which rented his newly purchased cargo ships and promptly lost them to German U-boat fire. Shortly thereafter came the 1947 deal to buy war surplus Liberty ships from the US. Gemstone skips over the next period of Onassis' life, which began with him as a whaling poacher in trouble with the Peruvian government, continued through his purchase of majority shares of the gambling concession in Monte Carlo, and ended when he founded Olympic Airlines in Greece in 1956.

Then came the pivotal year of 1957, the year Gemstone has Onassis kidnapping Hughes. That happened in March; conventional sources place the significance of that year for Onassis in September, when he began to court opera star Maria Callas. His rather public pursuit of the prima donna on a yacht cruise led to divorce for both of them, and they were

still a couple by the time of the events of the Kennedy assassination.

Onassis first invited Jackie Kennedy on a Christina cruise after the tragic death of the infant Patrick Kennedy in 1963. (Jack Kennedy had visited the Christina after losing the vice-presidential nomination at the Democratic Convention of 1956 and, according to Gemstone, was promised the presidency.) Through her younger sister, Princess Lee Radziwell, Onassis initiated the invitation, ostensibly to get the attentions of the president's wife to turn from the tragedy of her infant son's death. She returned from that trip a little more than a month before the assassination. Onassis was among the few people allowed to visit her directly after the assassination and he became a shadowy presence in her life from there forward, as she slowly reemerged into social life. The odd couple dated and married in 1968, after she received a guarantee from Onassis that he would never see Maria Callas again.

In his 1998 biographical book, *Just Jackie: Her Private Years* (Ballantine), author Edward Klein describes an affectional/ sexual relationship between Jackie Kennedy and Clint Hill, the Secret Service agent at the back of the presidential limo during the time of the assassination. Hill had pushed Jackie back into the car after she leaped out to recover a portion of JFK's brain matter, thrown there by the shot from the grassy knoll. Klein also notes another important affair that Jackie Kennedy had before wedding Onassis, with architect John Carl Warnecke. So Onassis' takeover of Jackie Kennedy's life was not as immediate or absolute as some interpretations of Gemstone suggest. She also insisted on separate bedrooms, an allowance of $750,000 (for the Kennedy children as well, and no doubt security assurances for them), and $10 million a year if he ever left her and an agreement for $18 million if she ever left him. The pair often fought. At one point, Jackie removed her bikini while sunbathing on Skorpios, apparently to anger Onassis. Paparazzi published photos in the Italian magazine *Playmen*, and they appeared in *Hustler* in the US.

According to biographies, Onassis' emotional life ended

with the death of his son Alexander in a plane crash near Athens on January 22, 1973. He brooded over it for a year before emerging with a conspiracy theory that the plane had been sabotaged. He offered a million-dollar reward for evidence, but died three months later, March 15, 1975, of a strange disease called myasthenia, which disabled his speech. Jackie was left with $2 million, an annuity of $250,000, and one million each for her children. The rest of Onassis' fortune went to his daughter Christina.

Howard Hughes came into the wealth of his Texas family at age 19 in 1925, the same year he married his first wife, Ella Rice. They divorced after four years, ostensibly because of his eccentric behavior. Hughes loved aviation, motion pictures and beautiful actresses. These eccentricities made him an American celebrity. His actual accomplishments as an aviator were restricted to a three-day global traverse in 1938, and the failed "Spruce Goose" test flight that went no more than 70 feet in the air in November 1947. Hughes and his company, Hughes Tool, however, did develop important aviation technology, such as the air-to-air missile, satellites, retractable landing gear and high altitude oxygen feeders.

The actresses he slept with included Ava Gardner, Katherine Hepburn, Lana Turner, Ginger Rogers and Rita Hayworth, who left her husband, the great Orson Welles, for a tryst with Hughes. (Welles' documentary, *F is for Fake* includes thoughtful rumination about Hughes.) Hughes discovered the screen talents of Jane Russell, the favored pin-up girl of American GIs during World War II. Hughes showcased Russell's talents in *The Outlaw,* a movie that was attacked as immoral by the Catholic Legion of Decency. At one point, Hughes contracted severe syphilis, and he suffered depression after almost dying in a 1946 plane crash. Standard biographies track his drug use and paranoia to this year.

Like Onassis, however, Howard Hughes swung important deals in the transportation industry in 1947, and the significant details of his biography left out of the Gemstone belong to that period. Hughes had to defend his $40,000,000 wartime plane

contracts against charges they were awarded to him because of lavish orgies he threw for FDR's son, Elliott Roosevelt. Support for Elliott Roosevelt as a party animal comes from Gemstone, which reports upon Onassis' heroin deals involving him. Still, the parties that came under public scrutiny in 194, were the products of the personal style of John W. Meyer, Hughes' press agent. Meyer routinely wooed Congressmen and military brass with wine, women and a party atmosphere. Hughes owned a twenty-room mansion in Arlington, Virginia for the purpose. Meyer also introduced Elliott Roosevelt to his future wife, Faye Emerson.

The younger Roosevelt did provide an endorsement for one of Hughes' experimental aircraft, a reconnaissance plane called the XF-11 that had little value so late in the war. Nevertheless, that endorsement resulted in a $70 million contract for Hughes Aircraft. At one point, Hughes crashed a malfunctioning XF-11 into a Beverly Hills house.

Hughes' famous "Spruce Goose" boat-plane, the HK-1 Hercules made of plywood with eight engines and 200 ton weight was built only partly with $50 million of his own money. The US government picked up the tab for another $22 million. The Army, Navy, Air Forces and Maritime Commission all opposed the plan, yet the contract was awarded for it in 1942 supposedly as a means to stem off submarine sinkings. When a War Production board member was asked why it approved the production of such a bizarre craft, his feeble response was that otherwise Hughes would have taken the case for it to the man in the street.

The controversy over Elliott Roosevelt played out in the papers as the first postwar flying saucer wave began in the US. Hughes' partner Henry Kaiser testified that he could not recollect whether or not his contacts with Roosevelt led to the wartime contracts. FDR's commerce secretary Jesse Jones testified that the president had approved continued work on the Spruce Goose, but had no knowledge of how a contract developed without approval of the various military services.

For his part, Howard Hughes claimed that the

investigation of his wartime contracts was actually an attempt to coerce him into agreeing to a merger between his airline, TWA, and Juan Tripp's Pan American Airline. He called the committee chairman, Owen Brewster, a mouthpiece for Tripp. The previous February, Hughes claimed, he had visited Brewster to discuss the Spruce Goose and at that point Brewster offered to call off the coming congressional investigation. The price: merge with Pan Am or at least sell it TWA's international routes. Brewster admitted his interest in introducing bills in the Senate and the House to propose the creation of a single United States airline for all overseas aviation, grouping all private airlines under a federal umbrella.

John Meyer had little chance to explain the $165,000 worth of entertainment expense used to fete Elliott Roosevelt when questions came up about his own selective service deferments. Elliott Roosevelt testified that that he never discussed the F-11 plane with his father and, besides, fellow members of his air corps mission had taken up a collection and paid Meyer back for the parties. He did cop to accepting wedding presents from Hughes.

Under oath, Brewster denied that he offered a deal to Hughes while Hughes affirmed it, also under oath. "Senator Brewster's testimony yesterday is a pack of lies!," intoned Hughes, "and I can tear it apart if I'm allowed to cross-examine him!" When he returned after Hughes' challenge, Brewster acknowledged that he had eaten "three breakfasts in the last few months" at a special residence maintained by Pan American airways as a guest center for officials and employees. He also confessed close friendship to a Pan Am vice president. All of this had the effect of turning the allegations against Elliott Roosevelt on their head.

In August 1947, the Senate probe was abruptly cut off. "The press and the public have my undying gratitude," Hughes told reporters. "It was they who made it impossible for Senator Brewster to continue his Gestapo methods. He has an unlimited capacity to hit below the belt. I know he will be in my

hair for the rest of my life."

If Gemstone is to be believed, continued hounding by Brewster became the least of Hughes' troubles ten years later. Hughes came out quite victorious, in fact, buying control of the US electoral process with graft money to senators, governors and other politicos, culminating in putting Richard Nixon on the payroll. History records that Howard Hughes married Jean Peters, a lover of twelve years, on March 16, 1957, after exacting a promise from her that she would never have him committed for mental illness.

Again, Gemstone has Onassis kidnap Hughes that very month. As bizarre as the Gemstone events seem, even standard biographies acknowledge that it was in 1957 that Hughes' life took a turn toward the weird, and the eccentric behavior for which he is now known achieved full flower. By official account, Hughes died in 1976 in mid-air, flying from Acapulco to Houston, Texas.

6.

THE NEWSPAPER
ARCHIVES
PART TWO

Kennedy Friend Denies Plot Ro

By JOHN M. CREWDSON

Special to The New York Times

SAN DIEGO, Dec. 17—Judith Campbell Exner maintained today that, although she had had a close personal relationship with President Kennedy while she was dating two leaders of a Chicago crime syndicate, she had never acted as an intermediary between the Mafia and the White House.

At a news conference here called to dispel what she termed "wild-eyed speculation," Mrs. Exner, who is about 41 years old, said she had never discussed with Mr. Kennedy her relationships with the late Sam Giancana, then head of the Chicago syndicate, or John Rosselli, an associate of Mr. Giancana.

Nor, she said, had she ever been aware during the time she was seeing President Kennedy and the two crime figures that Mr. Giancana and Mr. Rosselli, were helping the Central Intelligence Agency to recruit agents in an unsuccessful plot to assassinate Prime Minister Fidel Castro of Cuba.

Mr. Castro's name, the woman said, was never mentioned in the numerous telephone conversations she had with Mr. Kennedy, beginning in March 1961, or during what she said were a number of private White House lunches in the President's office.

Mrs. Exner, whose tanned face was partly hidden behind saucer-shaped sunglasses, said that all of her discussions with the President, whom she said she had also seen on some occasions while he was traveling outside of Washington, were entirely "of a personal nature."

Mrs. Exner declined to com-

United Press International

Judith Campbell Exner at news conference in San Die

ment on a report that she spent some time with Mr. nedy in Palm Beach, Fla., she said that she had paid whatever trips she had t. to meet Mr. Kennedy whei was traveling around the c try.

She added that, although had not worked during the

Continued on Page 52, Colun

w York Times.

LATE CITY EDITION

U. S. Weather Bureau Report (Page 36) Forecasts:
Partly cloudy and cold today; clear
tonight. Fair and milder tomorrow.
Temp. range: 50–34; yesterday: 48–40

SECTION ONE

YORK, SUNDAY, NOVEMBER 3, 1963.

40c Beyond 50 mile zone from New York City, except on Long Island
18c Beyond 200 mile zone from New York City, higher in air delivery cities

THIRTY CENTS

DIEM AND NHU ARE REPORTED SLAIN;
ARMY RULING SAIGON AFTER COUP;
KENNEDY REVIEWS VIETNAM POLICY

ns and Algerians
ge Accusations on
h in Figuig Area

PETER GROSE
to the New York Times

Morocco, Nov. 2
n artillery barrage at
a town early today
to have erased the
agreement between
d Morocco that was
taken effect at mid-
night

Algerian said the
breach was laid to
After having ex-
the hope, thru the
would be successful,
officials announced
ring along the bor-
near Figuig had

forces launched the
Figuig, an ancient
frontier fortress, at
avy Moroccan artil-
from hills around

and Counterattack
bardments followed a
ck and county attack
during which King
of Morocco announced
at that his forces had
from the town of

the observers were
he scene from Rabat
ing yesterday. They
silence to this morn-
le reports, which re-
order crisis that flared
fighting Oct. 8.

I in the diplomatic
Figuig was Ya'Doum
bassador of Mali, in
pital, Bajunko, King
nd President Ahmed
of Algeria signed the
was then heralded as
for African mediation
ismanship under the
King Haile Selassie of
The Ambassador de-
comment on the new

an Tells of Attack
erian captured on the
of Figuig last night

AFTER COUP: Crowd jeers as head of a demolished statue is carted through Saigon. The head was part of
monument that was destroyed by a mob because it was thought to bear a resemblance to Mrs. Ngo Dinh N...

MRS. NHU SAYS U.S. WILL BEAR STIGMA

Calls Americans Responsible for Fate of Her Family — Rules Out Suicide

Text of Mrs. Nhu's statement
appears on Page 21

By JACK LANGGUTH
Special to The New York Times

BEVERLY HILLS, Calif.,
Nov. 2 — Mrs. Ngo Dinh Nhu,

Washington Expects Ties With Saigon Within Week

By HEDRICK SMITH
Special to The New York Times

WASHINGTON, Nov. 2 — President Kennedy met twice
today with his top national security advisers to formulate a
United States policy on establishing relations with the Pro-
visional Government of South Vietnam.

The President canceled plans to attend the Army-Air
Force football game in Chicago so he could conduct a full
policy review.

any new crisis in Saigon.
Washington was expected to
extend recognition, probably
early in the week, as soon as

SUICIDES DOUBT

Deposed Chiefs Fl
Then Were Seized —
Throngs Exult

By DAVID HALBERST
Special to The New York Times

SAIGON, South Vietn
Nov. 2 — President Ngo I
Diem and his brother, Ngo I
Nhu, are dead in the wak
the military uprising that en
their regime.

While the Saigon radio

IZVESTIA DERIDES
REVOLT LEADERS

$1.00 beyond 50-mile zone from New York City,
except Long Island. Higher in air delivery cities.

CAREY PROPOSES STRONGER AGENCY TO HELP CONSUMER

Calls 'Caveat Emptor' Creed Long Dead—Fines of Up to $5,000 in Program

By FRANCIS X. CLINES
Special to The New York Times

ALBANY, March 15—Governor Carey submitted his consumer program to the Legislature today, proposing a stronger government agency to specialize in the field, greater authority for consumers to instigate lawsuits and a variety of protective measures covering such matters as credit cards, traffic tickets and apples.

The principal proposal is for the scrapping of the present Consumer Protection Board, which has been much criticized by consumer groups, and for the formation of a Division of Consumer Affairs.

The new agency would have the power to subpoena witnesses before hearings, to serve as a consumer advocate before regulatory bodies and to issue regulations carrying civil penalties of up to $5,000. The enforcement of the regulations, however, would rest not with the division but with the State Attorney General's office.

"We have long passed the

Aristotle Onassis Is Dead Of Pneumonia in France

Amassed a $500-Million Fortune in Shipping— Wed Mrs. Kennedy

Special to The New York Times

PARIS, March 15—Aristotle Onassis, the Greek shipping magnate, died today at the American Hospital in nearby Neuilly-sur-Seine.

Mr. Onassis was taken to the hospital by special plane from Athens last Feb. 7 and underwent an operation to remove his gall bladder two days later. Although the operation was successful, he was also suffering from myasthenia gravis, a debilitating neurological disease, which had affected his heart.

Dr. Maurice Mercadier, one of his physicians, said death was due to bronchial pneumonia, which "resisted all antibiotics." Mr. Onassis had been receiving cortisone treatment, which, the doctor said, lowered his resistance to infection and made the pneumonia "uncontrollable."

Mrs. Onassis, the former Jacqueline Kennedy, was in New York today, but left for here by air in the evening. Mr. Onassis had not left the hospital since he arrived five weeks

Associated Press
Aristotle Onassis

ago, and his wife had taken to commuting between Paris and New York.

Christina Onassis, the shipowner's daughter by his first marriage, was at the hospital with her father today.

His son, Alexander, died in an airplane crash in Greece two years ago.

Burial on Skorpios
By United Press International

ATHENS, March 15—Aristotle Onassis will be buried on his private island of Skorpios next to his son, Alexander, family

Continued on Page 54, Column 3

Rockefeller C.I.A. Inquiry

Ace S.F. Sleuth Lipset Indicted ---Hotel 'Bug'

HAROLD LIPSET
A 'chicken' thing to do

Harold K. Lipset, the San Francisco private detective and acknowledged expert on electronic devices, was arrested at 6 o'clock yesterday morning on a New York Grand Jury indictment.

The arrest was one of 20 made in four states yesterday as the climax to a 27-month wiretapping investigation carried out by New York District Attorney Frank S. Hogan.

Lipset, 47-year-old investigator whose transAtlantic chase of a pair of glamorous jewel thieves brought him a certain fame this year was picked up at his apartment at 2509 Pacific avenue.

The arrest was made by Inspectors Lester Hance and Edward Huegle of Special Services, armed with a New York warrant. Lipset was charged with eavesdropping, conspiracy to commit eavesdropping, and possession of eavesdropping equipment.

Contract for Delta Study On Pollution

■ Obituaries

Private Detective Harold Lipset Dies

Los Angeles Times

LOS ANGELES—Harold "Hal" Lipset, 78, an internationally known private detective whose trademark was electronic surveillance devices, including a bugged martini olive, died Dec. 8 at a hospital in San Francisco. He died of cardiac arrest after an aneurysm.

Mr. Lipset, sometimes known as "the private ear" as well as "the private eye" because of his listening mechanisms, was the founder of the World Association of Detectives, which has more than 700 members in about 40 countries.

He was appointed chief investigator of the Senate Watergate investigation committee in 1973, but he resigned after critics publicized his 1968 conviction for electronic eavesdropping. The misdemeanor was in violation of a New York wiretap statute and was considered such a minor offense that

Mr. Lipset, after pleading guilty, received no sentence.

True Detective magazine once called him "the maestro of electronic private detection." He acquired his first piece of electronic equipment, a wire recorder, in 1948.

Mr. Lipset was perhaps best known outside San Francisco for his often-parodied bugged martini olive. He introduced the olive to a U.S. Senate subcommittee in 1965 to illustrate how far miniaturization of surveillance equipment could go. The device, he later told a reporter, "was strictly for show" because it would operate for only 20 minutes and at a range of only 40 feet.

In a private demonstration, to win a contract to set up a surveillance system in a department store, Mr. Lipset secretly recorded a conversation with the owner when they were both nude in a Turkish bath. He concealed a recorder in a plastic replica of a bar of soap.

Mr. Lipset studied public relations in college but learned about the investigation business when he served in the Army during World War II and headed a criminal detective team in Europe. After the war, he set up his Lipset Service in San Francisco.

He began working for top lawyers in the San Francisco Bay Area and admitted patterning himself and his business after Paul Drake, the private eye assisting defense lawyer Perry Mason in classic detective yarns of Erle Stanley Gardner.

Mr. Lipset acted as technical adviser on Francis Ford Coppola's 1974 film "The Conversation," starring Gene Hackman as an obsessive surveillance expert.

Mr. Lipset's wife died in 1964.

Survivors include two sons, Louis, of San Francisco, and Lawrence, of Mendocino County, Calif.; and a grandchild.

Above: Ian Fleming at the Turkish set of *From Russia with Love*. Fleming may have been murdered because he had been telling too much in his novels.

Above: Ian Fleming's older brother Peter Fleming in a photograph from the book *Brazilian Adventure*. Peter may have collected the deadly poison curaré in the South American jungles.

7.
JAMES BOND &
THE GEMSTONE FILE

by
David Hatcher Childress

" Welcome to Hell, Blofeld," said Bond.
—Ian Fleming

"Your father, Ari, wouldn't approve."
—James Bond

James Bond books and movies have fascinated millions and the author of the James Bond novels, Ian Fleming, was a fascinating man himself—in many ways, the real James Bond.

Ian Fleming (1908-1964) had been in British Intelligence during WWII, and his experiences during and after the war became the basis for his James Bond novels, the first two being published in 1954, *Casino Royale* and *Live and Let Die.*

The official "biography" of James Bond, agent 007 (with a license to kill) has appeared in a number of books and the following appears in *Adventure Heroes* by Jeff Rovin (Facts on File, 1994):

James Bond was born on November 11, 1924, the son of a Scottish father, Andrew, and a Swiss mother. Andrew worked for the Vickers Armaments Company, and the family spent a great deal of time on the continent, where young James learned to speak French and German. When he was 11, James' parents were killed in a climbing accident and the boy went to live with his

spinster aunt, Charmain Bond. He entered Eton at age 12, got into unspecified (but deducible) trouble with a maid in the second semester, and was asked to leave; he transferred to Fettes, where he acquired renown as a lightweight boxer and saw to the establishment of a judo class.

Bond quit school when he was 17, though he subsequently took courses at the University of Geneva, where he also learned to ski. Claiming he was 19, Bond landed a job with the Ministry of Defense in 1941, working for the Special Branch of the Royal Naval Volunteer Reserves. A commander by the end of World War II, he was invited to join the secret service. After successfully executing two important assassinations, he was awarded the seventh Double-O number, which gave him legal license to kill but *only* in the line of duty. By 1953, 007 had been promoted to commander of the Order of St. Michael and St. George in recognition of of his exceptional service.

Bond was briefly married to Countess Tracy di Vicenzo; he met the beautiful young woman when her father, powerful gangster Marc-Ange Draco, agreed to provide 007 vital information about his archenemy, Ernst Stavro Blofeld, if Bond would spend some time with the flighty Tracy. The two fell in love and wed; she was shot to death on their honeymoon by Blofeld after Bond thwarted his latest scheme to control the world.

While Bond may have been a fictional hero, certain realities, including Bond's legendary bag of gadgets and dirty tricks, were mirrors of reality. Bond's archenemy, Blofeld, may have been based on a real person as well—none other than Aristotle Onassis.

From Skorpios with Love

Ian Fleming wrote a total of 14 books about James Bond: *Casino Royale, Live and Let Die* (1954), *Moonraker* (1955),

Diamonds are Forever (1956), *From Russia with Love* (1957), *Dr. No* (1958), *Goldfinger* (1959), *For Your Eyes Only* (1960, a collection of short stories), *Thunderball* (1961), *The Spy Who Loved Me* (1962), *On Her Majesty's Secret Service* (1963), *You Only Live Twice* (1964), *The Man with the Golden Gun* (1965), and *Octopussy* (1966, a collection of short stories). Fleming died in 1964 and the last two books were published posthumously.

Later, the James Bond series was added to, first by author Kingsley Amis with his single James Bond novel *Colonel Sun* (1968). John Gardner continued the James Bond series in earnest with the publication of *License Renewed* (1981) and followed with the books *For Special Services* (1982), *Icebreaker* (1983), *Role of Honor* (1985), *Nobody Lives Forever* (1986), *No Deals, Mr. Bond* (1987), *Scorpius* (1988), *Never Send Flowers* (1993), and the novelization of *License To Kill* (1989).

That Gardner would title one of his James Bond books *Scorpius* (1988) is testimony that Gardner knew that Fleming had patterned Blofeld after Onassis, as that was the name of Onassis' private island, Skorpios, off the Greek coast near Corfu. It was on this island that Onassis allegedly sometimes kept Howard Hughes, brain damaged and emaciated from daily heroin injections.

With the publication of *Casino Royale,* about a crooked casino owner named Le Chifre in Monte Carlo, Fleming had Bond hot on the trail of Onassis. It was in early January of 1953 that shipping tycoon Onassis purchased the Monte Carlo Casino in Monaco for a cool million dollars. It was the next year that Fleming's first book was published.

With Bond's arrival at the royal casino in Monaco, Ian Fleming put James Bond on a head on collision with the archvillain who wanted to control the world: Ernst Stavro Blofeld. The Stavro part of the name gives an indication that Fleming was aiming at Onassis and his Greek patriot shippers. Stavro was the first name of Onassis' rival Stavros Niarchos. (There is some confusion as to their relationship, as brothers,

archenemies, or whatever. They were not blood brothers, but rather, were married to sisters, and therefore, brothers-in-law.)

The buying of the Monte Carlo Casino in early 1953 put Onassis on the front page of newspapers around the world, and probably brought him to the attention of British Intelligence and thereby Ian Fleming and his friends.

Time magazine reported on January 19, 1953, "Aristotle Socrates Onassis is a Greek-born Argentine who water-skis in the best international circles and includes among his friends Prince Rainier III, Pooh-Bah of the tiny principality of Monaco and its famed Monte Carlo Casino. At 47, Onassis has homes in Paris, New York, Montevideo and Antibes, owns or controls a fleet of 91 tankers, freighters and whaling ships worth an estimated $300 million and has a pretty 23 year-old wife. But he didn't get all this by breaking the bank at Monte Carlo—quite the opposite. Last week "Ari" Onassis let it be known that, for $1,000,000, he had bought the 75-year-old Casino, lock, stock and roulette table, and with it the purse strings of Monaco. Reason: he needed some office space.

"As top man in nearly 30 shipping companies under five different flags, Onassis already has headquarters in Montevideo, branch offices in Paris, London, New York, Hamburg and Panama. But since much of his tanker business is bringing oil from the Middle East through the Mediterranean to Northern Europe, he thought he should have offices near the Mediterranean ports of Marseilles and Genoa, where many of his ships are repaired."

With Onassis now controlling the bank and casino in Monte Carlo—Fleming's *Casino Royale*—he now had more control over the heroin that flowed from Turkey to Marseilles on his ships, and a bank for laundering the money. He also virtually controlled his own country, that of tiny Monaco.

A year later, in 1954, Onassis made a deal with the King of Saudi Arabia that gave him a monopoly on the transportation of oil out of the kingdom. *Newsweek* on November 15, 1954

said of the historic deal, "The central figure is a fabulous Greek—Aristotle Socrates Onassis, owner of a worldwide tanker empire, of a dominant share in Monte Carlo's chief enterprises, and of one of the world's most luxurious yachts. Onassis (Ari to his friends) is not the mysterious and ruthless character that newspapers and magazines portray. Nonetheless, the role he set himself in the Arabian oil industry has produced baffling and as yet largely undisclosed intrigues.

"The crisis began when an agreement was completed on Jan. 20, 1954, between Saudi Arabia, represented by the Finance and Economics Minister, Sheik Abdullah el Sulaiman, and Onassis represented by Sheik Mohammed Abdullah Ali Ridha. The chief terms:

"1. The formation of a company called the Saudi Arabian Maritime Tankers Co. Ltd., with at least 500,000 tons of tankers.

"2. Shipment of all Saudi oil exports in tankers of the company, except that first preference would go to tankers owned by companies with concessions in Saudia Arabia—but under severe restrictions.

"3. The shipment of oil at a predetermined minimum rate.

"The Onassis contract was immediately interpreted by the major oil companies as a worldwide threat to the industry. Aramco, which holds the concession for Saudi Arabian oil, bitterly opposed the arrangement as contrary to the terms of its own concession. Aramco officials claimed that under the contract Saudi Arabia would be obliged immediately to ship 50 per cent of its oil in Onassis tankers while other companies gradually would be cut out completely."

Onassis, by the mid 1950s, owned the largest fleet of tankers in the world, the bank and casino in Monte Carlo, and had an exclusive concession on the shipping of Saudi Arabian oil to the west. What more could a man want? To control the world? Only two men would presume to control the world in such a way: Ernst Stavro Blofeld and Aristotle Socrates Onassis.

If James Bond could not bring down the empire of Onassis,

who could?

Ian Fleming, Master Spy

Ian Fleming was born in England in 1908 to a wealthy British family. His brother, Peter Fleming, was a writer and adventurer who authored *Brazilian Adventure* in 1933, the true story of a British expedition in search of the lost explorer Colonel Percy Fawcett. Peter Fleming had taken part in the expedition, a search through the Matto Grosso region of Brazil in an attempt to find out what had happened to Fawcett, a well-known figure, especially in Britain.

Fawcett had been the British representative to Bolivia, Peru and Brazil and had been hired to survey the remote jungle borders of these countries. Leaving in 1925 to find a lost city in the central jungles of Brazil, Fawcett vanished forever with his oldest son Jack and a young man named Raleigh (more information on Fawcett can be found in my book *Lost Cities & Ancient Mysteries of South America*). Though Peter Fleming and his companions were unable to find any real trace of Fawcett, he nonetheless was able to have a book of his jungle adventures published by major London and New York publishers.

Ian Fleming was influenced by his older brother, but did not become a writer himself until after he had served with British Intelligence during WWII. Bruce Rux, in his book *Hollywood vs. the Aliens,* says that Ian Fleming was involved with Aleister Crowley, the notorious self-styled warlock, and other notables of the British Secret Service in the plot that caused Deputy Führer Rudolf Hess to defect to England in May of 1941.

Fleming's Naval Intelligence colleagues attest to his having utilized government secrets in the plots of his books. Rux, and various Fleming biographers maintain that the ultra top-secret operation to steal the Enigma device from Germany during the war was one the operations that Fleming was involved in. This project was designated ULTRA and involved the cypher-machine that enabled the Allies to crack Germany's secret code.

Fleming was one of the top agents involved in ULTRA, both in England and later in Jamaica at the secondary decoding unit. It was while working in Jamaica for ULTRA that Fleming fell in love with the island, and lived there until his death in 1964. The top-secret Enigma machine was not declassified until 1975 (30 years after the war!), but Fleming had written about it in his 1957 book *From Russia With Love* which is proof that the Intelligence community will release top-secret material through books and movies many years before the knowledge is made public. In that book he called the device "Spektor" ("Lektor" in the film version).

Undoubtedly, Fleming was privy to a great deal of secret information, and knew many important world figures, including, apparently, Onassis. Some of this "secret" information that Fleming was putting into his books may have gotten him killed.

Fleming was also privy to early flying saucer information. Bruce Rux, in *Hollywood vs. the Aliens,* says Fleming had inside information on the UFO enigma, "UFO facts appear in at least two of his novels, *Doctor No* (1958) and *On Her Majesty's Secret Service* (1963), filmed by United Artists in 1961 and 1969, respectively." Rux points out that in *On Her Majesty's Secret Service* Blofeld and SPECTRE occupy a disk-shaped hideaway accessible only by private aircraft high in the Swiss Alps. This is SPECTRE's secret headquarters where mind-controlled assassins are created. Similarly, Rux points out, the name of SPECTRE's ship in *Thunderball* (1961) is the Disco Volante—the "Flying Saucer."

Certainly, Fleming had contacts with British Intelligence which discovered German plans for flying saucers at the end of the war ("Project Saucer") and knew Aleister Crowley, who was an early author on extraterrestrials. Crowley, like Fleming, knew a lot of interesting and unusual people, including Jack Parsons who started the Pasadena Jet Propulsion Laboratories (JPL) and L. Ron Hubbard who started the Church of Scientology. Hubbard was similar to Fleming in

that he was a world traveller, a writer of fictional adventures, and had worked in military intelligence during WWII. Fleming's links with Crowley, Parsons, Hubbard and to fellow British Intelligence agent Ivan T. Sanderson, may have led to his death.

Ian Fleming, Kennedy, and Castro

It was reported in Gus Russo's book *Live By the Sword* (1998, Bancroft Press, Baltimore) that Ian Fleming had influenced President Kennedy with his tales of agent 007. Kennedy loved the James Bond books, and *From Russia With Love* was listed as the President's ninth favorite book in a list issued from the White House just prior to the Bay of Pigs disaster.

Russo reports that Ian Fleming met with the Kennedys, along with Allen Dulles of the CIA, in Georgetown. As coffee was being served, Kennedy asked Fleming what James Bond would do if his superior "M" asked him to get rid of Castro. Fleming sidestepped the question and told Kennedy that he thought that Americans were too preoccupied with Castro and Cuba and that the attention that gave to Castro was inflating his importance.

Russo reports that Fleming then went on to regale the dinner guests with various proposals for "ridiculing" Castro in the eyes of his people and world press. Fleming claimed that there were three things that mattered more than anything else to all Cubans: money, sex and religion.

Fleming then went on to suggest the following three covert operations be taken against Castro:

1. The United States should send planes to scatter Cuban money over Havana, accompanying it with leaflets showing that it came with the compliments of the United States.

2. Using the Guantanamo base, the United States should conjure up some religious manifestation in the sky, such as a

76

cross or a vision of Jesus, which would induce the Cubans to look constantly skyward.

3. The United States should send planes over Cuba dropping pamphlets, "compliments of the Soviet Union," stating that the American A-Bomb tests had poisoned the atmosphere over the island; that radioactivity is held longest in beards; and that radioactivity makes men impotent. Consequently, the Cubans should shave off their beards, and, as the logic follows, without bearded Cubans, the revolution would collapse.

Russo reports that Fleming would have been proud of his suggestions had he not died in 1964 but had lived to read the report of the Church Committee issued in 1975, and the 1967 CIA "Inspector General's Report" released in 1993. All of his proposals were acted on by the CIA at the urging of the Mongoose coordinator, General Edward Lansdale.

Lansdale, apparently on the suggestion of Allen Dulles and JFK, urged the CIA to take Fleming seriously and attempted, among other things, to make Castro's beard fall out. The CIA considered staging a "religious event" off the coast using submarines based out of Guantanamo Bay (the U.S. Military Base on the eastern side of Cuba) and was also involved in a plot to flood Cuba with counterfeit currency.

Allen Dulles later wrote that after he was turned on to the James Bond books by the Kennedys, he became great friends with Bond's creator. "I kept in constant touch with him," Dulles wrote after Fleming's death. "I was always interested in the novel and secret 'gadgetry' Fleming described from time to time... They did get one to thinking and exploring, and that was worthwhile because sometimes you came up with other ideas that did work." (Quoted by Russo from the article "The Spy Boss Who Loved Bond" from the book *For Bond Lovers Only* by Lane and Sheldon, Dell Books, 1965).

Russo goes on to mention a more unsavory aspect of the administration's plotting against Castro: its use of the Mafia.

This also bore the Fleming stamp, although in this case, perhaps it was Kennedy inspiring Fleming. Judy Campbell (Judith Campbell Exner) had claimed that she while she was Kennedy's lover she passed Castro assassination plans from Kennedy to Chicago mob boss Sam Giancana. One year after Campbell says she performed this function, Fleming published *On Her Majesty's Secret Service* (1963). In that book, James Bond falls in love with the daughter of an organized crime syndicate leader (played by Diana Rigg in the film version). Bond proceeds to use his lover as a go-between with her father, and together they attempt to kill the sinister leader of an international terrorist organization (Blofeld, of course).

Curiously, the book (and movie) were about mind-controlled assassins. These mind-control assassins were being created by Blofeld at his clinic in Switzerland, high on top of a mountain. Shades of *The Manchurian Candidate* and of the mind-control aspects of Lee Harvey Oswald and Sirhan Sirhan in their respective Kennedy assassinations.

Gemstones Are Forever

In nearly half of the James Bond books, Fleming has as James Bond's archenemy the supervillain Ernst Stavro Blofeld, the head of SPECTRE. Bond tracks Blofeld around the world, to his luxury yacht and many holdings including "secret bases." In book after book Bond foils the plans of Blofeld, but is unable to apprehend the master criminal.

Bond tackles Blofeld in *Diamonds Are Forever* (1956), and then his new wife Tracy is tragically killed by Blofeld in *On Her Majesty's Secret Service* (1963). Bond continues to battle Blofeld at his secret base in Japan in *You Only Live Twice* (1964).

In the 1961 book *Thunderball*, Bond battles SPECTRE's Number Two (this guy's named Emilio Largo), an eye-patch wearing criminal who lives on a super-yacht named the Platos Volandos ("Flying Saucer"). The real-life model for Number Two is apparently Stavros Niarchos, Onassis' fellow shipping

"rival." Bond eliminates Number Two at the end of the book, but is still unable to get Blofeld, who escapes time after time. (Blofeld, and Number Two, are both parodied extensively in the hilarious 1997 movie *Austin Powers: International Man of Mystery.*)

The amazing story of Onassis, Hughes, Las Vegas, Area 51, and the oil industry (controlled, to some extent, by Onassis while he was alive) is told to incredible detail in the 1972 movie (based on Fleming's earlier book, but diverting extensively) *Diamonds Are Forever.*

In the filmed story of *Diamonds Are Forever,* the plot remarkably parallels The Gemstone File years before the Skeleton Key to the Gemstone File was ever circulated. The plot begins in the diamond fields of South Africa, as in Fleming's original book, but soon diverges from the book to bring in elements of The Gemstone File and the Mafia/Las Vegas/Area 51 entanglement.

Bond is assigned to follow a trail of diamonds from South Africa to Amsterdam and then to Las Vegas where he is confronted with the Mafia. In one scene, James Bond sneaks into a secret facility in the Nevada desert outside of Las Vegas. This facility is the location of Mercury, the exit off that interstate highway leading to Area 51, the top secret space facility in south central Nevada rumored to house flying saucers and alien technology. Once inside the facility, Bond pretends to be a worker in a lab coat and walks into a room where a German engineer is in charge. The man is clearly meant to be Werner von Braun. After witnessing the faking of the Apollo Moon missions, Bond steals the lunar rover and escapes into the desert. Does *Diamonds Are Forever* mirror the truth about NASA being part of a secret conspiracy? In the movie, the space facility and the Mafia are working together.

The movie, however, turns out to be the story of a kidnapped billionaire named Williard Whyte (played by Jimmy Dean of pork sausage fame), who is held in seclusion by Blofeld, exactly as Roberts claimed Hughes was held captive by

Onassis.

Bond frees the kidnapped Willard White and then proceeds, with the help of Tiffany Case (played by Jill St. John), to attack Blofeld at his secret base: an oil platform either off the coast of Texas or California, the movie does not indicate which. Bond destroys the oil platform but Blofeld escapes to reappear briefly in the 1981 film *For Your Eyes Only* when he is finally dispatched permanently. By this time, Onassis was dead as well.

Indeed, the parallels between *Diamonds Are Forever* and The Gemstone File are many:

•Willard Whyte is held captive in Las Vegas by Blofeld and the Mafia.

*Howard Hughes is held captive in Las Vegas and elsewhere by Onassis and the Mafia.

•Blofeld owns a casino named Casino Royale in Monte Carlo and has various "doubles."

*Onassis owns a casino in Monte Carlo named Casino Royale and Hughes has various "doubles" concocted by Onassis and Maheu.

•Blofeld owns oil fields and oil platforms. He is protected by foreign countries.

*Onassis owns oil tankers and has an exclusive deal with Saudi Arabia. He is protected by foreign countries such as Greece and Monaco.

•Blofeld is head of SPECTRE, a multi-national group of drug dealers, murders, arms dealers and oil men who are attempting to control the world.

*Onassis is the head of a multi-national group of drug dealers, oil tanker operators, casino owners, murderers and arms dealers.

•Blofeld owns his own island, high-tech yacht fleet, and private army.

*Onassis owns his own island (Skorpios), has a high-tech yacht fleet (Onassis owned many, many ships...), and controlled a private army that allegedly went beyond the

Mafia to the Marseille underground and the CIA and FBI.

•*Diamonds Are Forever* was about the secret NASA base outside of Las Vegas, and the use of diamonds to make a space-based laser system, one that could project holographic images into the sky.

*The Gemstone File is about synthetic rubies and their use by Hughes in laser research and Roberts' later use of these synthetic rubies as "gifts" with an attached "Gemstone Letter" that revealed certain behind-the-scenes activities of Onassis, the Mafia and the CIA to important and wealthy individuals. Las Vegas was the scene of Hughes' kidnapping and imprisonment, a city well known to be owned and run by the Mafia and their overt partners.

Ian Fleming: Sodium Morphate Victim

Ian Fleming died of mysterious circumstances in Jamaica on Aug. 12, 1964, of a "heart attack." According to Bruce Roberts, the "sodium morphate" used by Onassis and the Mafia made the victim appear to have died from a massive heart attack.

According to Preston B. Nichols and Peter Moon in their book *Pyramids of Montauk* (Sky Books, 1995), Ian Fleming knew certain information about the Rainbow Project, a secret endeavor that was to ultimately lead into what is known today as The Philadelphia Project. Fleming had worked with Aleister Crowley on the Rainbow Project, his part being a secret mission to meet with Karl Haushofer of the Nazi party in order to get him to convince Rudolf Hess to defect. Fleming met with Haushofer in Lisbon, Portugal, early in the war and persuaded the influential German occultist to talk with Hess on the behalf of Crowley. Both Haushofer and Hess admired Aleister Crowley a great deal, according to Nichols and Moon.

In August of 1964, say Nichols and Moon, Fleming was planning to fly from Jamaica to New Jersey to meet with Ivan T. Sanderson, a biologist and former British Intelligence agent. As a zoologist, Sanderson had written a number of books, including one on Bigfoot and Yeti, and appeared frequently on

radio shows and even Johnny Carson's *Tonight Show.*

Sanderson had become intensely interested in the paranormal, and was a personal friend of Morris K. Jessup, the UFO author who had first broken the news about the U.S. government's alleged attempts to achieve invisibility known as The Philadelphia Experiment (because the experiments originally took place in the Philadelphia Naval Yard). Sanderson often talked with his friends about UFOs, The Philadelphia Experiment, cryptozoology and other arcane subjects. Like Fleming, Sanderson was a British expatriot, Fleming living in Jamaica and Sanderson in New Jersey.

According to Nichols and Moon, Sanderson had been corresponding with Fleming, exchanging key information about the Rainbow Project; perhaps the involvement of Crowley, and how it related to the Philadelphia Project. Perhaps Fleming had some inside information as to the secret technology to make battleships invisible, teleport them, and ultimately on UFO technology in general.

In any event, Fleming never made it to his rendezvous with Sanderson. He died of a sudden heart attack on August 12th, 1964 at his home in Jamaica. Nichols and Moon point out that this is the 21st anniversary of The Philadelphia Experiment (August 12, 1943). Was Ian Fleming killed because he knew too much about such things as the Kennedy assassination, The Philadelphia Experiment and the genesis of UFO technology?

And what about Fleming's death? Did he have a sodium morphate apple pie that day after lunch? Served to him with pride by his Jamaican maid?

The identification of sodium morphate, as described by Roberts, has yet to be specifically identified. According to some researchers, a drug by that name does not exist. What does exist?

I propose that Roberts' sodium morphate heart attack drug is in reality three different drugs, all of which do the same thing: bring on a massive heart attack and kill the victim.

The first drug is what Roberts' sodium morphate is named

after: morphine. In large quantities, an "overdose," morphine will kill the user by stopping his heart. Heroin and morphine over-doses are all essentially heart failure. Therefore, injecting anyone with enough morphine would give them a "heart attack." Morphine would, however, be detected in an autopsy, were the body tested for such.

The next drug is the famous curaré, the poisonous secretion from certain Brazilian tree frogs that causes a massive attack in moments, and is virtually undetectable. Curaré is used by some tribes of hunters in the Amazon, and is also used by intelligence agents for certain assassinations. A small pinprick of curaré is enough to kill a large-sized man.

Neither drug would normally be cooked up in an apple pie as Roberts suggests. Rather, arsenic can be cooked in an apple pie very easily, in sufficient amounts, because it smells like almonds and can easily be disguised with cinnamon and apples.

It would appear that Roberts' "sodium morphate" is a combination of all three deadly poisons, morphine injection and arsenic pies being the favorite of the Mafia, while the CIA and British Intelligence prefer to use the more expensive curaré.

Was Ian Fleming offed with curaré—perhaps a drug that he helped develop along with his brother Peter? James Bond was aware of curaré. Was Ian Fleming murdered with an esoteric assassination tool which he helped to create? It is an interesting thought.

Armageddon and the James Bond/Gemstone Connection

Ian Fleming not only knew about the many secret machinations of British Intelligence, the activities of Onassis and other covert operations he may have known too much about the JFK assassination and the goings on around Cuba.

Fleming is mentioned in the Torbitt Document (as discussed in *NASA, NAZIS, & JFK*, AUP, 1996, as living on the exclusive north shore area of Jamaica, Hillowtown, overlooking

Montego Bay. His fellow residents included British Intelligence "former" operatives such as William Stephenson, head of British Intelligence in the United States during the war, Lord Beaver Brook, Sir William Wiseman and Noel Coward. Torbitt says that elements of British Intelligence were aware of the conspiracy to murder JFK, especially William Stephenson and his friends based in Jamaica. Torbitt called this group Jamaica's "Yale Club."

Because of the proximity of Jamaica to Cuba, it seems likely the British used Jamaica as their key military intelligence gathering location in terms of what was happening in Cuba, a hot spot at the time.

Fleming's suggestion to JFK and Dulles about using a religious projection in the sky to influence the Cubans with a spectacle visible to everyone on the island may be something that will happen in the near future—on a world scale.

A number of authors have suggested that a faked "Alien Invasion" has been planned by the U.S. Government and "the New World Order" for years. Using holographic laser projections (a technique partially pioneered by Bruce Roberts) all kinds of seemingly real "projections" could be seen by literally millions of people at once.

These projections could be of flying saucers, alien beings, or of famous religious personalities coming down from the sky. The Star Wars Defense System, which includes laser-type systems, could theoretically project such images from space. This was all Ian Fleming's idea.

Rayelan Allan in her unusual book *Diana, Queen of Heaven* (1999, Pigeon Point Publishing, Aptos, CA) claims that the U.S. Government has a secret project entitled Project Blue Beam. Project Blue Beam is supposedly a secret operation to influence people and bring in the "religious phase" of the New World Order.

Says Allan, quoting from the *Washington Report*, a monthly political newsletter (Feb. '95, V. 16): "In principle, 'Blue Beam' will make use of the sky as a movie screen as spaced based

laser generating satellites project simultaneous images to the four corners of the planet, in every language, in every dialect according to region.

"The 'Blue Beam' project deals with the religious aspect of the New World Order and is a large scale seduction.

"With computer animation and sound effects appearing to come from the depths of space, astonished followers of the various creeds will witness their own returned messiah in spectacularly convincing life-like realness."

Allan goes on to claim that Project Blue Beam would also use an image of Princess Diana 80 years from now in a similar holographic projection to create a new religion based on the ancient worship of the Greek goddess Diana. A fantastic notion, but an amusing idea to consider.

Nevertheless, Project Blue Beam may well be a real operation, and if it is, it was conceived by Ian Fleming, at least in part. Recent additions, such as Princess Diana would certainly not have been part of Fleming's idea, but such concepts as a fake alien invasion certainly could have been.

Does NASA and the secret government have a plan for Armageddon that involves UFOs, holographic projections from space and lots of fighting all over the world?

If such a scenario is even remotely correct, then there must be some sort of secret space program where flying saucers are made under cover, and special agents move around the world on top secret missions. Indeed, this is just the world that Fleming has given us: secret operations in space as portrayed in *Moonraker* and *You Only Live Twice,* and a cunning deception that is broader than national boundaries. Above all, the amazing technology, used by Bond and his adversaries, is far and above what the ordinary man would suspect.

Torbitt and others maintained that a secret space program does exist, complete with assassination teams and more, and that such personalities as Werner von Braun ran their own private space program, one that included deception and murder, exactly as portrayed in *Diamonds Are Forever,* which

even featured a character obviously based on von Braun.

Perhaps the greatest secret of the JFK assassination, according to Torbitt, is the role played by von Braun's clandestine space team known as The Defense Industrial Security Command (DISC) and the FBI's Division Five (satirized in the movie *Men In Black,* whose operations identified themselves as from "Division Six"). Perhaps the Kennedy space program and the von Braun/military industrial complex space program (commonly known as NASA) just didn't mesh. Electric spacecraft, magnetic spacecraft, gyro spacecraft and other alternative propulsion means were simply not an acceptable alternative to the oil companies and their defense department associates. Fleming knew all this, and brought this out in his books to an extent.

As for Division Five of the FBI and its role in the Kennedy assassination: of the many FBI agents and former FBI that are curiously involved in the assassination and its aftermath, one is Robert Maheu, a former FBI agent who became the CIA emissary first charged with recruiting the Mafia to kill Castro, a man who is also featured in The Gemstone File. It was supposedly Maheu who controlled the entire Howard Hughes empire after Hughes was "kidnapped."

One of the most curious episodes in the JFK "thing" was that of Canadian businessman Richard Giesbrecht who overheard David Ferrie discussing his role in the assassination with another man at the Winnipeg Airport on February 13, 1964. Giesbrecht overheard Ferrie talking several times about a package coming from Nevada. Later, the other man mentioned Mercury as the location where various contacts of one sort or another had taken place. Mercury, Nevada, is not known to most Americans, but it should be: it is part of NASA and is where the astronauts were trained for the Apollo Moon missions. This is also the location outside of Las Vegas that James Bond goes to in the film version of *Diamonds Are Forever.*

Giesbrecht talked to FBI agent Merryl Nelson, whom he

contacted through the U.S. consulate in Winnipeg. Giesbrecht said that the FBI agent at first told him, "This looks like the break we've been waiting for" — only to tell him a few months later to forget the whole thing. FBI agent Nelson is supposed to have said to Giesbrecht, "It's too big. We can't protect you in Canada."

Giesbrecht told the Canadian press that he believed that the FBI was ignoring his evidence and went to Jim Garrison in New Orleans. Garrison confirmed that Ferrie had been in Winnipeg that day. Garrison, however, may not have realized that Giesbrecht's greatest clue was that of Mercury, Nevada.

In the '90s, the past looks back at us larger than life. The manipulation of all aspects of our lives becomes more and more apparent, and the theories that Oswald was implanted and controlled as a 'mind control' victim are no longer so impossible. The aerospace and rocket industry of Nazi Germany became the American space program.

Fleming knew it all, and had to die. For ten years he leaked top secret information through his books. At certain levels, it was officially sanctioned. But not everyone appreciated the James Bond stories. Friends like Ivan T. Sanderson also knew, and talked about, the many mysteries of WWII, and beyond.

Did Onassis himself come to find the James Bond books a bit annoying? Or may British Intelligence was persuaded to eliminate one of its own kind? It is a sad thought, that Fleming may have had an apple pie for lunch August 12, 1964.

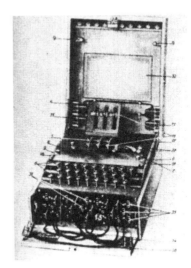

Above: Ian Fleming, handy with a gun. Right: The Enigma Device.

Ian Fleming's book *From Russia With Love* was made into a film starring Sean Connery and featured a fictionalized version of the Enigma Device.

Sam Giancana and friend.

Judith Campbell Exner

Ian Fleming's book *On Her Majesty's Secret Service* was later made into a film starring George Lazenby and Diana Rigg. Blofeld was played by Telly Savalas.

Ian Fleming's book *Diamonds Are Forever* was later made into a 1972 film starring Sean Connery and Jill St. John. The plot involved a kidnapping of a Hughes-like character named Willard Whyte and a faking of the Apollo Moon missions at the secret aerospace site of Area 51 and Mercury, Nevada.

8.
THE KIWI
GEMSTONE FILE

by Anonymous

The Kiwi Gemstone File, also known in some extant versions as the Opal File, has origins more mysterious than the original Skeleton Key. The compiler, or author, remains unidentified. The Kiwi Gemstone's basis in actual Bruce Roberts-penned Gemstone letters has not been established. It continues the themes of the original, however, and expands its global scope into the important areas of Australia and New Zealand.

In his last speech, JFK discussed Australia's role in the development of the Tactical Experimental Fighter (TFX), later renamed the F-111. The creation of the TFX opened a funding corridor between the down-under continent and the US that eventually led to the construction of Pine Gap, Australia's Area 51. In his book *Dark Side of Camelot* (Little, Brown, 1997), Seymour Hersh provides a footnote both to Gemstone and its Kiwi counterpart. He reports that members of the security operation for General Dynamics broke into the apartment of Gemstone-linked Judith Exner Campbell in August 1962, looking for information to blackmail JFK into making a controversial award of the TFX to General Dynamics. The award did indeed go to General Dynamics instead of the expected Boeing. New Orleans District Attorney Jim Garrison investigated a man named Fred Crisman as being a spy for Boeing, and possible support personnel for the Kennedy assassination.

The use of private forces to exert corporate control over government operations is reminiscent of the use of Wackenhut guards at government installations. The private group Wackenhut

still supplies security to Area 51 (see *NASA, Nazis & JFK*, Adventures Unlimited Press, 1996), and continues to perform security and surveillance services throughout the world. In 1998, UK Home secretary Jack Straw took bids from Wackenhut Corporation to build and run a "secure training centres" for 12-to 14-year-olds in Medomsley, Co. Durham, and a young offenders' institute at Pucklehurst, near Bristol. Straw also investigated the possibility of building a national database of DNA samples.

Straw is also named a member of an international cabal he referred to as *The Octopus* in the Kiwi Gemstone File. Indeed, the Kiwi Gemstone File is one of the earliest sources that mentions the long-reaching organization which sought to control the world, except for perhaps Ian Fleming. What follows is the original Kiwi Gemstone File as circulated from 1988 onwards:

The Kiwi Gemstone File
A Secret History of Australia and New Zealand
Author Unknown

"Fear them not, therefore; for there is nothing covered that shall not be revealed; and hidden, that shall shall not be known. What I tell you in darkness, that speak in light; and what ye hear in the ear, that proclaim upon the housetops."—Matthew

•18th May, 1967: Texas oil billionaire Nelson Bunker Hunt, using a sophisticated satellite technique to detect global deposits, discovers a huge oil source south of New Zealand in the Great South Basin.

•10th June, 1967: Hunt and New Zealand Finance Minister reach an agreement: Hunt will receive sole drilling rights and Muldoon will receive a $US100,000 non-repayable loan from Hunt's Placid Oil Co.

•8th September, 1967: Placid Oil granted drilling rights to the Great South Basin.

•10th May, 1968: Hawaiian meeting between Onassis and top lieutenants William Colby and Gerald Parsky to discuss establishment of a new front company in Australia—Australasian

and Pacific Holdings Limited—to be managed by Michael Hand. Using Onassis-Rockefeller banks, Chase Manhattan and Shroders, Travelodge Management Ltd. sets up another front to link the operations to the US.

Onassis crowned head of the Mafia; Colby (head of CIA covert operations in S.E. Asia) ran the Onassis heroin operations in the Golden Triangle (Laos, Burma, Thailand) with 200 Green Beret mercenaries—i.e. the Phoenix Program.

Gerald Parsky deputy to ex-CIA/FBI Robert Maheu in the Howard Hughes organisation, took orders from Onassis and was made responsible for laundering skim money from the Onassis casino operations in Las Vegas and the Bahamas.

Mid-July, 1968: Placid Oil Co and the Seven Sisters (major oil companies) begin Great South Basin oil exploration—Hunt finances 45.5% of exploration costs, Gulf Oil 14.5%, Shell (US) 10%, B.P. Oil 10%, Standard Oil California 10%, Mobil 6.5% and Arco 6.5%.

•12th October, 1968: Hunt and Seven Sisters announce confirmation of new oil source comparable to the Alaskan North Slope—gas reserves estimated at 150 times larger than the Kapuni Field.

•Early 1969: Mafia consolidates its banking operations; David Rockefeller becomes Chairman of Chase Manhattan; Wriston at Citibank and Michele Sindona captures the Vatican Bank, Partnership Pacific launched by Bank of America, Bank of Tokyo and Bank of New South Wales.

•24th February, 1969: Onassis calls Council meeting in Washington to discuss strategy to monopolize the Great South Basin discovery. Council members included Nelson Rockefeller and John McCloy, who managed the Seven Sisters, and David Rockefeller, who managed the Mafia's banking operations.

McCloy outlines the plan to capture all oil and mineral resources in Australia and N.Z.

•10th March, 1969: Parsky and Colby use Australasian and Pacific Holdings to set up a 'front' company in Australia. Using old banks—Mellon Bank and Pittsburgh National Bank—they buy

control of near-bankrupt Industrial Equity Ltd. (I.E.L.) managed by New Zealander Ron Brierly. 'Australasian and Pacific Holdings' 'consultant' Bob Seldon helps Michael Hand set up the new organisation. Seldon took orders from Mellon and Pittsburgh National Banks, while Hand was directly responsible to Gerald Parsky and William Colby. Ron Brierly would take orders from Hand.

•24th July, 1969: New board established for I.E.L. includes Hand, Seldon, Ron Brierly, plus two Brierly associates—Frank Nugan and Bob Jones. Both are appointed consultants to Australasian and Pacific Holdings Ltd.

Jones will help Brierly launder funds into real estate (Brierly/Jones Investments) while Seldon and Nugan will channel funds into oil and mineral resources through I.E.L.

•October 1969: Chase Manhattan begins new operation in Australia with National Bank Australasia and A.C. Goods Associates—Chase-NBA.

J.C. Fletcher appointed chairman of Seven Sisters' company—British Petroleum (N.Z.).

17th February 1970: Gerald Parsky sets up a new heroin-dollar laundry in Australia—Australian International Finance Corp—using the Irving Trust Co. New York.

•April 1970: Onassis, Rockefeller and the Seven Sisters begin setting up the shadow World Government using the Illuminati-controlled banks and the transnational corporations. In Melbourne they set up the Australian International Finance Corporation using:

> * Irving Trust Co. N.Y.—linked to Shell Oil, Continental Oil, Phillips Petroleum.
> * Crocker Citizens National—linked to Atlantic Richfield (Arco), Standard Oil of California which is Rockefeller-controlled.
> * Bank of Montreal—Petro Canada, Penarctic Oils, Alberta Gas, Gulf Oil.
> Australia and New Zealand Bank (ANZ).

•Meantime, Japanese members of One World Government move into New Zealand, helped by Finance Minister R. Muldoon; Mitsubishi and Mitsui make a profitable deal buying up rights to ironsands helped by Marcona Corp. (US) and Todd (Shell/BP/Todd). Todd rewarded with sole New Zealand franchise for Mitsubishi vehicles, Muldoon helps Mitsui (Oji Paper Co) obtain a lucrative 320 million cubic foot Kiangaroa Forestry contract with Carter Holt.

•November 1970: Fletchers extend the Rockefeller Travelodge operation by buying control of New Zealand's largest travel company—Atlantic and Pacific Travel.
 Manufacturers' and Retailers' Acceptance Company (in 1970 changed to Marac): This firm specializes in leasing and factoring (buying debts at a discount). It also finances imports and exports. The major shareholders are the Fletcher Group (38.0%), the Commercial Bank of Australia Ltd. (24.7%), NIMU Insurance (7.7%), Phillips Electrical (3.8%), National Mutual Life Association (2.4%), New Zealand United Corporation (4.0%). The CBA is a partner in the supranational Euro-Pacific Corporation, the other partners being the Midland Bank (UK), the United California Bank (USA), Fuji (Japan) and Societe Generale de Banque (France).

•Early 1971: Onassis and Rockefeller begin global operation to buy influence for the One World Government concept. They use Lockheed, Northrop and Litton Industries 'agent' Adnan Khashoggi, to organise operations in the Middle East, Iran and Indonesia. I.C.I. set up $2.5 million slush fund to Australia and N.Z.
 Finance Minister Muldoon changes law to allow Mafia-controlled banks to begin operations in New Zealand. Links also made by N.Z.I. in preparation for Paxus control with Hong Kong and Shanghai; Wells Fargo with Broadbank; Chase Manhattan with General Finance; Bank of America and Barclays with Fletchers and Renouf in New Zealand United Corp. All members of the Business Round Table Organisation.

•Late 1971: Gulf Oil and their man Brierly begin organising chains of Shell companies and dummy corporations to conceal their takeover operations of oil, gas and mineral resources and related industries such as vehicle franchises, vehicle spare parts and finance

services—all part of the Seven Sisters' controlled car culture.

•To extend links to the US banking operations they buy control of I.S.A.S. (NSW) and I.S.A.S. (Qld), which hold sole franchise for construction and mining equipment produced by International Harvester Credit Co, which is part of Chase Manhattan Bank and associated with First National Bank of Chicago (Chairman Sullivan also Executive Vice-President of Chase Manhattan), Continental Illinois (linked with CIA and Mafia Michele Sindona of Vatican Bank) and Rockefeller's Standard Oil of Indiana (AMOCO).

•I.S.A.S. (Qld) also has strategic holdings in North Flinders Mines, Flinders Petroleum, Apollo International Minerals.

•February 1972: Onassis and Rockefeller help associate Adnan Khashoggi buy the Security Pacific National Bank in California and take control of the United California Bank through CIA-linked Lockheed Aircraft Corporation. Both banks used by Onassis and Khashoggi to funnel bribes and payoffs via the CIA's Deak Bank to captive Japanese and other crooked politicians. Security Pacific also used to 'launder' over $2 million for Nixon's re-election campaign. Khashoggi also buys 21% of Southern Pacific Properties, which is the major stockholder in Travelodge (Aust), thereby establishing direct links to New Zealand, and U.E.B. and Fletchers through its equity links with Travelodge (N.Z.).

•April 1972: Mafia banking operations expanded through New Hebrides with establishment of Australian International Ltd. to finance Pacific development by the oil companies (Seven Sisters). Banks involved include Irving Trust NY, Bank of Montreal, Crocker International, Australia & N.Z. Bank and the Mitsubishi Bank, whose president, Nakamaru, is appointed Chairman.

•26th May, 1972: Gerald Parsky installs Michele Sindona as 'owner' of Franklin National Bank, helped by the Gambino Mafia family and David Kennedy—Chairman of Continental Illinois Bank and Nixon's Secretary of the Treasury.
Pacific Basin Economic Council Conference in Wellington, NZ. Vice-President Shigeo Nagano also chairman of Nippon Steel and

member of Onassis and other World Government organizations. Chairman of NZ sub-committee, J. Mowbray is also General Manager of the National Bank.

•Meanwhile, Michele Sindona, acting as the go-between for the Mafia and the CIA, was the conduit between US and European banks. Michele Sindona's Vatican Bank and associate Calvi's Abrosiano Bank was used to finance CIA neo-fascist Italian/Latin American operations through Licio Gelli's P2 Lodge, which helped to organise the 'death squads' of Argentina, Uruguay and Chile. This aided the P2 members such as Klaus Barbie ('The Butcher of Lyons') and Jose Rega—organiser of the A.A.A. in Argentina.

•16th August, 1972: Gulf Oil associate Bob Seldon helps establish new banking operation, first NZ international banks include Bank of New Zealand, D.F.C. (Aust), N.Z.I., Morgan Guaranty Trust, Morgan Grenfel and S.F. Warburg.
Fletchers begins expansion overseas with deals signed in Indonesia, Fiji and New Guinea.

•December 1972: Kirk elected Prime Minister of New Zealand.

•February 1973: Gerald Parsky, William Colby, Michael Hand, Frank Nugan and Bob Seldon move to further consolidate the Mafia banking operations. In NZ they acquire 20% Fletcher subsidiary Marac, using the Security Pacific National Bank helped by Marac Corporate secretary Alan Hawkins.

•Frank Nugan and Michael Hand use Fletcher and Renouf and their NZ United Corporation to link with I.E.L. and Brierly Investments through cross-shareholding agreement.

•In Australia, the Nugan Hand Bank begins operations with 30% of the stock held by Australasian and Pacific Holdings (100% Chase Manhattan Bank), 25% by CIA's Air America (known as 'Air Opium'), 25% by South Pacific Properties and 20% held by Seldon, Nugan and Hand.

•The Irving Trust Bank's New York Branch establishes US links

between the CIA and Nugan Hand, a worldwide network of 22 banks set up to:

*a) 'launder' money from Onassis heroin operations in the Golden Triangle and Iran; b) as a CIA funnel to pro-US political parties in Europe and Latin America, including Colby's P2; c) a spying conduit for information from Cambodia, Laos, Vietnam and Thailand; d) finance arms smuggled to Libya, Indonesia, South America, Middle East and Rhodesia using the CIA's Edward Wilson.

•Colby and Kissinger use key CIA and Naval Intelligence officers to oversee the operation, including Walter McDonald (former Deputy Director CIA), Dale Holmgren (Flight Service Manager CIA Civil Air Transport), Robert Jansen (former CIA Station Chief, Bangkok), etc.

•Heroin flown into Australia by CIA's Air America and trans-shipped to Onassis lieutenant in Florida, Santos Trafficante Jr, assisted by Australian Federal Bureau of Narcotics officials and co-ordinated by CIA's Ray Cline.
•14th June, 1973: Inauguration of the Onassis shadow World Government—the Trilateral Commission. Includes over 200 members from the US, Europe and Japan—bankers, government officials, transnational corporations' top executives, trade unionists, etc. Of the world's largest corporations, 24 directly represented and dozens more through interlocking directorships.

•Trilateralist strategy: monopolization of the world's resources, production facilities, labor technology, markets, transport and finance. These aims backed up by the US military and industrial complexes that are already controlled and backed up by the CIA.

•18th August, 1973: Ray Cline and Michael Hand meet in Adelaide to discuss CIA plan to establish spying operations in NZ.

•September 1973: Seagram's, with strong links to Chase Manhattan Bank of Montreal and Toronto Dominion Bank, buys 2,800 acres of prime land in Marlborough helped by Peter Maslen.

•17th February, 1974: Mafia sets up New Hebrides Bank—Commercial Pacific Trust Co (COMPAC). Banks include CBA, Europacific Finance Corporation, Trustee Executors and Agency Co, Fuji Bank, Toronto Dominion Bank, European Asian Bank and United California Bank. COMPAC to be used as a cover for heroin dollar laundering operations.

•26th February, 1974: Michael Hand meets Bob Jones in Wellington to implement plans for the CIA's new spying operation—countries targeted include France, Chile, West Germany and Israel.

•Using the Brierly/Jones Investment funnel, Jones buys building in Willeston Street which will be rented to France and Chile, another at Plimmer Steps to house West Germany and Israel.

•CIA will set up eavesdropping communications center inside the Willeston Street building and another at 163 The Terrace which will link with equipment installed in the Plimmer Steps building. Four CIA technicians will run the whole operation.

•April 1974: Finance Minister Rowling appoints Ron Trotter to the Overseas Investment Commission, whose chairman, G. Lau, is also a member of the Todd Foundation (Shell/BP/Todd) investment board.

•Mid-1974: Gough Whitlam and Norman Kirk begin a series of moves absolutely against the Mafia Trilateralists. Whitlam refuses to waive restrictions on overseas borrowings to finance Alwest Aluminium Consortium of Rupert Murdoch, BHP and R.J. Reynolds. Whitlam had also ended Vietnam War support, blocked uranium mining and wanted more control over US secret spy bases—e.g., Pine Gap.
Kirk had introduced a new, tough Anti-Monopoly Bill and had tried to redistribute income from big companies to the labor force through price regulation and a wages policy.

•Kirk had also rejected plans to build a second aluminum smelter

near Dunedin and was preparing the Petroleum Amendment Bill to give more control over New Zealand oil resources.

•Kirk had found out that Hunt Petroleum, drilling in the Great South Basin, had discovered a huge resource of oil comparable in size to the North Sea or Alaskan North Slope. Gas reserves alone now estimated at 30 times bigger than Kapuni and oil reserves of at least 20 billion barrels—enough for New Zealand to be self-sufficient for years. Oil companies completely hushed up these facts. To have announced a vast new oil source would probably have meant a decline in world oil prices, which would not have allowed OPEC's and Onassis's plans for the Arabs to eventuate. New Zealand could be exploited at a later date, particularly since the North Sea operations were about to come on stream—Kirk was the last hold out.

•September 1974: Death of Norman Kirk. According to CIA sources, Kirk was killed by Trilateralists using Sodium Morphate. Rowling's first act as Prime Minister was to withdraw Kirk's Anti-Monopoly Bill and the Petroleum Amendment Bill.
 Later, Rowling was to be rewarded with ambassadorship to Washington. Incidentally, the Shah of Iran was murdered the same way as Kirk on his arrival in the US.

•6th October, 1974: Ray Cline implements William Colby plan to oust Australian Prime Minister Whitlam. Nugan Hand Bank finances payoffs to Malcolm Fraser and other pro-US politicians. A joint bugging operation commences between CIA and ASIO. Rupert Murdoch, playing his part, uses his newspapers and television network to spread lies and misinformation. Whitlam, as well as refusing to waive restrictions on overseas borrowing to finance the aluminum consortium, had plans to ensure that all corporations were at least 50% Australian-owned. This interfered with the Seven Sisters' plans to build three oil refineries at Cape Northumberland in South Australia to exploit the Great South Basin discovery.

•December 1974: Australian Governor-General John Kerr joins Ray Cline's payroll and received his first pay-off of $US200,000 credited to his account number 767748 at the Singapore branch of

the Nugan Hand Bank.

•11th November, 1975: Governor-General Kerr sacks the Whitlam Government.

•August 1975: Rowling re-introduces unrecognizable Commerce Bill, designed to aid monopolization of the NZ economy and repeals the News Media Ownership Act, allowing more foreign ownership of NZ media. The new legislation does not define monopoly, competition or stipulate permissible maximum market share, or even ascertain what the public interest is—resulting in a sell-out to big business.

•December 1975: Election battle between Rowling and Muldoon. Oil companies pour thousands of dollars into Muldoon's campaign via National Bank (NZ), whose general manager Mowbray is also a member of Todd Foundations; Investment Board Director Tudhope also Managing Director Shell Oil and Chairman Shell/BP/Todd. Muldoon wins.

•February 1976: Muldoon implements pre-election secret agreement with the NZ Seven Sisters' oil representatives of Shell/BP/Todd for helping finance the National Party campaign. Muldoon removes the $3 per barrel oil levy for the New Zealand Refining Company, which increases the oil companies' profits by 100% at the taxpayers' expense and with all future oil prospecting licenses, the Government has the option to take 51% of any discovery without meeting exploration costs. This is designed to discourage further exploration, thereby keeping the lid on the Great South Basin discovery. Meanwhile, in Australia, new P.M. Malcolm Fraser reopens uranium mining and opens the way for takeover of mineral resources with big tax breaks for oil exploration, coal and mining.

Muldoon returns a favor to the oil companies by arranging $US200 million loan for Maui Gas Development for Shell/BP/Todd.

•September 1976: With captive politicians in place in both Australia and New Zealand, the Internationalists can now proceed with their strategy of takeover of the economy and exploitation of

natural resources. "In New Zealand, the elimination of unnecessary competition is fundamental to a sound economy," Brierly says. Parksy and Colby use Brierly/Jones Investments as a vehicle to buy into A.B. Consolidated Holdings in New Zealand. Associate of R. Jones, Pat Goodman, is appointed 'consultant' of Australasian and Pacific Holdings.

•November 1976: The Internationalists (Mafia) set up a NZ money 'funnel' using Brierly's City Realties. National Insurance Co acquires 33% of the stock. Largest stockholders in National Insurance are the US Firemen's Fund—Chairman and President Myron Du Bain also Vice Chairman of American Express (Amex). Chairman of I.E.L. linked International Harvester, Archie McCardell, also Amex Director. Amex linked with Chase Manhattan and seven Sisters' Texaco and Mobil. Du Bain also Director of CIA-linked United California Bank, which is a partner in Commercial Pacific Trust. To complete the money funnel, National Insurance becomes a stockholder in Chase Manhattan's Chase-NBA. Brierly's declared assets reach $100 million, with shareholders' capital of only $2.5 million—all cash acquisitions.

•3rd February, 1977: Parksy and Colby close down the Brierly/Jones Investment funnel and open up separate channels for Brierly and Jones. Jones will be supplied with 'laundered' funds via Sydney branch of the Nugan Hand Bank, while for Ron Brierly, Gerald Parsky uses Myron Du Bain, Dierctor of United California Bank and also chairman and president of the US Firemen's Fund, which are the largest stockholders in National Insurance (NZ). Funds to be 'laundered' via Chase Manhattan Bank through National Insurance to City Realty and via United California Bank through COMPAC (New Hebrides, now Vanuatu) to National Insurance and City Realties. To expand the Bierley/I.E.L. 'front', Parsky establishes Industrial Equity Pacific (Hong Kong).

•September 1977: Brierly's new holding company begins operations—A.B. Consolidated. H.W. Revell appointed Deputy Chairman and B. Hancox General Manager, while newly-appointed directors include S. Cushing, B. Judge, O. Gunn and P. Goodman, linked with Renouf, Fletcher and Papps through I.E.L./N.Z.U.C.

*Strategy: To target and divide key sectors of the economy for takeover, exploitation and monopolization. Operations to extend to use Hong Kong facility, I.E.P. Fletchers to extend the Khashoggi/Rockefeller Travelodge operation by taking holdings in Vacation Hotels and Intercontinental Properties (Renouf Chairman).

•October 1977: Muldoon and John Todd—Shell/BP/Todd—sign an agreement. NZ Govt would take 24.5% holding in the Great South Basin for $1.65 Billion. Hunt would reduce his holding from 45.5% to 27.5% and Arco would sell its 6.5%.
*Reason: Hunt did not possess the technology to pump oil from deep water; Gulf possessed the technology but did not tell Hunt. Arco was not told anything and was swindled out of its 6.5% concession.

•November 1977: Muldoon introduces the S.I.S Amendment Bill, designed to keep the economy free of obstruction and to help uncover obstructive elements. Telephone taps, mail tampering and other surveillance methods approved after CIA input on contents of legislation.

•Late 1977: Muldoon travels to the US to meet top Rockefeller officials, including Trilateralists' Deputy Secretary of State, Warren Christopher, and Richard Bolbrooke, who were in charge of the new "South Pacific Desk" at the State Department established by Rockefeller to target exploitation of both New Zealand and Australia. In Los Angeles, Muldoon meets top Rockefeller officials, Robert Anderson (Rockwell Chairman, also Director of Kashoggi's Security Pacific National Bank) and P. Larkin (Rockwell Director, also Chairman, Executive Committee Security Pacific National Bank and Director of Marac).

•April 1978: Muldoon sets up Petrocorp. New Zealand taxpayers pay for the exploration costs but the oil companies control all distribution outlets. Muldoon blocks development of "Maui B" as restructured supplies mean higher prices and bigger profits for Shell/BP/Todd. South Island gas market not developed as Great South Basin fields closer than Kapuni. Plans develop for re-opening of National Parks for mineral exploitation.

•22nd July, 1978: Director of Australian Federal Bureau of Narcotics suspends his investigation into the Nugan Hand Bank after pressure from the CIA and Australian politicians controlled by Mafia, particularly Malcolm Fraser. Brierly's declared assets reach $200 million, with shareholders' funds only $17 million.

•May 1979: Trilateral Commission secretary Zbignieu Brzezinski appoints Muldoon chairman of Board of Governors of IMF/World Bank on orders of David Rockefeller. Muldoon would head three-man administration committee which included Canadian Finance Minister Mitchell Sharp, key figure in the Mafia Council and the Trilateral Commission. Australian Treasurer McMahon also involved.

•8th June, 1979: Michael Hand, Frank Nugan, Brierly and James Fletcher meet in Hand's Sydney penthouse to discuss the establishment of the New Zealand Mafia organization.

•Mid-1979: Gulf Oil using its man Brierly, begins operations designed to capture key sectors of the economy. A.B Consolidated restructured into the Goodman Group and Goodman to run operations but with the majority of the stock held by IEL and Brierly using shell companies plus dummy corporations.
*Strategy: To take over food and produce resources, Brierly and Fletcher restructured a small private company, H.W. Smith, using Cyril Smith as Chairman but with key executives Judge, Collins and McKenzie. Bob Jones helps. Private company used, as no Commerce Commission control, accounts not published, no public disclosure of transactions.
Bunting is established as a shell company and the South Island is targeted for asset-stripping and takeover, as well as key sectors of the automobile industry.
Unlimited funds channeled through City Realties, NZUC and Marac extends Travelodge operations by buying control of Transholdings, which has strategic holdings in Vacation Hotels and Tourist Corp. Fiji Holdings.

•17th August, 1979: New Zealand Mafia inaugural meeting in

Sydney including Hand, Brierly, Fletcher, Goodman, R.Trotter, Alan Hawkins and L.Papps. Key sectors of the economy would be taken over—food, using Goodman; forestry and farming, using Fletcher and Trotter; property, using Brierly and Jones. Brierly, Hand and Papps would be responsible for banking, insurance and finance, while Hand and Hawkins would be responsible for setting up new "laundry" channels into New Zealand. The economy would be taken over using cheap loans of less than 5%, while consumers would pay 28%.

•October 1979: BP Oil begins $100 million joint venture deal with Fletcher and Trotter at Tasman. Muldoon makes secret deal with oil companies which effectively robs New Zealand taxpayers by giving Shell/BP/Todd the Maui Gas deal. Normally the granting of drilling rights on public land is done using a worldwide system which incorporates an auction tender system. Muldoon bypassed this. Also, Shell/BP/Todd pays no tax on Kapuni profits, while putting funds into Maui development.

•19th November, 1979: Secret meeting in Auckland between Muldoon, Fletcher and Trotter to transfer 43% Tasman Pulp and Paper held by New Zealand Government to Challenge Corporation (Chairman Trotter) and Fletchers. Tasman has lucrative 75-year contract for cheap timber signed in 1955. Muldoon paid off with a $1 million 'non-repayable' loan—$500,000 to be paid into account number 8746665 at New Hebrides branch of the Australian International Bank.

•November 1979: Muldoon drops restrictions on foreign investment. AMAX (Standard Oil of California subsidiary) captures the Martha Hill goldmine. Muldoon unveils the Government's plans (instructed by Rockefeller) to form New Zealand into an offshore production base for the multi-national corporations as benefits include government export incentives, stable government, cheap labor, and so on.

•27th November, 1979: Gerald Parsky's lieutenant, David Kennedy, meets Muldoon to deliver $US100,000 cash to Muldoon for implementing the Internationalists' Mafia Think Big plans. These

plans began with big contracts and guaranteed profits for the Seven Sisters, Bechtel, Mitsubishi, Mitsui, Nippon Steel, Internationalists' Mafia banks. With the experimental petroleum plant, the oil price has to be $50/barrel to be profitable, yet Mobil's profits are guaranteed. New Zealand Steel is to be expanded 500%, even though there was a global steel glut of 50%.

Fletchers own 10% of New Zealand Steel and are majority stockholders in Pacific Steel and control monopoly over wire rod, reinforcing steel. Also, New Zealand taxpayers subsidise Fletchers' profits. Muldoon introduces the National Development Bill with 'fast-track' legislation, to keep the economy 'free of obstruction' for long-term monopolization. C.E.R. plan introduced, designed to integrate the economies of Australia and New Zealand with the Trilateral Commission for the purpose of exploiting the South Pacific countries and as a 'back-door' entrance into China—the world's largest untapped consumer market. New Zealand is also the closest country to Antarctica, which has a vast mineral resource for future exploitation.

•"Think Big" projects begin, even though Muldoon aware of studies that show New Zealand could conserve up to 40% of energy consumption using existing technology, which would mean funds could be invested elsewhere to lower consumer prices, lower inflation rates, less demand for imported oil and increased employment by creating new industry to manufacture and install energy-saving technology. None of these options seriously considered as all would lessen profits for members of the Rockefeller organizations.

•December 1979: Muldoon unveils 'stage two' of a four-stage plan to exploit the Great South Basin discovery. Plan prepared by Trilateralist 'Think Tank'—the Brookings Institute. 'Stage Two' includes methanol plant and synthetic petrol plant, which would initially use gas from the Maui field and later would link with underwater gas pipe from Campbell Island.

•With the New Zealand Steel 500% expansion, 'stage three' of the project and Think Big contracts to go to Bechtel, Fluor Corp., Mitsubishi, Mitsui, Nippon Steel, etc. All investments would be

financed by the New Zealand taxpayer.

•17th January, 1980: $500,000 deposited in Muldoon's account number 8746665 at the Australian International Bank, being the final payment for the Tasman deal.

•Early 1980: Kashoggi Travelodge operations extended with affiliation agreement between Dominion Breweries and Western International Hotels (Seattle First National Bank).

•May 1980: Mafia's Nugan Hand banking operation crashes after Frank Nugan killed. Death ruled as suicide even though no fingerprints found on the rifle. Maloney, Houghton, Yates and Hand shred important documents, but miss some. CIA helps Hand and Bank President Donald Beasley escape to the US. The CIA and Australian Security Intelligence Organisation cover everything up. Beazley appointed President of Miami City National Bank, run by Alberto Dugue for 'laundering' profits from the CIA Colombian cocaine operation. There is a probability that Michael Hand killed Frank Nugan because of his involvement with Hand's fiancee.

•25th May, 1980: Colby arrived in Australia to discuss replacement of the Nugan Hand Bank with Hand, Brierly, and Seldon. Immediate funding available from Sydney branch of the Deak Bank, a separate CIA operation, and IEL would be used to buy NZI Corp., to prepare for future laundering operations.
Maloney, Houghton, Yates, and Hand would shred all documents leading back to the New Zealand Great South Basin connection, and the CIA would help Hand and Bank President Donald Beazley escape to the USA. The CIA and ASIO would also cover everything up.

•Hand and Beazley turn up in Miami—Beazley appointed President and Hand 'consultant' to the Miami City National Bank, but also Hand turned up in El Salvador to help organize bankrolling of the Contras with other ex-members of Nugan Hand.

•23rd June, 1980: New Zealand Mafia, including Brierly, Fletcher, Trotter, Jones, Hawkins, Goodman, and Papps meet in Wellington to discuss merger of Fletcher Challenge and Tasman. In

order to replace Nugan Hand Bank's 22 world-wide branches, quick moves are made to buy control of NZI by New Zealand Mafia using Brierly, thereby capturing an established, world-wide organization through the Hong Kong and Shanghai Bank, which is also linked to the CIA through its subsidiary, World Finance Corporation.

•Late 1980: Fletchers, with strong Rockefeller links, obtains lucrative contracts on US Bases in the Pacific and joint ventures in Saudi Arabia and Iraq.

Control extended over New Zealand natural resources—Fletcher Challenge and Tasman Pulp and Paper merged. NZFP takes control of M.S.D. Spiers and Moore Le Messurier (Aust). Brierly begins joint venture with NZFP through Williamson and Jeffrey. I.E.L, through Goodman, buys 20% of Watties and begins cross-shareholding agreement. Goodman continues buying up control of NZ bakeries and flour-mills.

•February 1981: TNL, Brierly, AMOIL and MIM Holdings begin joint gold mining operation. MIM major shareholder is ASARCO (US), whose Chairman, Barber, is also Director of Chase Manhattan Bank.

New Zealand Insurance and South British merger.

Parliamentarians For World Order—Richard Prebble elected one of twelve counselors.

•Fletcher and Papps (Chairman UEB) sell their hotel operations to Singaporian interest closely associated with the Pritzker family—owners of the Hyatt Hotel chain. Bueton Kanter, Pritzker family lawyer and Director of Hyatt Hotels, who helped arrange the deal, was an old family partner of Paul Helliwell (CIA paymaster for the Bay of Pigs fiasco) and had helped the Pritzker family set up tax shelters using the CIA's Mercantile Bank and Trust and the Castle Bank, which had been set up by Helliwell for 'laundering' profits from the Onassis heroin operations as well as 'skim money' from the Hughes casino operations in Las Vegas.

•Others who used these banks include Richard Nixon, Bebe Rebozo, Robert Vesco, Teamsters Union, etc.

•12th March, 1981: Brierly calls secret meeting in Auckland, which includes Jones, Fletcher, Hawkins, Papps and Burton Kanter, to discuss transfer of the Fletcher Challenge and UEB hotel operations to the Singapore front company controlled by the Pritzker family.

•20th July, 1981: Parsky, Colby, Brierly and Seldon meet in Sydney with two new members, Kerry Packer and Alan Bond. Chase Manhattan and Security Pacific National Bank will acquire 60% of Packer's company, with the stock being held in Australia, and 35% of Bond's company, with the stock being held in Hong Kong.

•August 1981: Gulf Oil, using Brierly, strengthens its hold over New Zealand natural resources. Cue Energy launched, starring Lawrey and Gunn. NZOG launched with strategic holdings by Jones, Renouf and Brierly with licenses in PPD 38206 and 38204—both next to Hunt's Great South Basin discovery, NZOG also controls 80 million tones of coal through the Pike River Coal Company. Brierly-controlled Wellington Gas, Christchurch Gas, Auckland and Hawkes Bay Gas and Dual Fuel Systems (Australasia) which controls the vehicle gas conversion market. Liquigas Limited set up to distribute LPG, controlled by Shell/BP/Todd and Fletcher Challenge.

•15th February, 1982: Brierly calls New Zealand meeting—Jones, Fletcher, Trotter, Hawkins, Goodman and Papps. New members include Bruce Judge, J. Fernyhough, and Frank Renouf. With Muldoon about to deregulate the liquor industry, Brierly and Fernyhough plan to buy up the New Zealand liquor industry, along with its outlets, Lion Breweries and Rothmans to help.
Brierly will do the same in Australia. J.R. Fletcher becomes Managing Director of Brierly's Dominion Breweries to oversee operations. Rothmans and Brierly (through Goodman) have equal holdings in Saudicapital Corp. Lion Directors Myers and Fernyhough also stockholders in NZOG. Fletcher and Brierly begin their takeover of the freezing works industry. FCL buys into South Island works while Brierly begins takeover of Waitaki NZR through Watties with the help of Athol Hutton. With Think Big projects beginning, Fletcher and Trotter plan to take strategic holdings in NZ

Cement, Wilkins Davies, Steel & Tube, etc., and Brierly would use Renouf to take 3% stake of the Martha Hill goldmine.

Also targetted are clothing, footwear, carpet manufacture and more of the auto industry for takeover and monopolization.

•June 1982: Meantime, in Australia, a new money funnel begins. H.W Smith buys the obscure South Pine Quarries, which is renamed Ariadne (Aust). South Pine Quarries owns 50% of Coal-Liquid Inc., with the other half owned by US Defence contractors McDonnell Douglas. Coal-Liquid renamed Impala Securities. The common link between Gulf Oil and McDonnell Douglas is the CIA's Mercantile Bank and Trust, which both companies use for world-wide bribery and payoff operations. McDonnell Douglas officials McKeough and G.T. Hawkins later appointed directors of Impala Securities. US links strengthened through Industrial Equity Pacific, which acquires part of Higbee Company in Cleveland, which in turn is closely linked to the National City Bank of Cleveland. This bank is closely associated with Gulf Oil's bank, Pittsburgh National and Mellon Bank. Bruce Judge installed as Ariadne manager.

•July 1982: Media takeover begins. Brierly takes 24% NZ News Ltd. and begins buying up private radio. Rupert Murdoch helps.

•27th July, 1982. Brierly, Jones and Goodman meet in Auckland with two Japanese members of the Trilateral Commission to discuss integration of the New Zealand economy into the Pacific Rim economy. Trilateralists include: Takeshi Watanabe (Japanese Chairman of Trilateral Commission) and Daigo Miyado (Chairman Sanwa Bank). The Japan/New Zealand Business Council would be established to co-ordinate policy with Goodman appointed as Chairman.

•17th August, 1982: Inauguration of restructured US Mafia Council—rulers include David Rockefeller, responsible for Banking; John McCloy; Redman Rockefeller and J.D. Rockefeller, who would run the Seven Sisters.

Second-tier Council includes:
* Gerald Parsky—responsible for heroin and cocaine operations
* William Simon—responsible for running the Presidency,

Cabinet, etc
 * Katherine Graham—link to arms manufacturers
 * Zbigniew Brzezinski—link to National Security Council and CIA
 * George S. Franklin—link to FBI
Third-tier Council includes:
 * Zbigniew Brzezinski—Secretary
 * Gerald Parsky—Heroin and cocaine operations
 * William Colby—crack operations, assassinations
 * John N. Perkins—banking, laundering
 * Leonard Woodcock—labor, unions
 * Mitchell Sharp—banking
 * William Simon—presidency, Cabinet
 * Ernest C. Arbuckly—arms manufacturers
 * George W. Bull—Bilderberg and Council of Foreign Relations
 * Katherine Graham—arms manufacturers
 * Alden W. Clausen—World Bank, IMF
 * Willam T. Coleman—CIA
 * Archibald K. Davis—media, radio, television, and newspapers
 * George S. Franklin—FBI, and Trilateral Commission co-ordinator
 * J.D. Rockefeller—to "spy" on the 15 man council.

•September 1982: Goodman now helps establish the Japan/New Zealand Council with the Bank of Tokyo and the Industrial Bank of Japan. Tokai Pulp Co. buys shareholding in NZFP, which also begins joint venture with Shell Oil.

Fletcher Challenge strengthens links with the Rockefeller organization by acquiring the Canadian operations of Crown Zellerbach, whose chairman is also director of Gulf Oil. Crown Zellerbach Corp. has direct connections to Rockefeller through directors Mumford, Hendrickson and Granville, to United California Bank through Roth and to the Bank of America through Chairman C.R. Dahl. Meanwhile, Robert Jones Investments floated to extend operations of City Realties, Ijmond Properties, Chase Corp., etc. The Commerce Building in Auckland sold to Robert Jones Investments by Robert Jones Holdings for $950,000 when recently it was offered on the market for $200,000. A quick $750,000 for Jones. Robert Jones Investments was set up by Brierly, Jones and Hawkins.

•8th December, 1982: Mitchell Sharp heads top-level Mafia meeting in San Francisco. Others include Parsky, Perkins, Woodcock and C.R. Dahl—Chairman of Crown Zellermach.

•Also present are—Brierly, Trotter, Fletcher and Seldon. Meeting to discuss Great South Basin exploitation strategy with first priority being monopolization of the economy; second priority to establish oil refineries and related industries; third to integrate New Zealand economy into Trilateral economy and, fourth, to concentrate power back to the US through the Seven Sisters, Chase Manhattan and Security Pacific National Bank. Fletcher Challenge will link New Zealand economy directly to the US by merging with Canadian subsidiary of Crown Zellerbach with funds provided by Security Pacific National Bank and United California Bank. Brierly, Fletcher, Trotter and Seldon will be New Zealand Ruling Council, headed by Brierly, who would take orders from Gerald Parsky.

•Mid-1983: Brierly's Ariadne (Aust) takes control of Repco (NZ) through Repco (Aust), thereby taking control of key auto-related industry, helped by Borg Warner and Honeywell—which are closely associated with IEL through International Harvester, Continental Illinois Bank and the First National Bank of Chicago. Toyota and Nissan also help so that Brierly now largest distributor of auto and industrial parts, largest manufacturer of pistons, filters and engine bearings, as well as biggest supplier of forklifts, tractors and agricultural equipment. Meantime, control is extended over the Great South Basin oil source with Hunt, after big losses resulting from trying to corner the world's silver market, being forced to sell out some of his concession to Gulf Oil, which uses Brierly to set up a new company—Southern Petroleum—which takes a 14.5% interest. Hunt retains overall control with 45.5%, Petro-Corp has 40% and Chairman F. Orr, also a Director of Brierly—controlled Watties.
Brierly, through Goodman, takes control of TNL Group and its subsidiaries NZ Motor Bodies and L & M Mining, which has 15% interest in the Chatham Rise, right next to the Hunt concession. Southern Petroleum set up by Brierly in New Zealand was spearheaded by the Seven Sisters' companies with Gerald Parsky and William Colby initiators. Southern Petroleum to include 21% of the

Great South Basin held by Gulf and Mobil Oil. 90% of this stock held in Australia through IEL (ie., Brierly's).

•11-12th May, 1983: New Zealand Mafia meet in Cook Islands. Includes Brierly, Trotter, Fletcher, Jones, Hawkins, Goodman, Pappas, Judge, Renouf, and Fernyhough. New members include A. Gibbs, McConnell, H.Fletcher and O.Gunn. Japanese Trilateralists Takeshi Wataneve and Daigo Miyado discuss 'integration' of New Zealand into the Pacific Rim economies. A new political party would be established using Jones and financed by the New Zealand Mafia Council.
 *Reason: Parsky and Colby wanted Muldoon out because he had 'welched' on a deal to set up two US military deep-water submarine bases planned for Dusky Sound and Guards Bay in the South Island.

•Parsky, Brierly and Ray Cline hold a separate meeting to discuss the purchase of New Zealand politicians, including Lange, Douglas and Bolger.
 Cline was 'consultant' to the CIA's Deak Bank, took orders from Colby, and was responsible for the 10 Australian politicians on the CIA's payroll, including Bjelke Petersen, I. Sinclair, Keating, McMullen, M.Fraser, D. Anthony, K. Newman, J. Carrick, B. Cowan and R. Connor. Cline outlines CIA plan to begin subliminal television advertising.

•22nd June, 1983: New Zealand politician J. Bolger meets Ray Cline in Sydney and agrees to join the organization for a monthly fee of $US20,000 to be paid into account number GA1282117 at Geneva branch of Credit Swisse.

•20th July, 1983: New Zealand politician R. Douglas meets Ray Cline in Wellington and agrees to join the organization for a monthly fee of $US10,000 to be paid into account number 3791686 at the Sydney Branch of the Deak Bank.

•July 1983: Parsky launches a new front company, Chase Corporation, with 25% of the stock being held through Security Pacific National Bank in Australia and 25% held in Hong Kong by Chase Manhattan. Brierly and Hawkins set up a 'back-door' listing to

cover up true ownership.

•August 1983: Muldoon imposes withholding tax on all offshore borrowing.

Chase Manhattan, United California Bank and Brierly begin new banking operation in New Zealand to take over the International Harvester Credit Co (NZ), Australasian Investment Company. Participants include Chase Manhattan's Kuwait Asia Bank, D.F.C., Saudicorp (Brierly has 12% through Goodman) and United California, represented by National Insurance which is part of Equus Holdings.

Renouf sells 20% NZUC to Barclays and prepared for expanding of operations with Brierly. Meantime, Murdoch and Brierly expand their close ties by each taking a piece of New Zealand Maritime Holdings and with the election imminent, divide up New Zealand media for takeover to increase Mafia control. NZ News buys Hawkes Bay News, Nelson Tribune, Timaru Herald, etc. Brierly increases holding in Hauraki Enterprises and other private radio stations. Brierly and Murdoch have majority stockholding in NZPA with 48.5%, while in the UK, Murdoch has large stockholding in Reuters. The phony news becomes THE news. Head of the Murdoch operation is Burnett, who is also on the board of Winstones—a Brierly company.

•September 1983: With global heroin epidemic, Rockefeller expands operations to recycle profits. New Zealand South British sets up the IDAPS computer bureau to establish international holding companies, dummy corporations, etc., and to pursue aggressive global acquisition program. IDAPS linked to satellite bureau in Australia, Far East, UK and the US, where the global network is completed through links with the Rockefeller organization computer network.

General Manager of the operation, George Wheller, previously director of the international operators of Firemen's Fund (US), Chairman Du Bain, director of the United California Bank, and Vice-Chairman of Amex. As part of the expanded laundry operation, Rockefeller associate Adnan Kashoggi establishes new Australian bank—Security Pacific National Bank (Aust). Brierly's part of this operation is to buy up computer companies such as Andas, CID

Distributors (NZ Apple computer franchise, etc.). Investment companies begin operations in Australia and New Zealand to assist recycle Mafia profits.

•October 1983: Brierly takes over NZFP through Watties, helped by newly-appointed chairman Papps. Papps also chairman of NZ Railways and presided over transport deregulation, the major beneficiaries of which include Watties and Freightways—Managing Director Pettigrew and Director Lang also both on the NZFP board with Papps. Papps also responsible for the railways' electrification programme with big contracts for Cory Wright & Slamon, whose directors include I.I. McKay, also on the board of NZFP.

•Late 1983: AMAX (Social) gives Gulf Oil a share in the Martha Hill gold bonanza by selling 15% of its holdings to Briereley through Goodmans. Oil companies say that only $870 million worth of minerals in Martha Hill, while true figure is closer to $3 billion.

•21st January, 1984: Australian Mafia Council meets in Sydney. Includes—Brierly, Seldon, Fletcher, Jones, Goodman, Hawkins, Papps, Packer, Bond and Japanese Trilaterist Daigo Miyado. New members include J. Elliott, L. Adler, and Holme's A'Court. Seldon outlines strategy of merging Australian economy with the Trilateralist economy through Europe and the US. In Australia, the Mafia Council will monopolize the economy with company takeovers through the use of loans at less than 5%. Holme's A'Court's company would be taken over using Security Pacific National Bank and Chase Manhattan Bank, with some of the stock being held in London. Equiticorp will be launched using Hawkins, with 50% of the stock held by Security Pacific National Bank and Chase Manhattan in the US. Equiticorp to be registered in Hong Kong to cover up true ownership, and will use the same laundry as Chase Corporation—Hawkins will set up a maze of shell companies and dummy organizations to disguise operations (Hawkins previous Corporation's holding in Teltherm).

•January 1984: Brierly and Elliott begin moves to monopolize the food industry in Australasia by merging Goodman and the Elders Group, while Brierly sells 10% of Watties to the NZ Dairy

Board—setting the stage for land takeover and establishment of the Corporate Farm.

•February 1984: New Zealand politician D. Lange meets Ray Cline in Wellington and agrees to go on the Mafia payroll for monthly fee of $UA40,000 paid into account number 5263161 at Commercial Pacific Trust, New Hebrides.

•March 1984: Muldoon knighted with GCMG for keeping the economy free of obstructions for easier takeover and exploitation.

•24th May, 1984: Four-man CIA team co-ordinated by Ray Cline arrive in New Zealand to begin installation of equipment for subliminal television advertising at five sites—Waiatarua, Mt Erin, Kaukau, Sugarloaf and Obelisk.

Sophisticated equipment can be installed within one kilometer of TV relay arrials and all linked to one IDAPS computer bureau in Auckland.

Same equipment installed in Australia August 1985; Japan September 1986; UK February 1987: New York 1987. Also, AMAX geologists now estimate Martha Hill gold source could be worth up to $30 billion on strength of high gold/tonne ore assay.

•17th July, 1984: In New Zealand, subliminal advertising begins on Channel Two between 6pm and midnight—hours later extended to begin at noon. Subliminal messages prepared in the US by the CIA and with New Zealand election imminent, tell voters to support the Labour Party, the New Zealand Party and to buy Mafia company products.

The New Zealand Party was formed to ensure that Muldoon would lose, as Big Business was unhappy with controls over economy. Big campaign contributions from Brierly, the oil companies and the Business Round Table ensure a Labor victory.

Later, Lange agrees to repay the favour to Brierly by selling the Government holding in the Kariori Pulp Mill to Winstones. New Zealand taxpayer loses $100 million. Government then becomes the arm of big business, using economic policies provided by the Business Round Table, implemented by Finance Minister Roger Douglas and the package being sold by David Lange, who also keeps

up a noisy CIA directed ANZUS withdrawal campaign.

*Reason: 1) ANZUS Treaty did not cover Mafia requirements over the Great South Basin discovery; 2) To identify any opposition or threats within New Zealand who align themselves with supposed Government policy, Lange increases the SIS budget and strengthens links with the CIA.

Brookings Institute are the actual designers of the New Zealand Government economic policies provided by the Business Round Table (NZ Mafia front) and implemented by the Government.

Douglas devalues the dollar and deregulates interest rates, which means cheaper labor, cheaper capital assets and high mortgage rates, thereby implementing Big Business policy of driving farmers off the land, establishment of the corporate farm and eventually remove viability of small business sector, etc.

•27th September, 1984: New Zealand Mafia meets at new 'safe house' registered under Fernyhough's name in Auckland. Those present include Brierly, J. Fletcher, Trotter, Jones, Goodman, Gunn, Papps, Hawkins, Judge, Renouf, Fernyhough, Gibbs and McConnell. Daigo Miyado announces appointment of Trotter as International Vice President of the Trilateral Commission Pacific Basin Economic Council. Brierly outlines strategy of privatization of the New Zealand Government and the establishment of the New Zealand Centre for Independent Studies which will be chaired by Gibbs, aided by Fernyhough and controlled by Cline, which will 'advise' Treasury on privatization. Parsky, Brierly and Seldon hold a separate meeting with Parsky, outlining plans for an expanded laundry operation which will coincide with the launch of 'Crack'—a new addictive product developed by CIA chemists for the world market. Equiticorp (Aust) will be launched with Adler as Manager and a new merchant bank using Elders, Goodmans, Allied Mills, Fielder Gillespie and Watties.

The first key company will control the food industry in Australasia through merger of Elders, Goodmans, Allied Mills, Fielder Gillespie and Watties. Allied Mills will control 30% Goodmans, 30% Fielder, 20% Watties and will expand into Europe via acquisition of Rank, Hovis McDougall (UK). Allied Mills will be controlled through IEL.

•26th October, 1984: Trotter, Hawkins, Lange and Douglas meet in Wellington to implement Mafia plans to privatize the Government and to deregulate the banking system.

•Late 1984: As part of the IDAPS computer-controlled 'laundry' operation, Trotter and Fletcher help establish the 'Pacific Investment Fund' with Australian and New Zealand investments to be managed by Hong Kong and Shanghai Bank subsidiary, Wardley and the Japanese operation controlled by Tokyo Trust and Banking Company—owned by Sanwa Bank, Taiyo-Kobe Bank and Nomura Securities. All are members of the Rockefeller World Government organization.

•18th July, 1985: Australian Mafia meet in Sydney to discuss privatisation of the Australian Government. Those present include—Brierly, Trotter, Fletcher, Seldon, Goodman, Papps, Packer, Bond, Elliott, Adler, and Japanese Trilateralist Daigo Miyado. Cline will set up Australian Center for Independent Studies to 'advise' the Treasurer on the takeover of the economy. Impala Pacific will be set up in Hong Kong through Ariadne with 60% of the company stock held by Chase Manhattan and Security Pacific National Bank in Australia. In the UK, Tozer, Kemsly & Millbourn would be taken over using IEP, while in Australia, the Holme's A'Court Bell Group would be used to merge with Hong Kong and Shanghai Bank, through Standard & Chartered Bank (Hong Kong), and Marae (NZ) Broadlands (Aust) would merge with NZI Corporation.

•18th August, 1985: Cline and 6-man CIA team begin installation of subliminal television equipment in Sydney, Brisbane and Perth.

•8th November, 1985: Parsky, Colby and J.D. Rockefeller meet in New York to discuss their plans to assassinate McCloy and the Rockefellers and to take control of the Mafia organisation. Colby would organise an 8-man 'hit squad' to be headed by Gordon Liddy who had worked for Colby in the 1960's as a CIA contract killer, and was responsible for over 10 murders including:

* 17/8/61—two members of the Gambino Mafia family in New

York
 * 24/11/63—Officer Tippitt after the Kennedy assassination in Dallas
 * 18/12/63—witness to the Kennedy assassination in Dallas
 * 19/4/65—politician in Chicago
 * 27/7/65—politician in Washington
 * 8/9/65—politician in Washington
 * 27/11/66—US 'independent' cocaine importer, in Mexico
 * 25/11/67—'independent' heroin importer, in Los Angeles
 * 9/2/69—politician in Washington

•28th November, 1985: Australian Mafia meet in Sydney—includes: Trotter, Fletcher, Hawkins, Bond, Elliott, Adler and Holme's A'Court—discussed strategy for merger of Goodman, Allied Mills, Fielde Gillespie Davis, Watties and Elders with Chase Manhattan Bank taking 20%, Elders and IEL 10%, with stock being held through Chase-AMP Bank. Elders would be used as major 'vehicle' in the global liquor economy with Courage Brewery in the UK to be used as entry into Europe.

Strategy finalized to take over BHP, Australia's largest company, using Holme's A'Court, Brierly, Elliott and Hawkins. In London, Chase Manhattan would take over stockbrokers Simon & Coates who specialize in Australasia Mafia owned companies such as Fletcher Challenge, Brierly, NZI Corp, Elders, Bell Group and BHP. Chase Manhattan could then issue and buy stock to manipulate the Australasian economy by increasing price, paying no taxes, creating inflation, and enslaving the people through debt to Mafia controlled banks.

Parsky would oversee the 'launder' of further loans to the NZ Government and would begin to channel 'loans' through the Australian Treasury using captive politician Keating. Also NZ Government buildings would be sold to Jones and Australia Government buildings would be sold to Adler which would then be rented back to the respective Governments at inflated prices.

•17th November 1986: Brierly, Seldon, Packer, Bond, Elliott, Holmes a Court and Adler meet in Sydney. Also present is Rupert Murdoch to assist in Parsky strategy of media takeover in Australasia and the Pacific using Packer and Bond (TV and Radio)

Brierly and Holmes A'Court (newspapers). Murdoch takes orders from Brzezinski since his News Corp was taken over in 1982 by Chase Manhattan and Security Pacific National Bank. At a separate meeting with Brierly, Seldon and Cline, Parsky outlines plan for 'key' Media Australasian Holding company using the Bell Group which would be taken over with Chase Manhattan holding 27.5% in London and the US. Another 10% of the stock would be held through Security Pacific National Bank (US).

•8th February, 1987: US Mafia Council meets in Washington—including David Rockefeller, John McCloy, Brzezinski, Parsky, Simon, Katherine Graham, and George Franklin. Brzezinski outlines plans to invade Iran using 75,000 strong mercenary army supported by US Air Force and Navy with starting date of 8th February, 1988. An integral part of the plan— Saudi and Kuwaiti oil tankers would fly the US flag to provoke an Iranian attack so that US invasion of Iran would be 'justified'.
*Reason: The Seven Sisters wanted to exploit a secret oil field near Bandar Abbas discovered in 1976 with estimated 150 billion barrels and also a huge gold source at Neyshabur discovered in 1977. The Iranian invasion would begin after the World economic system was collapsed by the Mafia controlled banks—target date 17th January, 1988. Other countries on the takeover list include:

* Mexico—for oil at Baisas
* Nicaragua—for oil at Connto
* Colombia—for gold at Papayan
* South Korea—for gold at Chunchon
* New Zealand—for oil in the Great South Basin.
(Obviously this part of the plan failed to happen)

•27th February, 1987: New subliminal messages appear on Kiwi TV screens—"Hello Friends. Make More Money. Vote Labor." Other messages include: "Greetings My Own. Buy Cars. Buy Now," and the most sinister of all, "Smash. Hate. Rape. Punch. Kill. Use Violence." With an election imminent in New Zealand, frequency of messages increases to average of four per hour.

•10th March, 1987: Parsky, Colby, Brierly, & Cline meet in the

Gibbs' safe house in Auckland. Parsky outlines the expansion of the European Pacific banking operation with 12 new subsidiaries to be set up in South America to replace the United Fruit Co. front and which will:

(a) launder heroin dollars from the Rockefeller operations in the Golden Triangle and Pakistan;

(b) launder coke & crack dollars from Columbia, Peru, Bolivia, Ecuador, & Venezuela;

(c) CIA funnel to pro-US political parties in Europe and Latin America;

(d) financial conduit to Colby's P2 neo-fascists in Panama, Argentina, Chile, & Uruguay;

(e) spying conduit for information from Middle East, Latin & South America;

(f) financing arms smuggling to Central & South America and the Middle East, including the Christian Militia In Lebanon;

(g) financial conduit to mercenary army in Kuwait (standing by to conduct CIA invasion of Iran) via CIA's Vinell Corp.

•1st April, 1987: Business Round Table plan, 'Government Departments to Corporations,' implemented by Lange & Douglas to privatize New Zealand national assets.

*Reason: You cannot bankrupt a government department, which belongs to the people of New Zealand. Privatization means that the whole country can be asset-stripped of all that was Crown-controlled—land, minerals, & energy.

•17th June, 1987: Kiwi Mafia meet in Gibbs' safe house in Auckland—including Brierly, Trotter, J. Fletcher, Jones, Goodman, & Gunn—to plan strategy for the Aotearoa election, bankrolling of the Labor Party, and post-election agenda for privatization of the Kiwi government. Included is establishment of a presidential (dictator) system, with Trotter installed as el presidente.

•27th July, 1987: J.D. Rockefeller, Colby, & Parsky meet in Paris to implement plans for the assassination of David Rockefeller, Rodman Rockefeller, and John McCloy, using Gordon Liddy and his eight man team.

•July 1987: Brierly-controlled Newmans/Ansett airline goes into operation. With Douglas, Lange, and Palmer helping with Banking Deregulation Bill, City Bank and Paxus NZI etc. become fully-fledged banks in New Zealand.

•Late July 1987: DFC and Trusteebank merger. End of the last Kiwi-owned bank. The Douglas Administration.

(End of the Kiwi Gemstone File)

HAL UPSET, WHOSE PRIMARY EMPLOYER AT THE TIME WAS KATHERINE MEYER GRAHAM, COULDN'T TELL HIM. NIXON FIGURED THAT IT HAD TO DO SOMEHOW WITH ROBERTS RUNNING AROUND IN VANCOUVER TRACING THE "HUGHES" MORMON MAFIA NURSEMAIDS SWINDLE (ELKERSLY) OF THE CANADIAN STOCK-EXCHANGE AND TRUDEAU.

THE 18½ MINUTES WAS OF NIXON RAVING ABOUT CANADA, "ASSHOLE TRUDEAU", "ASSHOLE ROBERTS", ONASSIS, HUGHES, FRANCIS DALE. IT SIMPLY COULDN'T BE RELEASED.

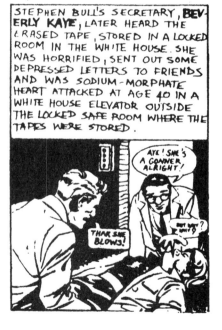

STEPHEN BULL'S SECRETARY, BEVERLY KAYE, LATER HEARD THE ERASED TAPE, STORED IN A LOCKED ROOM IN THE WHITE HOUSE. SHE WAS HORRIFIED, SENT OUT SOME DEPRESSED LETTERS TO FRIENDS AND WAS SODIUM-MORPHATE HEART ATTACKED AT AGE 40 IN A WHITE HOUSE ELEVATOR OUTSIDE THE LOCKED SAFE ROOM WHERE THE TAPES WERE STORED.

Left: Howard Hughes (allegedly) sketched by Shirl Solomon aboard an airplane in April of 1976. Shortly afterward Hughes was officially reported to be dead. According to The Skeleton Key, the real Hughes had died in 1971 of a drug overdose on Onassis' private island, Skorpios.

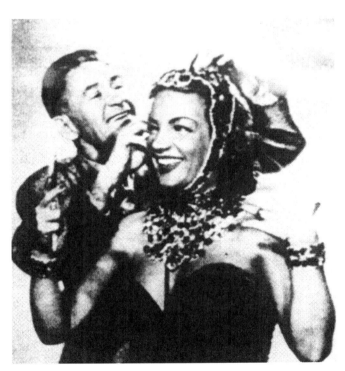

Above: Bruce Roberts fits actress Carmen Miranda with costume jewelry headgear in this 1952 photo from The Los Angeles Times.

First Photos of THE Wedding

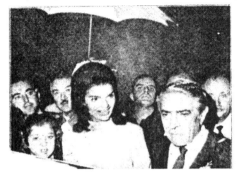

She's Just Wild About Ari...

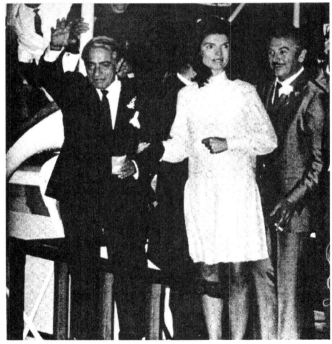

Above: Onassis and Jackie on their wedding day.

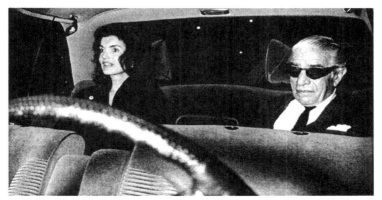

Above: Onassis and Jackie share a limo.

Left: Ari and friend. Where is Jackie?

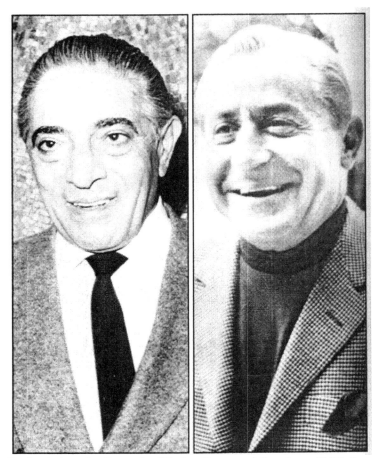

Left: Aristotle Onassis. Right: Stavros Niarchos. Will the real Blofeld please stand up?

Right: Alexander Onassis. Ari's only son, the Onassis empire was a dead end street with his death in an unfortunate airplane crash.

9.
FROM MAURY ISLAND TO DANNY CASOLARO

by Kenn Thomas

In the summer of 1947, Howard Hughes was spinning around, alternately hosting celebrity soirees in Hollywood and flying to Washington, DC, to defend himself to Congress over the sweetheart deals he had made for wartime plane contracts. Meanwhile, in the state of Washington, six flying saucers circled above a harbor boat in Puget Sound near Tacoma, Washington, one wobbling and spewing slag. The falling junk killed a dog and burned a boy's arm. His father, Harold Dahl, witnessed it as he led his son and fellow seamen to shelter. Later, he recovered some of the slag. The Maury Island incident became the first UFO event of the modern era, preceding Kenneth Arnold's famous sighting by three days.

Harold Dahl reported the Maury Island incident to the man he called boss, a man named Fred Crisman. Crisman was an unusual man who had claimed in the pages of Ray Palmer's pulp magazines that he had fought bizarre underground beings in the caves of Burma during World War II. He even described a laser-like wound at a time long before the invention of the laser. Crisman also claimed to have had a career in the OSS, precursor to the CIA. When he came back from the harbor after checking out Dahl's story, he also said that he witnessed another, single saucer.

Like The Gemstone File, the veracity of many of Crisman's

claims has been challenged repeatedly. He became one of the most curious characters in the UFO lore and the history of covert intelligence, the very model of a con man cum agent.

Kenneth Arnold, the famed pilot of the Mt. Rainier sightings, was hired by pulp publisher Ray Palmer to investigate the Maury Island story. He met with Crisman and Dahl at the Hotel Winthrop in Tacoma. Someone bugged the room, alerted the press and otherwise manipulated and confused the investigation. When the Air Force brought in two of its own A2 investigators to help Arnold, they died in the crash of their B25—after putting some of the flying saucer slag aboard. Crisman helped them load the plane.

It got weirder as time went on. In 1968 New Orleans District Attorney Jim Garrison identified Fred Crisman as one of the mystery tramps in the railyard at Dealy Plaza. Part of the tale that Oliver Stone left out of his JFK movie, Garrison called Crisman an industrial spy for Boeing Aircraft, steeped in the anti-Castro Cuban underground and right-wing church CIA fronts, who may have been one of the assassins. Other sources, such as the Torbitt Document, made claims that connected Crisman to Clay Shaw, Garrison's chief defendant, and to Operation Paperclip, the program to integrate former Nazi scientists like Werner Von Braun into the American space program.

Crisman's connections continue to the present day. His business and family ties include Michael Riconosciuto, chief informant to investigative writer Danny Casolaro. Casolaro died mysteriously while researching a transnational cabal called "the Octopus." Riconosciuto played a role in the Inslaw/PROMIS software scandal and developed a fuel-air explosive suspected in many notorious bombings, including the one in Oklahoma City. The Kiwi Gemstone File (see chapter 8) gives formative details about the role members of the Octopus played in the covert history of New Zealand and Australia, but it didn't have a name until Casolaro came along.

Because circumstances have shrouded Danny Casolaro's

death in mystery, the single aspect of his research that led to it may never be known for certain. Hotel workers in Martinsburg, West Virginia found the writer dead in August 1991 in what looked like a faked suicide. The "heads up" warning flashed among students of the conspiracy culture, particularly those aware of the Gemstone history, when the learned files he had on him were missing and the details of his investigative work slowly emerged from friends, family and fellow investigators. Casolaro had previously warned these same people not to believe any reports that he might have fallen victim to an "accident." The fishy circumstances of his death and the probable motivations of his possible killers remain obvious.

Mainstream news magazines often run charts outlining some of the many aspects of Casolaro's investigation of the Inslaw/PROMIS case. *Time* and *Village Voice* have done that, in fact, as with Gemstone, attempting to make his research look like a crazy patchwork of nonsense while also back-pedaling on the investigative tributaries it opened up.

Danny Casolaro sought to document and expose a sea of covert operatives, super-surveillance software and transnational spies. He called the monster he saw swimming in that sea "the Octopus." It consisted of a group of US intelligence veterans that had banded together to manipulate world events for the sake of consolidating and extending its power. Of course it covered some of the Gemstone territory, although nothing suggests that Casolaro read either the Skeleton Key or the Kiwi Gemstone, and it involved the Kennedy assassination. JFK's murder, however, was just one of many coups and assassinations pulled off by the Octopus since the end of World War II.

The group had come together over a covert operation to invade Albania that was betrayed by famed British turncoat Kim Philby. The Octopus had overthrown Jacob Arbenz in Guatemala in 1954. It had targeted operations against Fidel Castro culminating in the Bay of Pigs. It also had tentacles in

the political upheavals in Angola, Rhodesia, Zimbabwe, Mozambique, Nigeria, Chile, Iran and Iraq.

Casolaro had as his main concern Octopus involvement with putting Ronald Reagan in power—the infamous October Surpise—and the role that played in introducing the PROMIS software into police systems around the world.

Casolaro's catalogue of membership in the Octopus included such notorious spooks as John Singlaub and the late CIA director William Colby. As heads of the Phoenix assassination program in Vietnam they had implemented an early version of the PROMIS tracking software to keep tabs on the Viet Cong. Other Octopus tentacles included characters like E. Howard Hunt and Bernard Baker, who later emerged as Watergate burglars. Casolaro focussed on one person in the periphery of the Octopus as it had developed in the early 1980s, a man named Earl Brian, crony to Reagan's Attorney General Ed Meese. Brian had been given PROMIS to sell illegally as a reward for paying off Ayatollah Khomeini to hold on to American hostages until the Carter presidential re-election campaign clearly was doomed.

According to Casolaro, Meese used the US Justice department to steal PROMIS from its developers, the Inslaw group, which had its connections to the Phoenix program and also had developed the software, at least in part, on public money. Two congressional committees eventually agreed, however, that Inslaw was the legal private owner of PROMIS when the US Justice department shanghaied it and Earl Brian profiteered by selling it to the Royal Canadian Mounted Police, Interpol, the Mossad and other international police agencies as well as to the military. One application of the modified PROMIS included the ability to track Soviet submarines in previously untraceable marine trenches near Iceland.

If coded correctly, PROMIS could interface with other databases without reprogramming, giving it great ability to track criminals—but also, potentially, political dissidents—through the computer systems of various pollice

agencies. Casolaro's main informant, Michael Riconosciuto added to this the claim that he had personally reprogrammed PROMIS with a backdoor, so it could spy on the methods of the police agencies that were using it for tracking. This gave it added appeal as a covert tool. The US could spy on the very agencies it was selling the software to illegally. Riconsciuto's father Marshall Riconosciuto, a Nixon crony, was also a business partner to Fred Crisman, a man, like Howard Hughes, involved in high-flying high jinx in 1947. Michael Riconosciuto's teenage apprenticeship with Nobel-winning laser physicist Arthur Schalow could almost serve as a footnote to the Gemstone story.

Another figure in the Casolaro story, Earl Brian, tangles it up both with the Watergate dimensions of Gemstone and with the Iran-contra figures of the Kiwi. Earl Brian's role in the PROMIS theft was spelled out explicitly by Inslaw lawyer Elliot Richardson, another Watergate figure in the *New York Times* in 1992. Richardson was the Attorney General who actually stood up to Richard Nixon's corruption during the Saturday Night massacre. Brian sued over the *New York Times* article and lost. Richardson had written the article to encourage investigation of the case, but Brian used the opportunity to start a nuisance libel suit. On November 29, 1995, the New York Court of Appeals dismissed Brian's claim and declared that Richardson's assertions came under free speech protections.

Although never prosecuted over the PROMIS allegations, Brian survived only one more year after the libel suit before other past shady deals began to catch up with him. In October 1996 a California jury convicted him of Federal bank fraud, conspiracy and lying to auditors.

Prosecutors charged that Brian had drafted false documents to conceal the losses of the Financial News Network and United Press International, for whom he served as chief executive, in order to obtain $70 million in bank loans for his other concern, a biotechnology firm Infotechnology.

131

Interestingly, the pattern of financial impropriety in the case was identical to one that happened on assassination day, November 22, 1963.

Someone named Tony DeAngelis misrepresented his holdings of thousands of tons of salad oil with faked American Express warehouse receipts in order to get bank loans. Exposure of the fraud was the top news story in the *New York Times* editions that came out before the assassination on that date. Many people profiteered from the short-selling spree on the markets consequent to that and news of JFK's murder, including American Express magnate Warren Buffet and a transnational entity called Bunge Corporation, known in the financial literature of the time as—astute readers might guess it—"the Octopus."

In a classic work on the JFK assassination, *Were We Controlled*, pseudonymous author Lincoln Lawrence argues that DeAngelis, Ruby and Oswald were all mind-controlled in their actions on that day. (Adventures Unlimited Press reprinted this book with annotations, bibliography, photographs and index, under the title *Mind Control, Oswald & JFK*.) Add to that the fact that Earl Brian at one time was a brain surgeon, and the other Gemstone-Watergate-Inslaw connection, E. Howard Hunt, who had a phone relationship with Casolaro, has also been connected to mind control operations, and the story takes some extremely interesting speculative turns.

Michael Riconosciuto claimed that he had made his modifications to PROMIS on the tribal lands of the Cabazon Indians in Indio, California as part of a joint project the tribal administrators had with a private security firm known as Wackenhut. Wackenhut provides security services to the notorious secret airbase Area 51. After Danny Casolaro turned up dead and his current research file missing, other notes found at his apartment later clearly indicated his interest in this Nevada super-spook facility. The base, of course, had been around since before it was used to develop the U2 spy plane in

the late 1950s and early 1960s, later the SR71 Blackbird and now the mysterious Aurora super-plane. As Casolaro made his notes about it, however, it had not yet become the subject of popular lore that it is today. Nevertheless, Casolaro devoted pages of notes to Area 51.

One theory connected via history to the Gemstone thesis had it that Casolaro's death had less to do with the Octopus than it did with manufacturing fraud at Hughes Aircraft. Hughes Aircraft has a long history of exclusive and secret deals with the US government for aerospace technologies, many almost certainly involving Area 51. Casolaro had brushed up against this corruption in his pursuit of his Octopus spook group. A contact he made the day before he died, Bill Turner, gave him documentation of the fraud at Hughes. Turner noted that Casolaro added these papers to the ever-present accordion file of current research. After they found Casolaro's body, Turner got himself arrested on a bank robbery charge in order to remove himself from any further involvement.

The joint venture between the Cabazon Indian tribe and Area 51's Wackenhut did exist, at least between 1981 and 1983, and Michael Riconosciuto certainly was involved with it at least in some capacity. A report from a task force of the sheriff's office of Riverside County, California placed Riconosciuto at a weapons demonstration with Earl Brian ("of the CIA") put on by the Cabazons and Wackenhut.

Riconosciuto also claimed that he had a tape documenting threats made against him by another Justice Department official, but he had thrown it in a marsh near Puget Sound the night he was arrested on trumped up methamphetamine charges. Casolaro spent many days searching the Puget Sound bog—the same Maury Island area where Harold Dahl and Fred Crisman has seen the spaceships of 1947—to no avail, looking for the tape that ostensibly could verify the claims of "Danger Man," Casolaro's nickname for Riconosciuto. To underscore: the Puget Sound location was significant because of its proximity to a famous early UFO event, the 1947 Maury

Island incident. That event—six flying saucers seen by harbor seamen that left behind slag debris—had been witnessed, or hoaxed, by Fred Crisman, the business partner of Riconosciuto's father. Again, in the 1960s, Crisman was subpoenaed by New Orleans district attorney Jim Garrison as part of his investigation of the Kennedy assassination. Some researchers claimed that Crisman was one of the "railyard tramps" arrested near Dealy Plaza on November 22, 1963. Garrison was quite explicit about accusing Crisman of being an industrial spy for Boeing Aircraft. Other researchers note that he possibly gave refuge on his Oregon ranch to a member of the Minutemen, an early militia group investigated by the Warren Commission.

Nothing suggests that Casolaro knew of the Crisman connection, or of the significance it might hold for what he already knew about Area 51 and the other secret airbase that held his attention, Australia's Pine Gap.

Pine Gap is the top secret American underground base located near Alice Springs in the Northern Territory of the land down under, officially known as the Joint Defense Space Research Facility. It was built in 1968 officially to share program data with the Australians.

Intelligence agency defector Victor Marchetti, who served in the CIA director's office from 1966 to 1969, now acknowledges that he co-authored the secret agreement between the agency and the Australian Department of Defence on the establishment of the Pine Gap station.

Officially, it monitors spy satellites and intercepts and decodes broadcast communications between foreign powers unfriendly to the US.

One of Pine Gap's important functions is to monitor geostationary satellites for wide ranging information on enemy telemetry, radar emissions and telecommunications.

Opposition from the Australians to the base grew as its nature as an espionage facility outside of Australian control became clear. In his 1987 book *Crimes of Patriots*, author

Jonathan Kwitny demonstrates that covert manipulation led to the early end in Australia of the administration of Labor Party prime minister Gough Whitlam because of his opposition to Pine Gap. Casolaro noted with aggravation Kwitny's inability to see the tentacles of the Octopus in the affair. "It didn't take many people to design the apparatus that would insure the renewal of the lease for the Pine Gap installation near Alice Springs, Australia," Casolaro wrote. "After all, how could a democracy spit up a Prime Minister that could sack the security of the Western Alliance?" No indication exists that Kwitny, who died in 1999, ever read the Kiwi Gemstone.

Indeed, Whitlam was ousted after his public complaints about intelligence agency deceptions over the tragic US policy in East Timor, and the CIA's funding of Australia's right-wing Country Party, as well as his opposition to Pine Gap. Whitlam was not driven from office by an election, but was removed on a technicality by a governor-general he had appointed, one who had strong ties to the CIA. No doubt the paranoia about this destabilization of the Australian government by the US fueled rumors about the underground Pine Gap base involving alien/government collaborations, rumors that Danny Casolaro knew about that were very similar to what he was hearing about Area 51. Certainly the base's potential for surveillance also triggered his interest as well. PROMIS had been used in tracking Soviet submarines; might it also be used to track Soviet satellites? One report told of a Moscow summit conference in 1972 during which an early Pine Gap satellite picked up limousine radio-telephone conversations between Soviet missile designers, Andrei Gromyko and Leonid Brezhnev that revealed a missile secretly being kept from SALT negotiations.

Back on the Area 51 front, Casolaro was hearing rumors that Michael Riconosciuto had worked for Lear Aircraft in Reno, Nevada. This connected him to both John Lear, creator of the Lear jet, and often claimed by UFO buffs as having done research on anti-gravity for the government, as well as John

Lear, Jr., a former CIA pilot who also hit the UFO circuit with tales of saucers and aliens in cahoots with the US government. In 1989, a man named Bob Lazar went public with his claims that he had back-engineered alien spacecraft at Area 51. Lear and Lazar lectured widely on the UFO circuit in the late 1980s and early 1990s, along with other UFO lecture celebrities like Bill English and William Cooper. Cooper's 1991 classic, *Behold A Pale Horse*, shared the title of the first draft proposal of Casolaro's manuscript that eventually became titled *The Octopus.*

After Casolaro's death, Michael Riconosciuto made claims that Casolaro had learned nothing more than what one of two intelligence factions wanted him to know in order to embarrass the other faction, cliams that provide the basis for the Kiwi-like document known as the COM-12 briefing. One faction was called Aquarius and had a leadership sub-group called MJ-12, the name, of course, of the supposed secret group founded by Harry Truman in the wake of the Roswell flying saucer crash, after also the Maury Island incident, the Arnold sighting and Hughes' struggle to control international air traffic. Riconosciuto even told one writer that he had witnessed the autopsy of an alien body—this long before the famous alien autopsy film began to circulate.

Some have suggested that the tales of extraterrestrials that abound around places like Area 51 and Pine Gap, and in the chronologies found in the wild claims of The Gemstone File, serve as disinformation to deflect attention away from serious issues such as gun-running and black project weapons development. Clearly, though, they also draw attention to them. Casolaro's work, like The Gemstone Files, has long been dismissed as a fraud or the product of an overwrought imagination. The same has been said about the Maury Island incident, indeed about Fred Crisman's entire life. Surely the interlocking alternative time lines are, as W. B. Yeats might put it, at least half-perceived, half-created.

To lean on another literary giant, however, is perhaps the

best way to see this history: "Facts are but the Play-things of lawyers,—Tops and Hoops, forever a-spin. Alas, the Historian may indulge no such idle Rotating. History is not Chronology, for that is left to lawyers,—nor is it Remembrance, for Remembrance belongs to the People. History can as little pretend to the Veracity of the one, as claim the Power of the other, —her Practitioners, to survive, must soon learn the arts of the quidnunc, spy, and taproom Wit,—that there may ever continue more than one life-line back into the a Past we risk, each day, losing our forebears in forever,—not a Chain of single Links, for one broken could lose us All,—rather a great disorderly Tangle of Lines, long and short, weak and strong, vanishing into the Mnemonick, with only their Destination in common." —The Rev'd Wicks Cherrycoke, as told by Thomas Pynchon.

Note: Kenn Thomas's examination of the Maury Island case, using previously unavailable Freedom of Information Act files, oral histories (including one with Michael Riconosciuto about Fred Crisman), intelligence agency reports, correspondence and other primary sources, is available from IllumiNet Press. His previous book, *The Octopus: Secret Government and the Death of Danny Casolaro*, co-authored with Jim Keith, is available from Feral House.

Above: Hal Lipset with one of his microphones and recording devices. He was most famous for his invention of the microphone in the martini olive.

Above: The Drift Inn in San Francisco, where Bruce Roberts and others met from time to time. Plenty of olives for the martinis.

10.
MYSTERIOUS
DEATHS

by Kenn Thomas

Like much conspiracy history, The Gemstone File claims some credibility from the lists of mysterious deaths it compiles, by sodium morphate pie or other scurrilous methods. It also has as its back drop the aerospace and transportation industries. Curiously, this topical nexus—statistically anomalous and suspicious early deaths and industrial aerospace intrigue—come together frequently.

UFO researcher Cope Shellhorn, in a talk give to the 1998 International UFO Congress in Laughlin, Nevada, pointed out that many UFO researchers, some of them working for the military or airlines, all of them involved in sky mysteries, often fail to get their full four score years. The phenomenon has illuminated other strange situations, such as the mysterious death list attached to scientists contracted to the Star Wars/Strategic Defense initiative in the late 1980s, and the early death of writer Danny Casolaro, quite clearly murdered because he came too close to a high-tech, globalist cabal connected to Area 51 (see chapter 9), and a death that adds to a list of bizarre murders involving the Cabazon Indian tribe.

The idea of compiling lists of mysterious deaths began for most people with the Kennedy assassination. Lee Bowers, Mary Pinchot Meyer, Roger Craig, comprise part of a list of names well known among Kennedy researchers as witnesses to the assassination (or people connected to it in some way) who all met deaths by car crashes, murders, bizarre accidents, and

mysterious fast acting cancers. All of the them died quite young. Even though one recent author now claims that connection to the assassination actually increases a person's life span by 1.5 years, common sense and respect for probability suggests that an anomalous pattern of early deaths can be seen in a statistical population of Kennedy assassination witnesses and critics of the Warren Commission.

To review that list as it looked when The Gemstone File emerged:

11/63, Karyn Kupicinet, TV host's daughter overheard telling of JFK's death prior to 11/22/63, murdered;

12/63, Jack Zangretti, expressed foreknowledge of Ruby shooting Oswald, gunshot victim;

2/64, Eddy Benavides, lookalike brother to Tippit shooting witness Domingo Benavides, gunshot to head;

2/64, Betty MacDonald, former Ruby employee who gave alibi to Warren Reynolds shooting suspect, suicide by hanging in Dallas jail;

3/64, Bill Chesher, thought to have information linking Oswald and Ruby, heart attack;

3/64, Hank Killam, husband of Ruby employee, knew Oswald acquaintance, throat cut;

4/64, Bill Hunter, reporter who was in Ruby's apartment on 11/24/63, accidental police shooting;

5/64, Gary Underhill, CIA agent who claimed Agency was involved, gunshot in head ruled suicide;

5/64, Hugh Ward, private investigator working with Guy Banister and David Ferrie, plane crash in Mexico;

5/64, DeLesseps Morrison, New Orleans mayor, passenger in Ward's plane;

6/64, Guy Banister, ex-FBI agent in New Orleans connected to Ferrie, CIA, Carlos Marcello, Oswald and Fred Crisman, heart attack;

8/64, Teresa Norton, Ruby employee, fatally shot;

9/64, Jim Koethe, reporter who was in Ruby's apartment on

11/24/63, blow to neck;

9/64, C.D. Jackson, *Life* magazine senior vice-president who bought Zapruder film and locked it away, unknown;

10/64, Mary Pinchot Meyer, JFK lover whose diary was taken by CIA chief James Angleton after her death, murdered;

1965, David Goldstein, helped FBI trace Oswald's pistol, natural causes;

1/65, Paul Mandal, *Life* writer who told of JFK turning to rear when shot in throat, cancer;

3/65, Tom Howard, Ruby's first lawyer, was in Ruby's apartment on 11/24/63, heart attack;

5/65, Maurice Gatlin, pilot for Guy Banister, fatal fall;

8/65, Mona B. Saenz, Texas employment clerk who interviewed Oswald, hit by Dallas bus;

9/65, Rose Cheramie, advance knowledge of assassination hit/run victim;

11/65, Dorothy Kilgallen, columnist who had private interview with Ruby, pledged to "break" JFK case, drug overdose;

11/65, Mrs. Earl Smith, close friend to Dorothy Kilgallen, died two days after columnist, may have kept Kilgallen's notes, cause unknown;

12/65, William Whaley, cab driver who reportedly drove Oswald to Oak Cliff (the only Dallas taxi driver to die on duty), motor collision;

1966, Judge Joe Brown, presided over Ruby's trial, heart attack;

1966, Karen "Little Lynn" Carlin, Ruby employee who last talked with Ruby before Oswald shooting, gunshot victim;

1966, Clarence Oliver, District Attorney/investigator who worked Ruby case, unknown;

1/66, Earlene Roberts, Oswald's landlady, heart attack;

2/66, Albert Bogard, Car salesman who said Oswald test drove new car, suicide;

6/66, Capt. Frank Martin, Dallas policeman who witnessed Oswald slaying, told Warren Commission "there's a lot to be

said but probably be better if I don't say it," sudden cancer;

8/66, Lee Bowers Jr., witnessed men behind picket fence on Grassy Knoll, motor accident;

9/66, Marilyn "Delila Walle, Ruby dancer, shot by husband after one month of marriage;

10/66, Lt. William Pitzer, JFK autopsy photographer who described his duty as "horrifying experience," gunshot rule suicide;

11/66, Jimmy Levens, Fort Worth nightclub owner who hired Ruby employees, natural causes;

11/66, James Worrell Jr., saw man flee rear of Texas School Book Depository, motor accident;

12/66, Hank Suydam, *Life* magazine official in charge of JFK stories, heart attack;

1967, Leonard Pullin, civilian Navy employee who helped film "Last Two Days" about assassination, one-car crash;

1/67, Jack Ruby, Oswald's slayer, lung cancer (he told family he was injected with cancer cells);

2/67, Harold Russell, saw escape of Tippit killer, killed by cop in bar brawl;

2/67, David Ferrie, acquaintance of Oswald, Garrison suspect and employee of Guy Banister, blow to neck (ruled accidental);

2/67, Eladio Del Valle, anti-Castro Cuban associate of David Ferrie being sought by Garrison, gunshot and ax wounds to head;

3/67, Dr. Mary Sherman, Ferrie associate working on cancer research, died in fire (possibly shot);

1/68, A. D. Bowie, Asst. Dallas District Attorney prosecuting Ruby, cancer;

4/68, Hiram Ingram, Dallas Deputy Sheriff, close friend to Roger Craig, sudden cancer;

5/68, Dr. Nicholas Chetta, New Orleans coroner who worked on death of Ferrie, heart attack;

8/68, Philip Geraci, friend of Perry Russo, told of Oswald/Shaw conversation, electrocution;

1969, Charles Mentesana, filmed rifle other than Mannlicher-Carcano being taken from Depository, heart attack;

1/69, Henry Delaune, brother-in-law to coroner Chetta, murdered;

1/69, E.R. Walthers, Dallas Deputy Sheriff who was involved in Depository search, claimed to have found .45-cal. slug, shot by felon;

4/69, Mary Bledsoe, neighbor to Oswald, also knew David Ferrie, natural causes;

4/69, John Crawford, close friend to both Ruby and Wesley Frazier, who gave ride to Oswald on 11/22/63, crash of private plane;

7/69, Rev. Clyde Johnson, scheduled to testify about Clay Shaw/Oswald connection, fatally shot;

1970, George McGann, underworld figure connected to Ruby friends, wife, Beverly, took film in Dealey Plaza, Murdered;

1/70, Darrell W. Garner, arrested for shooting Warren Reynolds, released after alibi from Betty MacDonald, drug overdose;

8/70, Bill Decker, Dallas Sheriff who saw bullet hit street in front of JFK, natural causes;

8/70, Abraham Zapruder, took famous film of JFK assassination, natural causes;

12/70, Salvatore Granello, mobster linked to both Hoffa, Trafficante, and Castro assassination plots, murdered;

1971, James Plumeri, mobster tied to mob-CIA assassination plots, murdered;

3/71, Clayton Fowler, Ruby's chief defense attorney, unknown;

4/71, Gen. Charles Cabell, CIA deputy director connected to anti-Castro Cubans, collapsed and died after physical at Fort Myers;

1972, Hale Boggs, House Majority Leader, member of Warren Commission who began to publicly express doubts

about findings, disappeared on Alaskan plane flight;

5/72, J. Edgar Hoover, FBI director who pushed "lone assassin" theory in JFK assassination, heart attack (no autopsy);

9/73, Thomas E. Davis, gunrunner connected to both Ruby and CIA, electrocuted trying to steal wire;

1974, Dave Yaras, close friend to both Hoffa and Jack Ruby, murdered;

2/74, J.A. Milteer, Miami right-winger who predicted JFK's death and capture of scapegoat, heater explosion;

7/74, Earl Warren, Chief Justice who reluctantly chaired Warren Commission, heart failure;

8/74, Clay Shaw, prime suspect in Garrison case, reportedly a CIA contact with Ferrie and E. Howard Hunt, possible cancer;

1974, Earle Cabell, Mayor of Dallas on 11/22/63, whose brother, Gen. Charles Cabell was fired from CIA by JFK, natural causes;

1975, Allen Sweatt, Dallas Deputy Sheriff involved in investigation, natural causes;

6/75, Sam Giancana, Chicago Mafia boss slated to tell about CIA-mob death plots to Senate Committee, murdered;

7/75, Clyde Tolson, J. Edgar Hoover's assistant and roommate, natural causes;

12/75, Gen. Earle Wheeler, contact between JFK and CIA, unknown;

1976, Ralph Paul, Ruby's business partner connected with crime figures, heart attack;

4/76, James Chaney, Dallas motorcycle officer riding to JFK's right rear who said JFK "struck in the face" with bullet, heart attack;

4/76, Dr. Charles Gregory, Governor John Connally's physician, heart attack;

6/76, William Harvey, CIA coordinator for CIA-mob assassination plans against Castro, complications from heart surgery;

7/76, John Roselli, mobster who testified to Senate Committee and was to appear again, stabbed and stuffed in a metal drum.

JFK himself, of course, suffered the central mysterious death that Gemstone claims to explain. It's Mafia conspiracy adds a global dimension not present in other Mafia theories, and it is by no means the oddest of the theories. That distinction belongs to the theory that JFK was killed because of what he knew or was going to reveal about Roswell, UFOs or the alien presence in general. In 1998, UK ufologist Aleuti Francesca presented the latest support for this idea, reporting that a Cambridge professor has suggested that JFK had a speech on 4x5 cards in his pocket on that last fatal ride detailing the business about Roswell and what was by then a fifteen year old pact with the greys, exchanging human subjects for advanced technology.

This professor has not yet been found, but the theory is supported indirectly by the correspondence Stanton Friedman went through painstaking effort to uncover showing that the astronomer and UFO debunker Don Menzel wrote to JFK in an attempt to give him information about his own top secret involvements. Menzel supposedly signed the MJ-12 documents. (The US government indirectly supports the veracity of the MJ-12 documents by keeping in the National Archives a corroborative document called the Cutler-Twining memo.) If it has validity, this correspondence suggests that MJ-12 may have been keeping presidents out of the alien loop by 1963 and Menzel was trying to act as a back channel. Interesting also that Kennedy, Menzel and this professor mentioned by Ms. Francesci are all Harvard alums.

The story is also supported by something called the Speriglio document, a "Top Secret" memo named after the investigator who discovered it (Reproduced in the book *Mind Control, Oswald & JFK*, Adventures Unlimited Press, 1997). It purports to be a transcript of a conversation in which Marilyn Monroe says that JFK took her to Area 51 to look at the dead

alien bodies. The transcript ostensibly originates with newspaper columnist Dorothy Kilgallen, who as early as 1947 had reported on a crashed saucer event in Spitzbergen, Norway. Killgallen reported again on the topic in the mid-1950s, noting on February 15, 1954: "From the UK: Flying Saucers are of such vital importance that they will be the subject of a special hush-hush meeting of the world military heads next summer"; and in the Spring of 1955: "British scientists, after examining the wreckage of one mysterious flying ship are convinced these strange aerial objects are not optical illusions of Soviet invention but are flying saucers which originate on another planet. The source of my information is a British official of cabinet rank who prefers to remain unidentified. 'We believe on the basis of our inquiry so far that the saucers were staffed by small men, probably under four feet. It's frightening, but there's no denying the flying saucers come from another planet.' This officially quoted scientist was saying that a flying ship of this type could not possibly be constructed on earth. The British government, I learned, is withholding a report of the flying saucer at this time, possibly because it does not wish to frighten the public." When Kilgallen died in November 1965, after interviewing Jack Ruby (see above), an electrical blackout occurred along the eastern seaboard, accompanied by many UFO sightings.

Advanced technology a la Gemstone and a connection to high-weirdness in space remains an important part of the Kennedy assassination. Recall the security operation for General Dynamics discussed in chapter 8, in which operatives broke into the apartment of Judith Exner Campbell hoping to find something to use to blackmail JFK into awarding the contract for the Tactical Experimental Fighter to their company.

Such private covert ops as a tool of corporate control have a direct connection to concerns surrounding Area 51. They grew from practices like those of former Senator George Smathers. In the 1950s, it was the law firm of the Florida

Senator that hired guards from a subsidiary of the security services apparatus of his friend George Wackenhut. As noted in chapter 8, the guards worked at the nuclear-bomb site in Nevada and also at Cape Canaveral, despite federal prohibitions against such an arrangement between government and private police. The private group Wackenhut still supplies security to the US-owned Area 51, although apparently that distinction is now also shared with Bechtel.

Additionally, the controversy surrounding the contract with General Dynamics (again the topic of Kennedy's last speech on November 22), included early financial commitment to it from Australia, opening the funding corridor that led to the development of Pine Gap, the down-under version of Area 51.

But this is not the most important high-tech issue regarding mysterious deaths, such as those caused by the sodium morphate pie of Gemstone fame. The most dramatic demonstration of the technology of assassination can be found on the Zapruder film, particularly the sequence following Kennedy's emergence from the Stemmons Freeway sign. This shows the Umbrella Man, a man twirling an open umbrella on the sunny day of the assassination. The image of the Umbrella Man appeared regularly as a cartoon in rightist magazines like the *National Review* to represent the wimpy liberal Neville Chamberlain, who thought he had achieved "Peace In Our Time" through an appeasement policy with Adolph Hitler. Most publications stopped using the image after the JFK assassination because, lo and behold, the Umbrella Man actually showed up at the assassination.

Speculation about the Umbrella Man includes the possibility that he has opened his umbrella to give a signal to shooters in the Book Depository, at the Dal Tex building and on the grassy knoll to fire. Interestingly, the man next to him, known as Radio Controller Man, is also giving out signals. Two sets of signals? Doesn't seem likely. Fletcher Prouty has argued that the umbrella actually launched a flechette that contained curare poison. When it lodged in Kennedy's neck, it instantly

paralyzed him, and the extant Zapruder film shows that JFK's elbows do seem locked in an "up" position, not flailing, so that he would be a sitting duck for the shots that came after.

Many things remain to be debated about the Zapruder film, most notably the idea that the driver of JFK's car did the shooting. This notion was first put forth by researcher Lars Hansson, who now no longer believes it. It was later championed by William Cooper, author of the well-known book *Behold A Pale Horse,* who apparently still does believe it. Should it be believed? In fact, a secret service agent took the original Zapruder film on the night of the assassination for processing at a Kodak lab in Rochester, New York, and then took it to the CIA's National Photo Interpretation Center. The original film could have been changed any number of ways at that time. In fact, Homer McMahon, the NPIC manager at the time, testified to the Assassinations Material Review Board that after reviewing the film he thought Kennedy had been shot six to eight times from at least three directions. So it's really logically impossible to eliminate the driver-did-it theory.

The point, however, is that the Umbrella Man's flechette, and the radio control that his partner seems to have, reflect a technology already quite advanced in that day and time. The physical artifact of a flechette-firing umbrella was provided to the House Select Committee on Assassinations in 1978, although no attempt was made to connect it to Kennedy's death. It remains clear, however, that flechette poisons, fast acting cancers, heart attack inducing chemicals, and chemicals that mimic carbon monoxide poisoning are realities in the worlds of mafia, military, industrial and aerospace espionage. For perspective, readers should remember that the CIA has barely a tenth of the budget of other agencies in the alphabet soup of the intelligence world, like the DIA (Defense Intelligence Agency), the NSA, (National Security Agency), the NRO, (National Reconnaissance Office), or the Office of Naval Intelligence (ONI). All of these are subsets of a bigger, corporate, transnational and largely privately run sphere of

industrial espionage. Sometimes, for lesser projects, spies of this category contract with the CIA—indeed sometimes we hear of so-called former spooks proudly separating themselves from the CIA by saying they were only contract agents.

The medical industry, the government and the military acknowledge that they have collected more data on cancers of the fast acting kind than any other. Such cancers develop, for instance, with exposure to a wide range of dangerous chemicals in many job environments. Contact with the chemical benzene, for instance, causes acute myeloid leukemia, which is fatal within weeks. The National Cancer Institute has a long list of everyday occupations that are at high risk to develop fast cancers, including auto mechanics, dry cleaners, beauticians, farmers and nurses.

The list does not include spy assassins or conspiracy researchers, but perhaps it should.

The woman who first brought Bruce Roberts' Gemstone letters to the attention of a broader audience, famed conspiracy researcher Mae Brussell, died in three weeks of a fast acting cancer in Carmel, California at the age of 66, on October 3, 1988. She had just left her radio show of 17 years after receiving a death threat and having her home broken into. (Radio talk show host Art Bell followed a similar pattern, dropping out of his program after receiving a still unidentified threat. He returned in two weeks, however. Mae Brussell never came back.) At the time, Brussell had taught the only accredited course on conspiracy in the country, was listed in the International Who's Who of Intellectuals and had just received the George Seldes Award from the American Society of Journalists, bringing a whole new level of credibility to parapolitical research. Also at the time, she was investigating followers of Satanic cults in the military.

Another unusual cancer-related death was that of psychologist Wilhelm Reich. Reich developed an effective therapeutic technique against cancer using a natural energy he called orgone. In 1957 he was arrested for violating an FDA

injunction against shipping equipment for this therapy, the orgone boxes, across state lines. At the time, Reich also was working on ways to manipulate an atmospheric version of the orgone, for the purposes of climate control and against UFOs he had unexpectedly encountered in the desert near Tucson, Arizona. He called that activity "cloudbusting," and it returned to the JFK lore in a column written by Dorothy Kilgallen on December 21, 1964: "Memo to President Johnson: Please check with the State Department, the leaders of the Armed Forces or our chief scientists, to discover what, if anything, we are doing to explore the ramifications of 'cloud-busting' which in its refined stages means thought control and could change the history of the world. We could catch up if someone in command gave the word before it was too late." Reich died in Lewisberg prison of a heart attack, age 60, with no previous history of heart problems, and after taking medicine given to him by prison officials.

If the assassination technologies exist and they are applied in ways suspected by students of conspiracy, secrecy must necessarily surround them and the appearance of anomalous death lists becomes a means of making them visible. From 1982 to 1988, 22 British scientists died or disappeared under mysterious circumstances, each skilled in super computers and computer-controlled aircraft. Five of these scientists, however, could not control an automobile well enough to avoid unusual deadly accidents. Ten more were so depressed by their high-paying, high profile lifestyles they committed suicide, two with stripped leads of electrical wires attached to their bodies. To review that list: Professor Keith Bowden, 45, computer scientist, Essex University, car plunged off a bridge into an abandoned railyard, March 1982;

Lieutenant Colonel Anthony Godley, 49, head of work-study unit at the Royal Military College of Science, disappeared, April 1983;

Roger Hill, 49, radar designer and draftsman, allegedly killed himself with a shotgun at the family home;

Jonathan Walsh, 29, digital-communications expert assigned to British Telecom's secret Martlesham Health research, fell from his hotel room while working on a British Telecom project in Abidjan, Ivory Coast (Africa), November 1985;

Vimal Dajibhai, 24, computer software engineer for Tigeifish torpedo guidance system, broken body found 240 feet below the Clifton suspension bridge in Bristol, August 1986;

Ashaad Sharif, 26, found decapitated with one end of a rope around his neck, the other around a tree, apparently having driven in his car at high speed, October 1986;

Richard Pugh, computer consultant for the Ministry of Defense, found dead and head-to-toe in rope tied four times around his neck, January 1987 (deemed a sexual experiment gone haywire);

John Brittan, Ministry of Defense tank batteries expert, Royal Military College of Science, found dead in a parked car in his garage, January 1987;

Victor Moore, 46, design engineer, drug overdose, February 1987;

Peter Peapell, 46, scientist, Royal Military College of Science, carbon-monoxide poisoning, February 1987;

Edwin Skeels, 43, engineer, carbon-monoxide poisoning, February 1987;

David Sands, satellite projects manager, drove a car filled with gasoline cans into the brick wall of an abandoned café, March 1987;

Stuart Gooding, 23, postgraduate research student, Royal Military College of Science, car wreck in Cyprus during military exercises on the island, April 1987;

George Kountis, experienced systems analyst at British Polytechnic, drowned after his BMW plunged into the Mersey River in Liverpool, April 1987;

Mark Wisner, 24, software engineer at Ministry of Defense experimental station for combat aircraft, found dead with a plastic bag over his head, another ruling of weird sex gone

nuts, April 1987;

Michael Baker, 22, digital communications expert, BMW crash, May 1987;

Frank Jennings, 60, electronic weapons engineer, heart attack, June 1987;

Russel Smith, 23, lab technician at the Atomic Energy Research Establishment, body found at the bottom of a cliff, January 1988;

Trevor Knight, 52, computer engineer, carbon-monoxide asphyxiation, March 1988;

John Ferry, 60, assistant marketing director for weapons systems, stripped leads of an electrical cord in mouth, August 1988;

Alistair Beckham, 50, software engineer, wires running to a live main wrapped around chest, Plessey;

Andrew Hall, 33, engineering manager, carbon-monoxide asphyxiation, September 1988.

Each of these scientists worked for Marconi Defense Systems or another of the British Defense contractors to America's Strategic Defense Initiative, SDI, or what the US administration under Ronald Reagan called "Star Wars." Begun in 1983, the aim of this initiative was to develop space-based weaponry to shoot down Soviet missiles. What were these strange deaths all about? The protection of Star Wars missile shield technology which used pulse, microwave or even laser technology developed from that described in Gemstone? (Even as described in the popular press, the Star Wars satellites transferred the energy of nuclear detonations into a complex of mirrors, and then through a lens to produce its laser beam.) Were these deaths somehow related to that confluence of mystery deaths and aerospace espionage? Researchers still have few clues other than the death list itself.

Star Wars was a wasteful and unnecessary military expenditure typical of the Reagan years. Under Clinton, Defense Secretary Les Aspin declared that the end of the

Soviet Union eliminated the need for the Star Wars initiative and shut it down on May 13, 1994. Nevertheless, President Clinton renewed funding for it in January 1999, to the tune of $100 billion. Those interested in the Marconi mystery, the Kennedy assassination, Casolaro and The Gemstone File, no doubt stand ready with writing utensils to start compiling the next list.

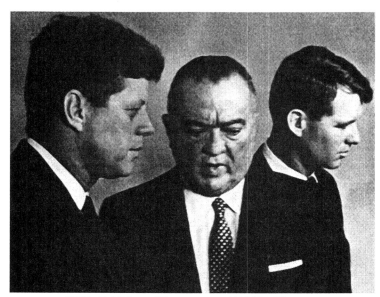

JFK, J. Edgar Hoover, and RFK: Have
you guys seen my panties and nylons?

❦ *Funerals* ❦

ROBERTS, Bruce Porter — July
30, 1976. Bruce Porter Roberts,
father of Beverly Sipanoff; be-
loved son of Eva R. Roberts;
brother of D. L. Roberts; neph-
ew of C. J. Kimball; a native of
New York; a veteran of WWII.
Services Mon. 2:30 p.m.
DAPHNE'S 1 CHURCH ST.

Bruce Roberts' obituary.

11.
THE MAE BRUSSELL FILES

compiled by
Kenn Thomas

Commentary about The Gemstone File from conspiracy maven Mae Brussell comprised two installments of her radio program, *Dialogue: Conspiracy,* on KLRB radio in Carmel, California. Tapes of these programs still circulate among conspiracy researchers, and Jim Keith dutifully transcribed them in his 1992 book, *The Gemstone File* (IllumiNet). The comments were not Ms. Brussell's last word on the subject, of course.

Despite the fact that she did not have full faith in their veracity, the Gemstone letters provided a back drop to much of what she discussed and exposed over the years. Moreover, Ms. Brussell's unique form of socio-political rant and analysis mirrored Gemstone, and both identified issues and political currents that still inform the cultural critique often carried out by students of conspiracy. The following transcripts provide further insight from Mae Brussell into Gemstone-illuminating areas., but also reflect her almost manic style and some of the still only dimly-understood historical realities she discerned apart from the Gemstone.

[A note of appreciation goes to Acharya S. and X. Sharks Despot for discovering and transcribing some of this material.]

"Mormon Uranium and the One World Government," August 4, 1978

This morning (July 20, 1978) a press conference was held at the scene of the ordination of Larry Lester, the black minister admitted to the Mormon priesthood two years ago. The subject of the conference was "Mormon Church Infiltration of Government Agencies Suspected of Sequestering Uranium Ore Outside the United States" This press conference was held by the Latter Day Saints Freedom Foundation. In connection with the development of Melody Mountain Ranch, Inc.,—an intended boy's vocational training school to be located at Cornelius, Oregon, in 1958, Charles A. Bean became involved in the acquisition of certain surplus government property. This led to the dismantling of some buildings for resale at the tri-city area in Washington.

During September of 1958, volunteer men working to assist in guaranteeing the supplies of iron ore alleged to be needed in the connection of nuclear reactor cooling processes at Hanford. [Note: Fred Crisman applied for work through the Atomic Energy Commission at this power plant shortly after the Maury Island incident in 1947.] As a result of these efforts several samplings of the ore indicated that hard rock uranium ore was located in Washington state and yellow care uranium in Utah. Through subsequent arrangements, the interests of 20 volunteers contributed to the National Association of Evangelicans—which became involved in backing the Melody Mountain Ranch project, later called Pacific Youth Institute— were exchanged for stock in the Yellow Cat Uranium Co., Utah-based corp., which later changed its name to Trans Pacific Enterprises in 1957.

Simultaneously, then Lyndon B. Johnson (senator) became involved in the uranium discovery through one J.J. McCoy, a fund-raiser who had affiliations with Johnson. Johnson was also a member of the Teamsters Trust Fund Committee at Lubbock, Texas, that was utilized to move money to the [unitelligible] number one endeavors of the National

Association of Evangelicals, made of 30,000 American churches. The Internal Revenue Service eventually became involved due to the reason of some $4,000,000 intended for use by the Pacific Youth Institute backed by the Evangelicals. Bond of ten percent (10%) was deposited against claims, which might arise from non-tax-exempt status of the corp. This bond, deposited with the Justice Dept., was made up of $20,000, some parcels of land by individual owners and subsequently by the Teamsters' Funding. Teamster funding of many other projects was guaranteed by the anticipated proceeds from the uranium production.

The Treasury Dept. and the Securities Exchange Commission were to monitor the activities of all concerned. Ralph Grandquist, an Oregon IRS director recommended to Mr. Bean that he file a Government Conveniency Bankruptcy to secure and preserve for future Americans the file which was developed concerning the uranium. This occurred in late 1958 after the discovery. The file was lost and is not now part of the bankruptcy files. A subsequent file was developed by Mr. Bean, and it also was stolen later!

It began to appear that the CIA was involved, for in 1960, some 15 months before the Bay of Pigs Invasion, by the request that Mr. Bean, who had the authority, sign off on 60 mothball Liberty Ships stored at a Calif. port, ostensibly for use in the Bay of Pigs. Later these ships were used to transport the mined uranium to Australia for refining described as manure/fertilizer. Since virtually all the ore shipped was mined in Utah under the eyes of the Mormon Church, who controls everything that goes on in that state, it may be safely stated that the Church was involved directly or indirectly in the affair. It is of no small moment that the LDS church has infiltrated the CIA and the FBI, and that the special interests of the church have been handled by those church members who had the agencies of government to assist them in the conspiracy.

It is also interesting to note that the Utah Corporation is

also the largest mining and refining organization in Australia. This corporation, affiliated with the Mormon church, was the alleged destination of the shipped uranium. THE OBJECTIVE OF THE MORMON CONSPIRACY WAS TO TRANSPORT THE ORE BEYOND THE CONTROL OF THE FEDERAL GOVERNMENT. THE AVOWED PURPOSE OF THE CHURCH IN ITS SECRET POLITICAL CONQUEST COUNCIL OF FIFTY, WAS TO OBTAIN NUCLEAR CAPABILITY FOR FUTURE USE WHEN IT WOULD ATTEMPT TO OBTAIN WORLD CONQUEST AND SINGLE WORLD GOVERNMENT.

It appears as though President Lyndon Johnson assisted the Mormon Church in this Conspiracy by promoting such projects as "Atoms For Peace," "Food For Peace," and "Water for Peace." By executive order, Johnson ordered the movement into international treaty of one million tons of the mined uranium, which was subsequently shipped to Australia. This order issued in 1966 was violated, in that during three years (66-67-68) all ten million tons of the ore were shipped off to Australia aboard those ships registered to Lady Bird Johnson.

It is a well-known fact to researchers at the LDS Freedom Foundation that Lyndon Johnson had placed in the limousine, two pillows on the floor upon which the Secret Service agents could push him at the moment President Kennedy was to be shot in 1963. It is also known that the pathologist that conducted the pathology on Kennedy has denounced the official pathology report as not being his report, which indicated that several shots penetrated the president's head from different angles. The Warren Commission, appointed by Johnson, has been accused of whitewashing the entire episode.

It is also of no small significance that Lady Bird Johnson acquired numerous FCC licenses beyond normal regulations during this period of time, and further that the chairman of the FCC has always been a Mormon since its inception.

The nuclear capability of Israel has resulted from this conspiracy, which provided for the hijacking of 200 tons of the

ore in 1968. The rumor was widespread in the knowledgeable circles of Salt Lake City that the Mormon Church had arranged to assist Israel in bringing off Armageddon.

Upon hearing of the ore shipments, Lyndon Johnson made a hurried four-day world trip after which he abandoned plans to run for reelection. His death shortly after retiring appears to be a part of the cover-up of the conspiracy along with numerous others involved.

Twenty notes for 1.5 million dollars each are acknowledged to be in a Swiss bank to repay the value of part of the one million tons of ore authorized for shipment. Mr. Bean and an associate, Mr. Robert J. Wright, have filed suit in a federal court in Oregon seeking to make the Treasury Dept. responsible and accountable for the loss to themselves and the National Association of Evangelicals.

Lyndon Johnson was the head of NASA, and Werner von Braun, the Nazi war criminal, was brought to this country, and the atomic bomb and the nuclear capabilities could be moved with the assistance of L.B. Johnson and the Mormon Church. The Mullen Associates in Washington, DC, the public relations firm, had been a non-Mormon account for the Tabernacle tours overseas, yet all Mormons give their business to other Mormons.

But they used a Washington firm, which not only carried the Latter Day Saints Tabernacle around the world, which was s good method of disseminating agents from the tours—but they also funded the Free Cuba Committee (which again is Mormon) and the ships for the Bay of Pigs, and they funded the Mr. Riley of Riley Coffee Co., where Lee Harvey Oswald worked. E. Howard Hunt was the vice president of Mullen Associates, so that Lyndon Johnson, atomic weaponry, the Nazi-Mormon-CIA, had obvious connections. Australia has one-fifth of the world's non-Communist uranium, making it a major supplier. The ore is shipped from the US to Australia and from there to other nations. This is to the thanks of the Mormons.

This all started having steam in 1957, a very important year. That's when Admiral Byrd died; his documents, and the truth of his visits to the Antarctic in 1946, was never published. That was the year of the International Geophysical Year. That was the year that Candy Jones was put into her mind control experiments, without her even knowing it for some many years. It was the year that Lyndon Johnson made great strides for the Mormon cause. Satellites were organizing Earth for the industrialists, launched by NASA, who uses the uranium.

[Note: Some part of the above was taken from a press conference by attorney Doug Wallace.]

"Operation Bernhard," June 2, 1978 *Inquiry Magazine* article by Tad Zule claiming the reason RICHARD HELMS was not prosecuted by Jimmy Carter was because, even though he had committed perjury, (ITT case) it would reveal the CIA connections to the large banks of the world. HARRY TRUMAN was instrumental in calling off the investigations of NAZI money in Swiss bank accounts. OPERATION BERNHARD, the project to counterfeit millions of dollars of American, British, and German currency just prior to the end of WWII could very well be the main supplier of the founding of the BILDERBERGERS in 1954.

MR. TRUMAN was not exactly an innocent bystander in informing the National Security Council or in stopping the investigating of the Nazi money. This was one of the things RICHARD HELMS was in immediate control of because he was instrumental for the sources of CIA money.

MEMOIRS OF RICHARD NIXON—page 33, 1966, his running for Congress. He tells about his letter from Herman Perry, the manager of a Bank of America in Whittier—"Dear Dick, Do you want to run on a Republican ticket? Air mail me your reply. HL Perry." The date is important because he was taken to see Mr. Perry and then to the bungalow of HOWARD HUGHES, and they decided, yes, this is our man. He had already written to the law offices of ALLEN DULLES, had asked to be in intelligence work. When he was in the Navy, he

had written to the FBI asking to be in the FBI.

The fact that he didn't get a response from them doesn't mean that he wasn't hired. His answer came in the form of Perry and Howard Hughes, who contacted him, and he was brought to California to run against Jerry Vorhees. In the book *WANTED: THE SEARCH FOR THE NAZIS,* this same Mr. Perry was instrumental in bringing war criminals to the United States—like the Nazi NICHOLI MOLOXI brought to NIXONs office, and then MOLOXI of ODDESSA went down to Argentina. Nixons first visit to the White House in '47, meeting with Truman who discusses helping restore Europe and esp. German industry. This was to include I.G. FARBEN and munitions makers. THIS CLASS OF '46-'47 was very important. MR. SMATHERS FROM FLORIDA, GERALD FORD FROM MICHIGAN, NIXON FROM CALIFORNIA. Those elected in '46 with the Nazi war criminals, and OSS-CIA officials formed the NATIONAL SECURITY COUNCIL, and then foreigners like KISSINGER AND BRZENSKY come in and run our country. It's no longer run by Americans.

And they could look at the globe and smack their lips and decide how it would be divided.

That was the importance of bringing the German space scientists to this country (that's written up very carefully in the book *OPERATION PAPERCLIP)*, is that the satellites tell you were the minerals, water, oil, vegetation, and population is. And then from this vantage point you can displace people from where the oil is or the minerals you want, and control is either bought or forced to get. The war was over in May 1945, and in Aug. of '45 we dropped the A-Bombs made by Hitler and Oppenheimer (a basket of "pineapples") on Japan to keep Russia from going into those oil fields of Asia any further. Russia had already gone west and they wanted to stop her from going East.

HITLER'S ABOMBS—Some producer has the Nat. Archive documents that prove that the bombs we dropped were Hitler's bombs; there's tape recordings of Mr. Oppenheimer

speaking about those bombs as Hitler's used to end the war and get those satellite scientists over here quickly and get those satellites launched so that monitoring can begin.

The book that has the "Swiss Bank Connection" is by LESLIE WALKER.

This exposé is about the Nazi money in the SWISS BANKS. Information by JIM HOROWITZ , LA, who works with MARK LANE AND DON FREED. They apparently suppressed information on several issues at conspiracy conferences. Jim Horowitz has a newsletter, Vol. 5 #6, about EVIL YOUNGER whose ORGANIZED CRIME COLLECTOR SCHOOL (he ads as a spy czar)—actually an ANTI-TERRORIST RED SCHOOL. Our country is no longer chasing communists; we're doing trade with Russia and China. They are looking for Terrorists, and they will become the excuse to open our mail and break into newspaper offices, survey people, do anything they want under the cover of "TERRORISM." ANACAPA SCIENCES INC.—a mystery firm hired for politically paramilitary-motivated campaigns, to get dissidents. In ZAIRE it is GENERAL MOTORS that is sending in troops. Private corporation's work with the defense department, CIA, so we don't have to declare war and the FBI doesn't have to do half of its underground work. MR. FBI WEBSTER set 80 informers on the terrorists work, but then these private corporations get the money from the government so the FBI can look at you say, "We only have 80 agents on this subject." But ANACAPA, whose cover is organized crime, is to set up NATIONAL—as in GESTAPO—national training schools. They will work with local police officers. HITLER worked with INTERPOL; he had the best police system. It was not only national, but also Vienna, Poland, Hungary, and Rumania, and it became international. SWAT TEAMS are formed under all this and they want more SWAT TEAMS for URBAN COUNTER-INSURGENCY AND MILITARIZATION OF POLICE FORCES, with headquarters in LOS ANGELES.

DARYL GATES of LAPD who was under ED DAVIS. SAN

FRANCISCO where we have CHARLES GAINS, who ran the FBI COUNTER-INTELLIGENCE program in Oakland against the Black Panthers, and then made Chief of Police in San Francisco. Oakland is the third center then.

ANACAPA is linked with the CIA. It shares with them their ANTI-TERRORISTS money; project director is JACK KINNEY of Air Force Intelligence, and a top secret NATIONAL SECURITY AGENCY executive. It also is tied to officers of Navy Intelligence, DEFENCE INTELLIGENCE AGENCY, using reciprocal relations with the CIA. EVELLE YOUNGER's influence reaches through OCCS—ORGANIZED CRIME COLLECTORS SCHOOL—are black unemployed, chicano unemployed; no jobs for them... stealing to get food. Those who are forced to become criminals—these are your "terrrorists." There's going to be unemployment, riots, food-riots, and so on in this country. There are no "terrorists." There's going to be SELF DEFENCE; that's the reason the Panthers started.

YOUNGER works with this OCCS and ANACAPA, but also with a group in Washington DC called the PAA—PSYCHOLOGICAL ASSESSMENT ASSOCIATES—which is a deep cover the CIA'S PROPRIETARY AND HOUSES THAT WORKED WITH BEHAVIOR MODIFICATION-LIKE EXPERIMENTS. You get a DONALD DEFREEEZE working in Vacavile prison in California, working under the DEFENSE DEPARTMENT mind control program of the WESTBROOK (CIA), forming an SLA WHICH BECOMES THE EXCUSE TO BURN THOSE PEOPLE (SLA MEMBERS CAUGHT IN THE HOUSE IN LOS ANGELES ON PRIME TIME TV). THESE SIX PEOPLES' DEATH BECOMES THE INAUGURAL OF THE SWAT TEAMS' BURNING OF "TERRORISTS." BOY, IT'S REALLY GREAT THAT THEY SAVED US IN TIME FROM THEM TERRORISTS UTILIZING THE COURTS!. D.A. BROWNING who prosecuted that case, who still hasn't prosecuted EMILY WILLIAM HARRIS (four years now) for kidnapping PATTY HEARST, IS RUNNING FOR ATTORNEY

GENERAL OF CALIFORNIA WHILE EVELLE YOUNGER RUNS FOR GOVERNOR.

Their links to the mind control programs and one of Younger's laisons in Washington for their PAA (PSYCHOLOGICAL ASSESSMENT ASSOCIATES), works under the cover, or with, a JOHN GETINGER. J. W. GETINGER is an agent who works under the cover of the HUMAN ECOLOGY FUND—known as a CIA conduit. Three years ago, a man went to England and told me to get out of the country at that time. He told me about the radio towers used in SAN FRANCISCO—that is, the use of ELF (extremely low frequency) waves as mood setters for the stimulation of depression or suicides, or epileptic fits to name only a few—to perform mind control on whole cities to break meditations and subdue the populous. He told that an ECOLOGY AND ENERGY CRISIS would be the excuse to eliminate 63 MILLION AMERICANS ACCORDING TO A RAND STUDY. HUMAN ECOLOGY MEANS TO CLEAN UP THE EARTH.

Charles Lindberg was into ecology, and was moving into GERMANY the day the Hitler invaded Poland, and thought maybe it would be bad for the American image and just stayed over in England. ECOLOGY MEANS (according to CIA, etc.), AS HITLER SAID, "BY LOSING WWII WE GET THE MONGRELIZATION OF RACES AND WE LOSE YEARS, EONS OF TIME," because then black GIs went into Germany and married white German women, etc.

Hitler's idea of ecology was the "PURE WHITE ARYAN RACE." The Nazis will work with the Arabs and the Asians to a degree until they have control, and then through STERILIZATION—as in American Indian misfortune—and MASS PROGRAMS OF GERMS AND GENOCIDE, white people such as in SOUTH AFRICA—which was an experiment after WWII, where a handful of whites handle a bunch of blacks. It works. People may object to STEVE BILKO being killed. 33 other men were killed in those prisons last year.

There will be no leaders, a parasol will remain—it's a test

case AND IT WORKS. AND THERE'S NO REASON WHY THESE PEOPLE CAN'T CONTINUE THEIR GENOCIDE policy and that is what is the HUMAN ECOLOGY FUND. All this is from Jim Horrowitz's Newsletter on Evelle Younger's spy network in LA, rather some of it is.

LIFE MAGAZINE article MARCH 26, 1971—(look it up in the library). This is an article on ARMY, NAVY DOMESTIC INTELLIGENCE—(during this time there was hundreds of articles on the government domestic spying from SAM ERVIN's committee—that caught on that Army and Navy Intelligence, FBI CIA, NSA, etc., were engaged in domestic spying. February, March and April newspapers will contain a great deal of info..At first the Army said they were surveying only 7,000 people, then it was 14,000, THEN IT WAS 2 MILLION PEOPLE—ONE FOURTH OF THE US POPULATION UNDER SURVEYANCE IN 1971. This *Life* magazine article on Sam Ervin's investigations contains a page that describes the reason for military surveillance of any US Citizen.

ANYONE WHO:

•WENT TO THE FUNERAL OF MARTIN LUTHER KING WAS IN THE PRESENCE OF WHITNEY YOUNG. He was a black civil rights leader who died swimming over in Africa (from an underwater gun?) recently claimed that he died from a "discrepancy of diagnosis." Under the KING ALFRED PLAN all black leaders were and have been effectively eliminated.

•PERSONS WHO CHANGED THEIR JOBS OR RESIDENCES FOUR TIMES IN THE LAST TEN YEARS. In other words, if you sat on a porch in Tennessee, Iowa, or Kansas or your apartment in New York and weren't curious and didn't leave the office then you were not subversive. If you wanted to see what was going on in this world, if you resisted the draft, dropped out, crossed state lines to find out how they do it in other states, organizations in other states—PEOPLE GETTING IT TOGETHER.

•PEOPLE WHO QUESTIONED AND DROPPED OUT,

CHANGED JOBS AND RESIDENCE WERE TO BE UNDER SURVEYANCE. (FOUR TIMES IN TEN YEARS!) PEOPLE WHO CHANGED THEIR HAIR IN THE PAST TWO YEARS OR HAD SIDEBURNS.

•ANY PERSON WHO PUBLICALLY OBJECTED TO RICHARD NIXON'S STATEMENT THAT MANSON WAS GUILTY EVEN THOUGH THE TRIAL WAS NOT OVER.

(Why should they worry about Charles Manson? Was it because TRW took the Defense Department-CIA contract to fund Manson's bizarre experiment)

•OR IF YOU TALKED WITH AN ANTI WAR RADICAL IN THE '70s.

This is useful to see what was happening around us then, but fits into what is happening right now. The future becomes unfortunately easy to project considering that very little has changed except that Americans are less aware now then in the '60s or early '70s and meanwhile business as usual means HUMAN ECOLOGY programs are the order of the day.

In many respects our present times are no different than in Germany in 1938, except that the techniques to do us in are much more refined and awesome. In the early '20s , just as in the '60s, there was an attempt to educate the public about what was going to happen. In the book *J'ACCUSE, THE MEN WHO BETRAYED FRANCE,* by Andre Simone (1940) a story is told about 200 people in France who, long before WWII (1920s), decide they would go along with this NAZIFICATION OF THE WORLD. THAT THE IMPORTANT THING WAS TO STOP WHAT THEY FEARED—COMMUNISM, either ruling out the church's excuse for existence or to rule out the royalty that Hitler wanted to put back into power, the promise to put royal families back in; or to break up the feudal land holdings of a handful of people.

In ZAIRE you can read how ITT, MOBIL, etc., has divided up the land and booty—which is why we're in war. It's no longer important what it means to send people to die or to kill those black people or whoever.

Americans have the investments for the PLUTONIUM, COPPER, ETC., so we go there to get it and keep it. Just as France was given away, this country is being given away and it's been going on since the Russian revolution when Hitler, the British, and the Italians put Franco into power, and they pushed to collect and save their holdings, tighten their hold, put a satellite up to tell us where the goods are at, and to go in there and fight for it. People are no longer important. That was the importance of the movie *NETWORK*, where the TV personality is told that he's no longer important and that nations are no longer important. ONLY CORPORATIONS ARE IMPORTANT. DOW CHEMICAL, ITT, STANDARD, ATT, MOBIL, GENERAL MOTORS, etc., don't think of countries or boundaries, and have long since stopped thinking about that and being concerned.

Those who can still ask the question," Do I think people in this country are capable of genocide?—One can only say, take the time to ponder who perpetrates and prospers from the 20 million deaths a year from cancers and diseases, from chemicals in the food and water, from starvation, from sterilizations, from microwave pollution, etc., etc., much of which can be traced to purposeful malice and is the reason that there are almost no publications for investigative reporting left in America. This year four or five have been bought out by Rockefeller or gone out of business, and it's not from a lack of things to report or the need to be informed.

"Mysterious Deaths," October 6, 1978

There has been an escalation of deaths since the Senator CHURCH Committee on the Assassinations. Witnesses have died strange or violently. What they would have told us about the assassinations could have been very valuable and we must make the effort to surmise their role in these pivots of history.

FOR EXAMPLE: The House Select Committee stuffed off the notion of Oswald's "double" just because there were six signatures that matched each other; therefore there were no doubles. There were two Oswalds in the Texas School

Depository. SHERIFF CRAIG saw one in the front of the building. He admitted he saw that person in the afternoon in Captain FRITZ'S office. He talked with JAMES HOSTY, and recognized him, the FBI man. And he mentioned RUTH PAINE, whom he lived with and a MR. WORREL saw another one, from the back of the building. James Worrell died shortly after that. SHERRIFF CRAIG DIED ALSO. One Oswald was supposed to have taken a bus and a taxi cab and gone to the rooming house. THE BUS DRIVER, THE TAXI CAB DRIVER, AND EARLENE ROBERTS AT THE ROOMING HOUSE ARE ALL DEAD! So how would anyone know who was at the rooming house? or was one flown out of town? What would these witnesses have said from their vantage points? Those who write these reports from the Senate or elsewhere cannot claim to have the last word on this and other issues because the bodies are piling up.

The last hearing on the assassinations had a woman on very quickly the day before the end, rushed off for 17 minutes the deaths of some witnesses who had died, only up to 1967. She gave their names and put down Penn Jones (researcher), whose 1967 book said that people like Earlene Roberts could have a heart attack, and calcium deposits wasn't a suspicious death. What they didn't say was that Earlene Roberts' sister, BERTHA CHEEK, was at Jack Ruby's home three weeks before the assassination, loaning or giving him about $17,000. BERTHA CHEEK IS DEAD. Passed off very quickly was the fact that a great deal of witnesses have died since 1967. Not mentioned, but very important, were Dr. GREGORY— necessary to describe the wounds in Connelly's wrist; DR. MORTON HELPREN, chief medical examiner of New York City, wrote a section of *WHERE DEATH DELIGHTS* (1967) blasting the Warren Commission—a critique of the methods and doctors of the Kennedy autopsy. He was replaced by Dr. Michael Baden who was then used to testify about the bullets and wounds for the House Select Committee. Sounds too very familiar to Los Angeles and the effort to discredit THOMAS

NOGUCHI, WHO WAS FIRED AND REPLACED BECAUSE A CORONOR, WHO LATER TURNED OUT TO BE A FRAUD, WAS DECLARING JUSTIFIABLE HOMICIDE ON CADAVERS THAT WERE IN FACT MURDERS AND NOGUCHI EXPOSED THEM. Note that it was doctors or lawyers that claimed "justifiable homicide." Likewise, Dr. Helpren would have some very pointed things to say, were he alive.

The secretary of the Embassy in Mexico, the Cuban Embassy, was killed in a car crash. She was replaced by a suspected CIA agent, SILVIA DURAN. When Oswald goes to Mexico, Sylvia is there to say he's been at the Agency. Here's a witness who says that it was absolutely Oswald, not a double. Two days after the JFK killing, Silvia was removed and held in protective custody by Mexican police.

LYNDON JOHNSON was informed of the plot to kill Fidel Castro, the use of organized crime and the CIA, and when Lyndon Johnson said we have a "Murder Incorporated in the Caribbean" he sealed his death. Three months later he was dead. With him at that time was MIKE HOWARD, the secret service agent who was with Marina Oswald at the time of the assassination and took care of her.

HOMER CLARK—a big part of the hearings involved him, who wrote for the *National Enquirer* 1972—alleged to have seen Castro and talked about the plans to kill Castro and that Castro was to have retaliated and killed Kennedy and this was published in the *Enquirer*, which is owned by a man from the CIA (POPE). Clark is dead. The story, according to Castro, was planted as a provocation to blame him for John Kennedy.

When Richard Helms, former CIA chief, was questioned about Oswald's Navy Intelligence work, he said, "Why ask me? Call Navy Intelligence." And he threw out the name RUFUS TAYLOR and he mentioned that Taylor just died last week. He was a very important witness who died a week before Helms was to testify. RUFUS TAYLOR, Annapolis grad, studied in Japan from 1938-41, native of St. Louis Mo., was with General

MacArthur after the war in Japan. Assistant Chief of Staff For Intelligence for the entire Pacific fleet, he was in Japan from 1941 to 1959 in NAVY INTELLIGENCE at the time that Lee Oswald was over there in 1959 in the Philippines, and Atsugi Air bases, U2. He (Oswald) served in the Marines with TOP SECRET security clearance at the time that Rufus was Pacific Intelligence chief. Oswald went to the Soviet Union and Rufus went to Washington DC.

Oswald said, "I'm going to give away Radar secrets." Rufus then became the DIRECTOR FOR FOREIGN INTELLIGENCE IN THE SOVIET UNION. Rufus was director of NAVY INTELLIGENCE in 1963 and up till the time Kennedy was killed; 1963-66. In 1967-69 he became Deputy Director of the CIA, #2 post under Helms. These were the years that PERMINDEX and the international cartels were working along with the SOLIDARISTS—the WHITE RUSSIAN COMMUNITIES, the SYNDICATE, the gaming, the FBI, the PENTAGON, (DIVISION #5 FBI) described in the TORBITT DOCUMENT [Note: Adventures Unlimited Press published the Torbitt Document under the title *NASA, Nazis & JFK* in 1996] as behind all these assassinations. The fact that Rufus was not called until he was dead is baiting the issue a little too much. These murders are concealed not for the shame or disgrace of what transpired, BUT BECAUSE OF THE FUTURE PLANS THAT WOULD BE SPOILED.

THOMAS KARAMESSINES—another important man, he died Labor Day just before his name was mentioned in the September session of the Select Committee. At Senator Church's committee on Intelligence Activities, his name comes up under the opening of the mail sections. He had legal training, and was CHIEF OF THE CLANDESTINE SERVICE WHEN OSWALD WAS IN THE SOVIET UNION. The committee asked him why he didn't tell the Justice Dept. or the FBI about opening mail; the FBI is in charge of domestic security, the CIA is not supposed to be opening the mail. But the CIA didn't tell the FBI that they were opening the mail or why.

Thomas died in Canada and there wasn't any mention of it in the papers. Yet he was responsible for the mail openings while Oswald was a defector in Russia.

DOCTOR MILTON HELPREN—he tells in his book *Where Death Delights* about performing over 60,000 autopsies; 10,000 gunshot wounds. And he talks about Commander Humes who had only done medicine in peacetime, or BOSWELL who had no expertise in forensic pathology, Col. FINKE, who said he only did 200 autopsies for Germany, two of which were bullet cases; and present at the autopsy was the Surgeon general ADMIRAL GALLOWAY, COMMANDING OFFICER OF THE NAVY; CAPT. JOHN STOBER, Navy medical school. No one probed manually for a bullet that was in JFK; they didn't use the X-rays or the photographs, and that there was secrecy is a truism. In 1967 there was secrecy on the X-rays and the pictures and it still goes on. Doctor Helpren died March 28, 1978 while lecturing in San Diego.

HOMER CLARK, writer for *Enquirer*, was another death of import. His quote from Fidel Castro, "It's possible that I could have saved Kennedy, I might have been able to, but I didn't. I never believed the plan would be put into effect. I thought Oswald must have been a nut." The implication here is that Castro knew beforehand that Kennedy was going to be killed. Then the House Select Committee answers back, Mr. BLAKEY saying "that this article is not without some substance. Clark may never have interviewed Castro as claimed, but the substance is supported by highly confidential but reliable sources available to the US government (from the Defense Industry Security Command, ORNSA, CIA, DIA). ALLAN BLANCHARD—he died in Washington, DC at the time of the hearings Sept. 18, 1978. He was 49, from Detroit, chief of the Washington bureau of the *Detroit News,* he had a good nose for news, at the right place, at the right time; in the south for civil rights, the Dominican Republic, the trial of Jack Ruby, an award-winning journalist. HE DIED OF LEGIONAIRRE'S DISEASE! Only known person to die of that disease in

Washington, DC.

THE LIST GOES ON. 123 people who died directly connected with JFK.

MANUEL ARTIME—(anyone who died in 76, 77, 78, is primary witness because the decision to open the hearings was in 1976—DEAD, '77, member the CIA ASSASSINATION TEAMS, WORKED CLOSELY WITH ANTI-CASTRO CUBANS, STURGIS, HOWARD HUNT.

CHARLES BATCHELOR—ASSISTANT CHIEF OF POLICE IN DALLAS, escorted Oswald down the ramp when he was killed.

ALAN BELMONT—DEAD AUG. '77. FORMER ASSISTANT TO J. EDGAR HOOVER (FBI). He worked with the Warren Commission. and his name came up at the recent committee.

EDDIE BENAVIDES—His brother was witness to the Tippit (police officer) murder, he was shot in the head, the killer never found.

GUY BANISTER—An FBI partner of Robert Mayhew in Chicago, went to New Orleans to set up office back behind where Oswald worked. (Note: Banister worked for the FBI in the Tacoma region during the time of the Maury Island incident, along with Jim Garrison.)

JACK BEERS—He took the picture of the tramps at Dealey Plaza. The question of whether or not they are E. Howard Hunt and Frank Sturgis has not been resolved. [Note: Maury Island figure Fred Crisman also may have been one of the tramps. See reference below.]

MARY BLEDSOE—The woman on the bus with Oswald after the killing, also rented a room in her house to him previously.

ALLAN BLANCHARD—Newsman who covered the Ruby trial.

ALBERT GUY BOGARD—A witness to the JFK assassination; a man from the Lincoln-Mercury car agency who said Oswald had been there and wanted some kind of car

(getaway type).

HALE BOGGS—Of Louisiana, died on a plane in Alaska, a member of the Warren report, putting together pieces of the Watergate-Kennedy Assassinations.

LEE BOWERS—A witness from the over pass/grassy knoll area of JFK kill.

BABUSHKA WOMAN'S HUSBAND—She was a witness on the grassy knoll, her husband was a part of the Crime Syndicate in Texas.

DANIEL BURROS—HEAD OF THE NAZI PARTY IN THE US (with Rockwell) His name was in Oswald's notebook.

JOE COOPER—writer for *Tattler*, now out of print, made important links of the JFK-Baton Rouge connections to NAVY INTELLIGENCE.

ROGER CRAIG—Saw Oswald leave in Michael Paine's car in Dallas at the front of the book building.

FRED LEE CRISMAN—DEAD 1975, from the CIA—DEFENSE AGENT DISGUISED AS A PREIST ON THE GRASSY KNOLL, HIS PICTURE WAS RECOGNIZED AT THE HOUSE SELECT COMMITTEE. Home base was the Boeing Aircraft Company in Seattle.

AUSTIN COOK—Minuteman ran a drive-in in Dallas, familiar with officer Tippit.

MARIE CALLAS—Opera singer, died September '77, she was going to write a book to "tell everything I know about Onassis." Onassis had links to Germans (Nazis), reported to have a blueprint for the assassinations. The whole Onassis, Aristotle, Alexander, and Rincallah died because of WHAT they knew about JFK.

CHARLES CABEL—Former CIA official, dead 1971, in charge of the Bay of Pigs went to the hospital for a routine check and died. He had been fired along with Allen Dulles from the CIA by Kennedy (J), his brother was killed.

ROSE CHERAMI—Employed by Ruby who hinted there was a conspiracy, dead from terrible automobile accident.

JAMES CANDIGAN—Firearms expert who testified before

the Warren Commission.

HENRY CARTER—knew of Ruby's connections in Dallas-Ft. Worth close to Hank.

JAMES CHANEY—escorted JFK to Parkland Hospital, a Dallas police officer, saw Kennedy struck in the face, but never called as a witness.

WILLIAM CHESHER—had information on Oswald and Ruby.

BERTHA CHEEK—offered Ruby money, sister of the rooming house. Landlord of Oswald, who is also dead.

DR. NICHOLAS CHETTA—Did autopsies in New Orleans on David Ferrie, Robert Perrin (another victim), given truth serum to Perry Russo, Garrison's witness after he arrested Clay Shaw.

JOHN CRAWFORD—close friend of Ruby and Gil Frazier who drove Oswald to the Texas Book Depository the morning of the assassination, and was instrumental in getting the job for Oswald.

PROF. H. DE LAUNE—brother in law of Dr. Chetta in New Orleans coroner's office, had information on the assassination and died a suspicious death.

ELADIO DEL VALLE—friend of David Ferrie also worked with Anti-Castro Cubans, CIA; the same day Ferrie died in New Orleans, Valle died in Miami.

GEORGE De MOHRENSCHILDT—Dead March 1977. Contacts with CIA, DIA, the Nazis, the Rockefellers, Oswald's control agent, the "China Man."

DONALD DONALDSON—Dead Dec. 1977, associate of George DeMohrenschildt, information of the plot supposedly linking to Rockefeller connection.

SHEFFIELD EDWARDS—Dead 1977, after appearing before Senator Church Committee.

J.M. ENGLISH-Headed the Forensic Science Lab 1966 (and '63) the FBI lab, dead in 1977, so new experts could be brought in.

CLAYTON FOWLER—Ruby's defense lawyer, there at the

polygraph test, died.

DAVID FERRIE—Del Valle and Victor Marchetti; CIA.

CARLO GAMBINO—Dead '75, syndicate family worker, military CIA gunrunner.

EARL WAYNE GARNER—Suspected witness of Tippit murder, threats on his life by Dallas police officials, dead 1970.

MAURICE BROOKS GATLIN—CIA, FBI, Guy Banister, PERMINDEX, was familiar with people named in plans to kill Kennedy and De Gaulle. Fell out a sixth story window in 1964.

SAM GIANCANA—Part of CIA team with Robert Mayheu assassination team, died just before he was to be called before Senator Church's committee.

DAVID GOLDSTEIN—Was the man who traced the weapon used to kill J.D.

Tippit. dead 1965.

JESUS GONZALES CARTA—Worked with anti-Castro Cubans, given $200,000 to kill the president of Costa Rica, part of the assassination team.

ALEXANDER GUTERMA—Dead 1977, white Russian exile involved with the Gehlen operation (Nazis) and George DeMorhenschildt.

BILL HUNTER—A reporter in Ruby's apartment, was there November 24, 1963, dead.

TOM HOWARD—Ruby's first attorney. He was seen in the basement when Oswald was shot.

WILLIAM HARVEY—CIA provided the weapons for killings of the assassination teams. Connection links (with Sheffield Edwards) of organized crime and the CIA.

MILTON HELPREN—Exposed the JFK autopsy.

LISA HOWARD—A diplomatic go-between for Castro and Kennedy.

MARGUERITE HIGGINS—Accused the US of complicity in killing Diem, a writer and before the JFK killing was aware of joint conspiracies.

JIMMY HOFFA—Had links to JFK killing, his hatred of them (Kennedys), close with Sam Giancana, Marchello.

S.M. HOLLAND—A witness to JFK killing on the grassy knoll.

WALTER HEADLEY, JR.—Who made tapes while police chief in Miami on the details of JFK killing three weeks before JFK dead. Plans involved Joseph Milteer.

HOBART HIGGINS—Pilot who flew private planes to South America, could have been involved in a getaway of the Oswald double , and had links to Ruby.

J. E. HOOVER—Dead May 1972 (not soon enough) the White House Plumbers had poisoned him, he knew too much (says Phillip Deago). Certainly he would have the info on William Sullivan's Division Five and the assassinations.

MRS. DOROTHY HUNT—E. Howard Hunt's wife, killed in plane crash in Chicago, at a time when the White House was talking about Watergate going back to the Bay of Pigs, which was a code name for the JFK kill.

HIRAM INGRAM—Friend of Roger Craig.

REV. CLYDE JOHNSON—A key witness to the Clay Shaw trial, made connections of Oswald to Shaw, attended parties where Ferrie, Oswald, and Jack attended, and was to testify before Jim Garrison but Ferrie never made them.

LYNDON B. JOHNSON—Jan. 1973, he did in fact know about the assassination teams of organized crime and the CIA.

THOMAS KARAMESSINES—Chief of CIA clandestine services, dead, September 1978.

DOROTHY KILGALLEN—About to break the story of the JFK killing, she was with Ruby. There's an entire book coming out about her.

HANK KILLAM—His wife worked for Ruby, a close friend of his lived with LEE OSWALD at the rooming house on Beckly Street.

"Disinformation," July 26, 1978

"The CIA Tried To Have Oswald Exhumed,"—Washington Post.

Newly released files show that the CIA, suspicious that the

Soviet Union may have brainwashed Lee Harvey Oswald, sought unsuccessfully to exhume his corpse, to see if his reported 1959 suicide attempt was a Russian cover-up. The CIA considered Oswald's alleged suicide attempt, four years before he killed John Kennedy, one of the crucial points in Oswald's experiences in the Soviet Union, according to a Warren Commission memo made public yesterday through the Freedom of Information Act. The CIA wanted to dig up Oswald's corpse and examine a scar on his left wrist. He supposedly slashed himself deeply October 21, 1959, after being denied Soviet citizenship. The CIA felt that if the suicide is a fabrication, the time supposedly recovering in a Moscow hospital could have been spent by him in a secret police hospital being coached and brainwashed for his appearance at the American Embassy, three days later where he renounced his US citizenship. The body was never dug up, says the commission, and the commission says the CIA made no final judgment whether Oswald's suicide attempt was authentic. Followers of conspiracy theory content that one strong possibility is that Oswald was a Soviet agent when he shot Kennedy. A copy of the memo from one commission assistant, W. David Slaughson, to Arlen Spector, was made available to UPI by Michael Levy, free lance researcher, who obtained thousands of assassination documents from the Freedom of Information Act."

THE ABOVE IS A PRIME EXAMPLE OF DISINFORMATION. E. Howard Hunt was forging documents that could be released later after Nixon completed his election in 1972, to show how Kennedy was not only sleeping with various women, but had also ordered the murder of a man three weeks before he was killed. Neither the Warren Commission nor the Justice Department were deprived of information to find the killers of Kennedy or King. E. Howard Hunt, a CIA agent, along with other persons would be called to testify at the assassination hearings, and Hunt was caught as a forger at the White House. The White House, Pentagon, the

press, the FBI/CIA, were part of a combined effort to deceive the American public. Top State Department papers trusted to the military were delivered to Mr. Hunt along with scissors, razor and typewriter to blame John Kennedy for the murder of Diem. It is the admission of new evidence during the hearings into the Kennedy killings that should be suspect. If FBI agent James Hosty threw Oswald's letter in the toilet after the assassination of JFK he should be indicted for destruction of evidence and for perjury.

The UPI memo above signed by Slaughson—he is the same CIA lawyer on the Warren Commission who took two weeks before the report was published—said they should go ahead with the allegation of Oswald in Mexico, his quote being: "I have fudged the text sufficiently to put in phantom exhibits," a crime of falsification of documents.

Arlen Spector is running for Governor of Pennsylvania. He was the attorney who hid the amount of bullets and the possibility of silencers, did not ask to see the car that Kennedy was in, now sequestered in Dearborn, Michigan at Ford Motor Company. Arlen Spector created the Bullet 399 story, the fabrication of the number of bullets that went through JFK.

This recently released CIA document is false. The CIA did not ask to have Oswald's corpse dug up, in fact they ordered it cremated. And if the Warren Commission had the body of Oswald cremated, then a body was substituted, and not the same Oswald that was in Russia. If any challenged the Commission or the hearing officials to exhume that body now would be the story of the century.

David Lifton documents addendum to the Warren Report: January 21 meeting, for Marina Oswald, called before any of the witnesses were called. In reference to this meeting Chairman Earl Warren said, "We will go to the next item H under Roman #2, the remains of Lee Harvey Oswald, and a letter we received from from Nicholas Katzenbaum, Attorney General.

Now the situation is this, this man is buried in a cemetery

and it takes officers around the clock to watch him and watch that "they" don't come in and exhume him and do something that would further injure the country. No one ever asked Warren who "they" were. Jerry Ford is still a survivor of that meeting. He might know. So it has been suggested that we should save expenses, we should exhume him and cremate him. The mother (Marguerite) says she didn't care how much it cost or what it is, she just won't consent to his cremation. But if anyone took credit for cremating this man we would be in trouble.

Senator Russell: "Do we have jurisdiction in that? It seems to me it would be in the court down there in Texas. I don't see that we would have any right to pass that on." Warren, the same Warren who ordered the concentration camps for the Japanese in World War II: "Well the question might arise as to something on that body. Now, I don't know what it is, it could be in the course of the bullet, or it might be something else. But I don't think we would want that disposed of until the report had been made." There was some question about how Oswald died, that perhaps he ad to be helped to the death state, and didn't die from the shot by Ruby. The Chief Justice of the Supreme Court, Warren, has been told something about the corpse, otherwise why would he make such overtures. "We can't injure the country. The country can't stand another shock." "We wouldn't want to do something until the reports are made," Senator Boggs. "Absolutely not," Senator Russell, "because then they would make a case of it. I thought we might do this. I thought we might get a mausoleum to take the body, and we seal it up and put it in the mausoleum and it would be unknown to anybody else." At the Warren Commission, every secretary was a pregnant CIA woman, or on leave as CIA agent and every stenographer and custodian of the minutes of the report worked for the CIA. "Now the wife would consent to that, and the mother hasn't anything to say about it, if the wife consents. I would have that rather than cremate it or dig it right now. We might get into a great religious controversy."

John McCloy, head of the World Bank, chairman Chase Manhattan, on the Warren Commission, released the bulk of the prisoners from the Nuremberg trials. George Selty, two million files of Nazis were found by the US government in World War II, kept secret. Here it is 1964 and he's continuing the cover ups. "I don't think we ought to have it on the record that we're moving him on this thing. We're not saying anything about it." The steno took it down and it was found in the Archives. Senator Boggs says that even if you move that corpse 20 feet, somebody is going to say that the body has been switched, that it's not Oswald, and you're going to have to drag that body out and take pictures and x-rays. It may take a little extra money to pay a few cops to watch it, but in this case, it's worth it.

Quite possibly the real Oswald was flown out of Dallas to Baton Rouge and then to Brazil to the Nazi colony of Daniel Ludwick, described as a missionary of the Latter Day Saints. Relatives who visited L. H. Oswald in Helsinki before he went to Russia arrived on a military plane. A former Mormon is trying to expose the conspiratorial assassination links to Mullen Associates, a public relations firm who represented the Free Cuba Committee and Mr. Riley, who was receiving money from Mullen and Associates of Washington, DC, hired L. H. Oswald at the Riley Coffee Company in New Orleans.

A helicopter was left for Oswald's escape from Dallas. The escape route is not documented yet. Joe Cooper, *National Tattler*, was doing a big story on the Baton Rouge connections to the JFK assassinations and the Navy Intelligence connections when he was blown to smithereens and killed. *National Tattler* went out of publication after that. This is a very secret story.

The fact that certain witnesses are dead means that Marina Oswald can successfully lie. Because DeMorenschildt is dead. If his wife Jean DeMohrenschildt testifies under oath it will be taken as truth because the man is dead. She put him into Parkland Hospital, where the teacher was given multiple shock

treatments to ruin his memory and induce suicide, and drug treatments, and then he "became suicidal" and "crazy."

There's no accountability of the car to Michigan or the clothes of JFK or Connally. The evidence destroyed and the witnesses murdered should have been investigated before new evidence was pondered. A list of witnesses who have been put in prison or the mental hospital as a result of what they know about the assassination needs to be pursued. Like Mrs. Stevens, or Abraham Bolden or DeMohrenschildt. A list of witnesses who worked for the House Select Committee and lawyers who have been blackmailed and are stopping the investigation.

"Letter to Nixon," May 20, 1973
Dear President Nixon:
My name is Mae Brussell.
Have you ever heard my name?
I have a radio program in Carmel, California called "Dialogue Conspiracy." On this weekly show I illustrate government conspiracies, how they operate, who is behind them.

My background is nine years research into political assassinations and espionage operations.

The purpose of my work was never a negative one, to hurt any particular people or to tear the country apart. The sad situation today was inevitable because truth will come out. To cure a sickness, you have to first diagnose it.

In addition to seeking a diagnosis to America's problems, I spend many hours thinking about the alternatives. That is why I write to you now.

You are sitting almost alone at this point as the head of a great country you loved which needs your help.

I have studied the causes for this tragedy.

I have also studied the cures.

Half or 3/4 of the problems were created by errors on your part.

But you were also the victim and were going to be the victim of a tragedy worse than what took place so far.

While I am pleased to see truths exposed, and all my messages proven to be correct, I would still like to help you.

I understand the history of the Cold War, the 1960s, the 1970s and have given a great deal of thought to all these complexities.

I will tell you what I want to do for you, if you would allow me.

What I want is is to go with you, away some place, like San Clemente preferably, only because I live in California.

Alone, only with your wife and children, I would give you a complete blueprint of alternatives at this point.

As I stated, my work and research is very positive in many, many ways.

I could take you out of the mess in Washington, present a carefully thought-out plan based upon some evidence, to make you the hero you wanted to be. You could finish off your office with dignity. You would not be asked to resign but could establish yourself as the great person you always wanted to be.

The things I would offer you, if you would listen very carefully, would lift you above all this.

Even if there was an espionage squad inside the White House, even if they did everything to assure your election, the problem was they intended to kill you after the nominations. And you could prove, in a hurry, that their necessity to sabotage the government agencies, the CIA, FBI, Justice Department, was to gain control after you are dead.

Now I am a serious researcher, not some person making jokes or scares. I have tapes of all my radio shows, and I speak week after week about the plans they had for you later.

As I say, I have alternatives for you to present to Americans on the streets, minorities, Blacks, Chicanos, political prisoners for you to be able to announce drastic changes, make 180 degree change in your plans and posture, so all would forgive you after the Watergate. They would all realize that you are a

victim, as much as us, of deceit and unlawful plans.

My father is a friend of yours. He has blessed you in the White House.

We don't agree about many political things because I identify with the underdog and he protects the status quo. But you, President Nixon, are the underdog today, and I can help heal this nation while the investigations proceed and you can face the public with a new determination, based upon facts and plans I hold are important for you and all of us at the same time.

Sincerely, Mae Brussell

"Letter To Ford," March 12, 1975
Dear President Ford,
You were a member of the infamous Warren Commission.

You are now in a position of defending these total lies and fabrications or to expose the methods by which public officials are manipulated into the direction of untruths.

[deleted] was appointed by you to head the Rockefeller Commission. As co-worker in this concealment of the conspiracy that murdered President John F. Kennedy, he is the fox guarding the chicken house.

For eleven years I have researched political assassinations.

This is what I want you to do in payment for my years of dedication, and public service to this country.

I want you to provide my transportation to Washington, DC.

Furthermore, I want to sit down with you, and go into all the avenues where the Warren Commission failed, and how they failed.

Then I will tell you where the gunmen came from, how they got out of town, who financed the assassinations. How the witnesses were manipulated.

You attended the Dec. 16, 1963 meeting of the Warren Commission.

You must know that Lee Oswald, 5' 11," who was in the

Marines, and in the Soviet Union, was flown to Baton Rouge, then to Brazil to serve as a missionary three years.

That Oswald had a top secret security clearance, was trained in radar, U2 work, learned language at the spy school in Monterey, California.

I have been in contact with one of the Oswalds, living in the midwest.

Now is the time for me to tell you what I have learned through my studies. Lyndon Johnson, before he died, said, "Oswald didn't kill Kennedy." He mentioned a group in the Caribbean that arranged the murder. It is time you received the address of this place, and how the "missionary" was financed.

If you don't listen to what I say, this will hang around your neck like Watergate did for Richard Nixon. This is the time to come forward, with courage and allow these truths to be exposed.

I hope you will not send me a form letter and pass this off lightly because all I have stated above is true.

Sincerely,
Mae Brussell

12.
THE COM-12
BRIEFING DOCUMENTS

The COM-12 briefing exists as a bit of samizdat connected in form to the Gemstone thesis, although clearly not authored by Bruce Roberts. It also is not likely written by the Kiwi Gemstone author, although it reports on events that build on history detailed in the Kiwi. Danny Casolaro's research resides in the history between the Kiwi Gemstone and the COM-12 briefing, and comprises part of the story in the COM-12.

Nothing in Casolaro's files suggests that he read the Kiwi Gemstone, which lends it some credibility through triangulation of research. The anonymous authors of the Kiwi Gemstone and the COM-12 join the list of independent researchers with widely varying agendas, including Bo Gritz and Daniel Sheehan, who have examined the same history and reached similar conclusions.

The COM-12 Briefing began circulating in photocopied form in 1992. It has as its premise the idea that a faction within the Navy Seal Team code-named COM-12 struggles to restore and maintain the US Constitution in the face of widespread Gemstone-like corruption. The thesis reflects a naïve misunderstanding of the transnational, corporate structure of what Casolaro came to call the Octopus and is clearly a fantasy. The notion of such a factional split within the intelligence world captivated the imagination of spy lorists and conspiracy students, however, and became part of the Casolaro story. Additionally, the events and details of the COM-12 are best examined within the broader context of the book, *The Octopus: Secret Government and the Death of Danny Casolaro* (Feral House, 1996).

COM-12 Briefing
(Activities from 1980 to Present)

The following briefing concerns individuals and events, which are keys in the Continuing Cabazon-Wackenhut venture and related involvements. While some information has become available to a few investigative journalists and research-investigators, the main body of information has been classified.

Dr. John P. Nichols is the first individual of interest as it is he who first approached the Cabazon Tribe, at the request and support of Wackenhut's Special Interests Group known as Wackenhut World Technologies, Inc. (WWT, Inc.), to offer the Cabazon Tribe (Native Americans) his administrative expertise.

Dr. Nichols had formerly been known as a labor worker and was commonly referred to as an 'International Grantsman.' Dr. Nichols was recognized for his ability to raise funds for a whole host of different organizations, all with differing interests and objectives. Dr. Nichols also spent approximately ten years in South America, namely in Chile, Bolivia and Brazil. For one year he even took the position of a Coca-Cola Bottling Plant Manager in Brazil despite the fact he holds no credentials or experience to hold any such position for the company. It is believed this move was made at the behest of the Central Intelligence Agency for a related project under way at the time.

Shortly after this period, Dr. Nichols returned to the U.S. and continued his activities concerning collection of funds for various extra-curricular intelligence activities. At this time, he, along with WWT Inc., took an interest in the Cabazon Indian Tribe. The Cabazon Tribe consists of only 25 Cabazon Indians.

Shortly after Nichols became administrator for the tribe, the Cabazons began opening gambling ventures on tribal lands. These ventures were being observed at the time by special agents with the FBI and ATF because well-known members of

organized crime groups were also becoming involved.

After setting up the gambling ventures at the Cabazon site, Dr. Nichols began traveling around the country lobbying and proposing a wide variety of military interests for military projects. Dr. Nichols' access to Black Operations funds, as well as international arms merchants, led other U.S. Intelligence Agencies to take notice. The projects discussed by Dr. Nichols concerned the research and development of everything from HMX processing to ABW manufacturing. His meetings and business associations were with the top-level personnel in the defense industry and the Pentagon, such as the Assistant Director for Land Warfare for DARPA.

The legal association concerning Indian land grants and Indian sovereignty has for some time been very attractive to some U.S. intelligence interests as well as Black Rose Operations. Black Rose and other intelligence operatives have realized that their non-Indian administration can gain a substantial profit in a business role with the tribe under the cover of Indian sovereign status. This allows them to conduct gambling operations and other activities without the scrutiny of the U.S. Government. These sovereign status rights have left the tribes open to a variety of ills, such as organized crime involvement and intelligence operations infiltration.

Note: 'Rose' is George Bush's code name which has often been 'White Rose'. The rose has been historically a symbol in underground societies.

In addition to gambling ventures, intelligence and organized crime groups have found that there are unlimited opportunities for operation of such activities as Toxic Waste Disposal, Conventional and Biological Warfare Arms manufacturing and a whole variety of other questionable activities. These agencies and groups understand that on tribal lands they are only subject to federal laws, which are either non-existent or much more lenient than state or local laws. They can avoid all the checks and balances of the legislative or other government watch-dogs and will not be subject to U.S.

law so long as the business is conducted within the reservation territory.

The death of journalist Joseph "Danny" Casolaro occurred shortly after he began requesting an interview with Dr. Nichols regarding the Cabazon venture and other subjects. Mr. Casolaro had discovered Dr. Nichols' involvement as an operative in Deep Black Operations.

Part of the operations of illegal activities being documented by a select group of intelligence operatives, as well as a few private individuals such as Mr. Casolaro, was the involvement of these operations in connection to private interests and individuals connected to intelligence groups. One of these groups is Wackenhut.

The Wackenhut Corporation was started by ex-FBI agent George Wackenhut in 1954. The Wackenhut Corp. is involved in everything from regular minimum security contracts up to the protection of some U.S. and private interests with the 'Above Top Secret' security status. The Florida-based Wackenhut Corp. holds very lucrative contracts with such government agencies as the Department of Energy, the State Department and NASA. It is also involved with privatized prison operations and management, recently acquiring new contracts overseas. Wackenhut Corp. has also been increasingly involved in the intelligence field. Its operations of a secret operations group known as WWT, Inc. (Wackenhut World Technologies) are deeply involved in the inter-agency struggle among those who wish to maintain a Constitutional Government and those who wish to abolish it.

NOTE: Parts of the CIA and Naval Intelligence are on BOTH sides of the fence regarding Constitutional government.

The president of the Wackenhut group is Richard R. Wackenhut, son of the founder. The company has developed an array of specialized services, currently providing security and investigative services to private business and government in the U.S. as well as over 40 other countries. Twenty-five

percent of its annual revenue comes from the U.S. Department of Energy (DOE). These DOE contracts range from protection of the Savannah River Nuclear Plant to The Strategic Petroleum Reserve and all the way to S-4 and S-6 classification facilities for the U.S. Government. It also manages the Department of Energy's Central Training Academy (CTA).

CTA is located deep within the confines of Kirtland Air Force Base in Albuquerque, New Mexico. Actually, it is very, very near Dulce wherein highly advanced technological biological experiments are being done in the underground facilities. It provides and maintains security for all U.S. nuclear weapons and components in inventory as well as Top Secret Security Assets. The CTA is assigned to protect 47 national security sites. Between 3,000 and 4,000 individuals graduate from CTA training cycles each year. Their expertise is in the area of SRT skills, Weapons and Tactics, Crisis Negotiations and Management, Dignitary Protection, Sniper Observation Teams, Tactical Leadership, Overt and Covert Surveillance, Fire Team Tactics, Explosives and Explosives Identification, Armorer and Rangemaster Certification, Advanced Survival, etc. SRT work is divided into three levels—SRT 1: Basic Teamwork and Covert Tactics and Intelligence. SRT 2: Planning and Dynamic Counter-intelligence Factors.

The joint venture between Wackenhut and the Cabazon Indians was managed by Dr. Nichols and the Nichols Group. On Wackenhut's Board of Directors is an army of former CIA, FBI, NSA, NSC, ISA and NRO members. The Wackenhut World Technologies Group made several trips to Canada to meet with and attempt to purchase the explosives manufacturing company of Gerald Bull. (Mr. Bull was the designer and seller of the 'Giant Gun' being built by Iraq which was destroyed by a joint U.S.-Mossad Removal Team shortly before our military conflict with Iraq. Mr. Bull was then removed in a hit by U.S. and Mossad operatives.

Wackenhut used Dr. Nichols as its representative to act as a

go-between for dealings between the Canadian Co. and the Cabazon Indian Tribe. During the set up of the weapons manufacturing operations at the Cabazon facility several key players involved in the Contra supply effort appeared in person at different times on the reservation as guests of the Nichols family and Wackenhut. These individuals were present for such things as demonstrations of various weapons and advanced night vision equipment.

The Wackenhut Group and the CTA have handled the security of the nation's nuclear arsenals and highly classified sites since being requested to do so by the Reagan-Bush Administration when it privatized the U.S.'s nuclear arsenal. In some instances, Wackenhut took the place of the elite U.S. Marine Corps Black Beret Guard-Special Operations Units.

An individual by the name of Michael Riconosciuto was taken on by Wackenhut and the Nichols Group as Director of Research. Mr. Riconosciuto has a vast scientific background. Riconosciuto studied under Arthur Schalow, the Nobel Prize-winning physicist who was the co-inventor of the laser. Riconosciuto is extremely intelligent. He has skills in a variety of fields, with an expertise in Electronics, Engineering, and Advanced Computer Technologies.

It was at the Cabazon facility that Riconosciuto received the software package of INSLAW's material known as PROMIS (Prosecutors Management and Intelligence System). The software was borrowed from Nancy and Bill Hamilton (owners and founders of INSLAW company) by the U.S. Justice Department. The Justice Department claimed it was interested in obtaining the program for its department as well as other law enforcement interests. In reality, the U.S. Department of Justice ended up stealing the program.

After INSLAW lent the program to the Justice Department, it was forwarded to Wackenhut and the Nichols Group. It was at the Cabazon facility that Riconosciuto assessed the program and determined what an asset it could be. At this point, Dr. Earl Brian (a Ronald Reagan 'kitchen' cabinet member who

goes all the way back to E. Meese, W. Clark, etc.) and his associate from the Department of Justice, Peter Videnieks, oversaw the operation to copy and altered the PROMIS software and to create a back door access to the various U.S. intelligence agencies which would remain secret. This backdoor group, 92 countries, will find that they have a very compromised system—compromised by the U.S. Intelligence Service—WHEN THOSE COUNTRIES FIND OUT ABOUT THIS LITTLE FLAW THEY ARE GOING TO BE EXTREMELY AGITATED!

Presently, 92 countries have purchased this stolen and altered program. The illegal sales generated hundreds of millions of dollars in revenue. Most of this work occurred at the Cabazon site. Since sale of such intelligence gathering software to a foreign country is illegal in itself, the property of William and Nancy Hamilton was pirated and sold under the approval and management of the U.S. intelligence agencies and the U.S. Justice Department. INSLAW is now defunct and the Hamiltons are in bankruptcy.

The Cabazon reservation is widely scattered on patches of land that stretch over nearly a 10-mile area, a total of approximately 1,700 acres. There are several different parts to this reservation. There is an underground, multi-operational base on the property. The large Bingo Hall and its expanse of 50,000 sq. ft. can be seen off the left side of Highway 10 if headed toward Palm Springs from the West. Clearly visible off Highway 111 is a huge Southern California Edison power plant being developed (a $150 million project). A $140 million housing project near Avenue 52 on the reservation can also be seen. As it has for many years now, Wackenhut runs the security for the underground installation at the Cabazon reservation. For a time, Wackenhut security personnel were even guarding the reservation meeting hall. The hall is a very small building which was paid for by HUD in an interesting use of funds.

Dr. Nichols, as mentioned, was known as a 'grantsman'.

His most recent grant procurement was from HUD in the amount of $500,000 to create a facility to encourage other development in the area. Despite all the wealth that is being passed through this micro-sized Indian reservation, the grant was to be ostensibly used for establishment of an off-track betting operation. Incredibly, an off-track betting facility had already existed for nearly two years when the grant was given. HUD still granted the funds after a personal interest in the grant was taken by Jack Kemp. The $500,000 was given to Dr. Nichols' sons who currently run the Cabazon operations.

Former Senator James Abaresque was also involved with Dr. Nichols and acted as his attorney. Abaresque was a member of the Senate Select Committee on Indian Affairs. He traveled to Iran in 1979-80 under the direction of Ted Kennedy, supposedly to try to arrange release of the hostages. He has very powerful connections in the Middle East—a personal relationship with Arafat, as well as a number of very highly placed Saudi officials and members of the Saudi royal family.

Dr. Nichols had many connections all over the world with parliamentary officials, royal family members, and presidents, as well as Idi Amin. One of the Cabazon-Wackenhut ventures under the direction of Dr. Nichols was the development of an extremely high-tech and highly advanced electronic as well as physical security network for the Saudi royal family, in particular, one Saudi Royal Palace.

An individual by the name of Fred Alvarez, a college-educated Cabazon Indian, opposed Dr. Nichols, Wackenhut and the new gambling ventures on the reservations. After making his opposition well known in the press and the public in 1980-81, he received several death threats. He was voted out of his position as tribal Vice-Chairman of the small, decision-making body of the tribe. A highly placed operative, who is a non-Indian member, flies in privately from Wisconsin for every meeting to act as the group's parliamentarian.

A few months after Alvarez was voted out, he was shot, execution style, at point-blank range, along with two non-

Indian friends. The weapon was a .38 caliber automatic. Although there were grand jury, state and federal investigations involving many levels for over 3-1/2 years, the case was never solved and no suspects were ever named. However, Dr. Nichols WAS convicted of the "Murder for Hire Scheme" regarding the murders of these three individuals.

Joseph "Danny" Casolaro was the second reporter involved with the INSLAW investigations to be murdered within a 30 day period. On July 29, 1990, Mr. Anson Ng, a reporter for *The Financial Times*, was found murdered in Guatemala, although his death was ruled a suicide. A third reporter, Harry Ghouli, also with *The Financial Times*, has gone into hiding.

On the night of his murder, Casolaro's contact met with him in the parking lot of the Sheraton Inn in Martinsburg, West Virginia because Casolaro was afraid to go to his hotel room. The contact was made between the hour of 5:00 and 6:00 p.m., during which he was given 60 assorted documents, in part, proprietary information from a defense contractor (Hughes Aircraft) involving a whistle-blowing operation of immense proportions. At 6:15 p.m., Casolaro telephoned his family to tell them he was on Interstate 81 in Pennsylvania and was heading home for a family birthday celebration. And then, just like Dexter Jacobsen in Sausalito, for an unknown reason Casolaro pulled off of Interstate 81.

Mr. Casolaro had declined to take his contact to his hotel room because he feared the room was bugged. His body was found by a hotel maid in his room. His clothes were found very neatly laid out on the bed. An open bottle of wine was on the bathroom floor, yet NO alcohol was found in the body in the autopsy report. There were eight very deep slash wounds on his right forearm (Casolaro was right-handed), and four were on his left forearm. The autopsy revealed that each of these 12 wounds cleanly severed all cartilage, tendons and ligaments in the wrist—an absolute impossibility if the wounds were self inflicted, yet the death was ruled a suicide. Casolaro also had a large bruise on the upper left inside arm of the biceps. It was

estimated that it took about 20 to 25 minutes for him to die.

Wackenhut Special Services Teams, along with NSA officials, informed the Martinsburg Police Department that they would secretly conduct the investigation of Casolaro's death and the police were to maintain this cover. Within three hours of the body being discovered and before next of kin was notified, it was taken to a local funeral home and embalmed. This happened while the corpse was in the custody and jurisdiction of the Martinsburg Police Department. Casolaro's hotel room was also industrially cleaned. Assisting in the cover-up, the Martinsburg Police Dept. assured concerned family and friends who voiced their suspicions of a murder and not a suicide, that the crime scene was being protected and that no official finding regarding his death had been made.

Michael Riconosciuto is the next one on the list. His wife Bobbi and their children are also in grave danger if Mr. Riconosciuto decides to talk

Charles McVay, involved in the Star Wars Software Scandal and the TOW Missile deal with Iran, is the foremost techno-bandit of the decade. McVay was set up in 1987 in an attempt to bring him back into U.S. jurisdiction. Presently in a hospital in Canada, he has won two cases of extradition against the U.S. and is about to be involved in a third attempt by the U.S. Justice Department. McVay also operated as a deep immersion agent for the KGB since the late 1960s. He is an associate of Michael Riconosciuto.

Riconosciuto was a CIA operative who wanted OUT of "The Company." He contacted Mr. Hamilton of INSLAW in May of 1991 and fed the Hamiltons classified information on "The Network" and its operations and how they had screwed INSLAW. Riconosciuto called the Hamiltons from pay phones—anonymously (or so he thought). He was actually being watched and tracked by a Special Intelligence Assignments Group. He soon realized his life was in danger.

On March 21, he did what is called an "Outing" by authoring and signing a statement which was COMPLETELY

DEVASTATING to the U.S. Government. In the document, he detailed that the U.S. Government, specifically the CIA, was using Indian reservations as sovereign nations to manufacture and produce arms of high sophistication as well as general arms to support the Nicaraguan Contra effort.

BLACK ROSE ORGANIZATION

The Black Rose Organization originally funded the 'Black World Order' with proceeds from two areas. One, in Southeast Asia, is known as the Golden Triangle. The other area lies on the border of Iran and Iraq, and between Iran and Afghanistan and is known as the Golden Crescent. The drug-proceeds from these two areas wound up deposited in Nugan-Hand Bank in Australia after Dr. Earl Brian carried the bank codes out of Southeast Asia using formal diplomatic immunity. In Australia countless banks and persons were ruined when two operatives by the names of Frank Nugan and Michael Hand went into action. Frank Nugan was later "terminated" (listed as suicide). Michael Hand fled Australia with all the money from this so-called Black Fund.

Hand is currently the most-wanted individual the Australian government has it sights on. He is living in the Middle East under the protection of an Islamic group by the name of the "Gray Wolves" which is in a strange way connected to the Black Rose who were behind the last assassination attempt on the Pope due to mind-control operations used on the unwitting victim (attempted assassin). This Black Fund next surfaced in Honolulu at BBR&W (Bishop, Baldwin, Renwald & Wong) before it disappeared again.

Michael Riconosciuto is the son of Marshall Riconosciuto, a former business partner of Richard Nixon. Marshall is a former long-time business associate and very close friend of W. Patrick Moriarity. In 1985, Moriarity was sent to jail for bribing government officials. To illustrate their involvement, in 1984, Moriarity and Marshall Riconosciuto filed bankruptcy on

a corporation they both founded known as Pleasanton Properties. Along with their personal attorney, Henry Baer, they had purchased a 940-acre stretch of canyon land. Previously owned by Sinbad 720 of Honolulu, the property was a political front. Mr. Moriarity had obtained a loan of $1.3 million from California-Canadian Bank based only upon his signature. When he got into the financial difficulty with Pleasanton Properties, a deal was struck with the East Bay Regional Park District with a letter of credit. Subsequently, $1.6 million in profit was laundered through to Moriarity as he sat in prison.

The largest white heroin bust in history occurred in Hayward, California and is partial proof of the scale of the involvement. The Chang family was all arrested and cars, homes, boats, and properties were all seized by the DEA. However, no one seized the warehouse in which the drugs were found because the warehouse was owned by Bedford Properties. Peter Bedford and his wife Kirsten are also known for Kemper Life Insurance out of Chicago. Despite the fact that everyone knows that new federal law states that the DEA and the Federal government immediately and automatically seize ALL property in and on which illegal drugs are found, it was not done in this case.

Casolaro's phone conversations, which were being monitored by the intelligence team assigned to him, revealed that one week prior to his death he stated to close friends that, whereas he had always denied any belief that the U.S. Government was involved in drug sales to support its covert operations, he was suddenly CONVINCED IT WAS TRUE.

The House Judiciary is at this time in possession of documentation supplied by Michael Riconosciuto which contains incriminating evidence of some of these operations.

Getting back to the aforementioned BBR&W of Honolulu, the next phase of the Black Fund's annihilating effect was to heavily hit investors in the Northern California area. The

money again disappeared. The people that had invested in the general partnership lost everything they had. The U.S. Government refused to help them seek restitution. Renwald went to jail for a very short period of time. Renwald was also a victim of "suicide" by slashed wrists, but he managed to survive.

Anson Ng, the reporter who was killed in Guatemala, went there for two reasons. He was attempting to trace the Black Fund, which now reappears with the BCCI incident. Also, he wished to make contact with an eyewitness to the CIA triple execution at Rancho Mirage who happened to be a bag man for the money. This man was James "Jimmy" Hughes who had fled to Guatemala when he learned that a contract or a sanction had been placed on him by the family in charge of the Cabazon Indian Reservation, namely the John Peter Nichols family. John Nichols' father, Dr. John Philip Nichols, was formerly involved in the hit of President Allende of Chile and was also an associate of G. Wayne Reader, a CIA operative involved in the Silverado Savings and Loan fiasco along with the President's son, Neal Bush. G. Wayne Reader and Neal Bush were also involved with the now insolvent San Marino Savings & Loan. Reader was also the owner of the Palm Desert Golf and Country Club.

Jimmy Hughes, the bag man for the money for the triple execution of Fred Alvarez and his friends, fled to Guatemala after a lawsuit was filed against him by G. Wayne Reader alleging that Hughes had made an attempt on his life.

An operative helped Jimmy Hughes, taking him into safety. This operative is also currently in hiding. This individual is closely connected to the downfall of Sid Shaw and Centennial Savings & Loan. This debacle resulted in the "unexpected death" of Mr. Hanson and the brief but illustrious life of Beverly Haines. Beverly Haines had accrued many enemies, two of whom were involved with the U.S. Justice Department. One was former U.S. Attorney Joseph Rucinello and the other was former Assistant U.S. Attorney Peter Robinson. The

Centennial Savings and Loan fiasco also links former Congressman Doug Bosco.

Joseph Rucinello and Peter Robinson had filed a complaint with the Justice Dept. in 1986 regarding the misconduct of a man by the name of Charles Duck. Duck was bankrupt in 1968 and was later appointed by Conley S. Brown, the now-deceased judge from Eureka, to become a bankruptcy trustee. Mr. Duck is currently in the Sheridan Federal Prison in Sheridan, Oregon serving time for the largest embezzlement by a bankruptcy trustee in U.S. history. His attorney is the aforementioned Peter Robinson who was the Assistant U.S. Attorney investigating Centennial Savings & Loan. Robinson personally apologized to Beverly Haines for having to convict her. But he also was appointed, in direct violation of the "Revolving Door Policy," by Marilyn Hall Capell to represent one of the largest drug dealers from the Colombian Cartel. His client, Mr. Pasera, received a 40-year sentence.

A reporter by the name of Virginia McCullough contacted the Justice Department to make inquiries and request an investigation as to why Peter Robinson had been assigned these Investigations in direct conflict with the "Revolving Door Policy." She also wrote a letter to the House Judiciary at that time because she and her husband had met with members of the Justice Department on August 15, 1989. At that time, they were told to cease and desist or it could get violent. Needless, to say, they were outraged.

On August 30, Mrs. McCullough and her husband were returning to their home in Alameda County after stopping at a McDonald's to get dinner for the family. As they pulled into their isolated property, they witnessed a man run out of the back door. When he saw them, he ran back into the house, which he had already set on fire, ran past her children and out another door. At this point, a car abruptly pulled up, the man jumped into the passenger side and the car sped off. The McCullough children were uninjured but the house did bum completely due to its isolated location. Mrs. McCullough riled

complaints with the Alameda Sheriff's Office, as well as writing letters to the U.S. Department of Forestry (who extinguished the fire), the U.S. Attorney, and the FBI. Nothing was done regarding her complaints. Dexter Jacobsen, whose body was found in August of 1989 in Sausalito, was investigating corruption in the federal bankruptcy system and reporting back to the FBI about it. He was found by John L. Mullinari who ran for mayor of San Francisco in the last election.

John Mullinari and the Trioni Brothers managed to tie up all of Mr. Duck's assets. Mr. Rucinello is fighting to keep from giving one dime of the bond money to any victim. Their companies have successfully disallowed or tied up in litigation any repair to the bankruptcy victims for the rape of their assets by Charles Duck. At this point the Justice Department had been hearing complaints from many hundreds of victims of the Savings & Loan Scandal for four years. A woman by the name of Susan Uecher was the successor trustee in one bankruptcy involving a man named Bill Connely. Susan Uecher, on four separate declarations and as a matter of court record, threatened the life of Bill Connely if he were to set foot on his own property. The threat to his life was actually recorded by a woman by the name of Betty Ann Bruno of KRVU when she and her news crew accompanied Connely to Oregon as he attempted to set foot on his property.

There was one individual in all of this who apparently was an honest man. He is a U.S. Bankruptcy Trustee who was placed there to "clean house." His name is Anthony Souza. When Mr. Souza tried to clean house, he was called back to Washington and was met by several CIA officers and Justice Department officials. He was told that they didn't want things "quite that clean." They then shut him down. They did this politically by removing his personal assistants—assistants he had worked with very efficiently and well. This was also accomplished by putting moles into his office and eventually calling him back to Washington and telling him to "shut up."

In court, Mr. Robinson, representing Duck, stated that his client had passed the polygraph test when he denied mismanagement of funds. For the record, Judge Souza said HE DID NOT. Although the polygraph results were never resolved, Duck was sentenced to 2-1/2 years and shortly after went to prison. Through his sources, Casolaro had obtained the "declaration" written and signed by Michael Riconosciuto. Riconosciuto, through third parties, had managed to supply enough documentation to back up some rather preposterous claims. After reading the material, Casolaro realized to what extent things really were involved. Casolaro had received 60 pages of whistle-blowing documentation on a major defense contractor. The material was "repossessed," that night by the assignment team from NSA and Wackenhut.

In April of 1991, the House Judiciary Committee met with Riconosciuto in Washington and afterward asked him for proof of his credibility by supplying them documents. Riconosciuto requested the documents in question from his attorney and asked that they be clearly marked 'Lawyer-Client Privilege'. By law, this is the only type of mail which is completely exempt from search and seizure by any government entity. When the documents were received by the jail in which Riconosciuto was incarcerated, jail officials admit they opened the documents and then refused to forward any of them to Riconosciuto. They immediately contacted the NSA which sent out a team to review the material. As of December 1, 1991, the NSA still refused to comment on when the documents would be forwarded to Riconosciuto.

One of Riconosciuto's associates who had managed to send him this material had in the meantime contacted a couple of attorneys. One of these attorneys was a very high-profile attorney by the name of Dennis H. Eisman. Eisman, also known as the 'Fatal Vision Lawyer,' was the attorney in the Jeffrey McDonald case. Eisman was scheduled to come out to meet with a third attorney and visit Riconosciuto at the Pierce County Jail in order to represent him.

Wackenhut and the CIA became extremely irate over this arrangement. Shortly afterward, Eisman was found shot to death in Philadelphia, from a single bullet to the chest. Before the story of his death went public, the government issued an Associated Press report announcing that the Justice Department was going to bring down indictments against Eisman and other named attorneys for money laundering and dealings in narcotics. It could therefore be assumed, the story continued that Mr. Eisman had not been killed but rather, feeling cornered and quite despondent had killed himself in the basement of his office's garage, sitting in his car.

The indictments were phony—they never surfaced and no one has bothered to follow up on this. Eisman had been scheduled to fly to Seattle to meet with Riconosciuto the day after his death. Knowing this, the team searched for and removed Eisman's plane tickets to Seattle as well as Riconosciuto's documents.

At this point, Peter Videniecks of the Justice Department, who had served as Contract Officer on INSLAW, threatened Riconosciuto. Videnieks told Riconosciuto that if Riconosciuto were to continue to cooperate with Jack Brooks (Congressman), the House Judiciary and the INSLAW people, he would be indicted along with his friends from Los Angeles. One of these friends Videnieks was referring to was Mr. Ferrante of Consolidated Savings & Loan. There had been an attempt on Mr. Ferrante's life, which was very nearly successful. In the first reports that he gave to the police, Mr. Ferrante indicated that he felt it had been an attempt by the Israeli Mafia.

In tracing the $40 million that was paid in the "October Surprise," we come to Alan Michael May. May, a former Nixon campaign financial aide, wired the money to the Iranians in October of 1980 as a down payment on the hostage deal. On Wednesday, June 19, he died of an apparent heart attack despite the fact he was 50 years old and in perfect health. His death occurred four days after the Napa Sentinel

reported his connection to the October Surprise. On June 14, May told relatives that he had been threatened and he knew his life was in danger. In a phone conversation with Riconosciuto, May was recorded telling Riconosciuto to "Sit on your fat Italian ass and keep your mouth shut, or we're all going to be dead."

In Alan May's case, his autopsy report released on July 26 stated he died of pulmonary failure, with complications of diabetes. Also listed as a contributory cause was polypharmaceuticals or many drugs in his system. A cross reference with the drugs that had been prescribed to him brought to light the fact that these were not the only pharmaceuticals found in his system.

In every one of these deaths there is one common factor—the residence is broken into, their computer banks are raided and personal notes, diaries and files are confiscated. In the case of Dexter Jacobsen, two days after his death his office was broken into twice and his apartment once. In Anson Ng's case, the ISA instructed the Guatemalan government to retrieve the floppy discs and his personal papers regarding his investigation. It did so and turned them over to a U.S. intelligence agency. In a press conference a few weeks later, Senator Alan Cranston requested that these items be returned but they have not. After the killing of Alan May, Riconosciuto was told that his wife and children were in grave danger.

The 1981 government contract-hit of Fred Alvarez and his friends occurred in Rancho Mirage. Alvarez had been working for the Nichols family, specifically, for the senior Nichols in the security field. In 1985, Linda Streeter, Alvarez's sister, contacted 20/20 and managed to get Geraldo Rivera and Barbara Walters to do an investigative report on the situation. During their report, Rivera and Walters detailed the changes of the Indian laws which resulted in the control of the reservations by non-Indian business managers. After 20/20's report, Governor George Deukmejian reopened the investigation of the three murders for hire.

The man in charge of the investigation was a detective with the Riverside District Attorney's office by the name of Gene Gilbert. As a result of the investigation it was determined who had ordered the execution and how much money was paid for the hit. However, the investigators were never able to get an indictment handed down from the Grand Jury due to extreme pressure from the NSA through the Justice Department.

During the investigation, when Detective Gilbert made repeated requests to interview Riconosciuto, they were always denied. Because Riconosciuto was being prevented from seeing an attorney and therefore had no legal representation, he could not get or have access to his papers or files and was even denied access to a law library to defend himself. Thus, he decided to work through people in the media. At that particular time, the Justice Department shipped him out to the Bureau of Prisons facility in Springfield, Missouri for Mental Competency Hearings. While in Springfield, several of the media people who had become involved made arrangements for Detective Gilbert to fly to Springfield to finally obtain an interview with Riconosciuto. When the NSA found out about the proposed interview, they quickly flew out a U.S. Attorney who stopped the interview after only 45 minutes and immediately had Riconosciuto flown back to Washington.

The NSA and Wackenhut then proceeded to determine exactly what information had been discussed during that 45-minute period. What they found out tied the noose on Riconosciuto's life line. Riconosciuto had revealed which Wackenhut operative had acted as the primary triggerman in the Alvarez murders.

Riconosciuto is now back in Tacoma, Washington at Pierce County Jail. He is being held in solitary custody to prevent him from talking to anyone. He is in grave danger because the Bureau of Prisons has repeatedly ignored and then refused attempts by Riconosciuto family and friends to get him medical equipment needed to sustain his life. This is due to the fact that he is very obese and suffers from the condition known as Sleep

Apnea, which requires a machine to trigger breathing at night, should the sufferer stop breathing. The Pierce County jail authorities have repeatedly denied allowing this necessary medical equipment to be brought in.

Dr. Earl Brian never finished his medical internship at Stanford University, quitting a full quarter short of completing it. Despite this, he went on to serve under then-governor Ronald Reagan. He identifies himself as a neurosurgeon. This is a falsehood since he never finished his internship, let alone residency.

The Cabazon "business Committee" of which Alvarez was a member until his death, is very closely controlled by an attorney by the name of Glen Feldman who resides in Phoenix, Arizona. Prior to this position, Feldman was the business partner and law partner of the aforementioned Senator Abaresque from South Dakota, who is now retired and in private practice. Senator Abaresque acted as a representative for both the Iraqi and the Iranian governments. Abaresque and Feldman also worked together to help draft the 1978 revisions to the Bureau of Indian Affairs laws which have been so resented by the Indian communities of the nation.

Linda Streeter and the Indians who have joined her cause to have her brother and his friends' murders investigated have now been officially labeled as dissidents by the Justice Department and the federal government. The three Wackenhut security members involved in these Rancho Mirage executions were themselves done away with in a Helicopter Crash which occurred on the Groom Range (Area 5 1) of Nellis AFB, Nevada.

One of Casolaro's contacts was an Alan David Standorf. Standorf was one of Casolaro's main suppliers of documents that directly exposed the government's connection to Savings & Loan failures, international drug smuggling, bank scandals, and Mafia ties. The NSA and NRO employed Standorf in a very restricted and sensitive Secret Communication Center. At the center he could listen to and intercept message traffic

(crypto & codex) from the intelligence community.

Casolaro and Standorf had set up a Nerve Center for operations involving the duplication of sensitive documents. High-speed Xerox commercial duplicating and collating machinery was installed in Room #900 of the Hilton Hotel in West Virginia to provide Casolaro copies of all documents and to allow Standorf a location and time to return the documents back to their original storage files.

After Casolaro's murder, Standorf's body was found in the rear seat of his car, under luggage and personal items, at Washington's National Airport. He died from a massive blow to the head. Riconosciuto, a primary electronics expert for the U.S. intelligence community, was arrested seven days after providing Congress with testimony in the INSLAW case. When his attorney Dennis Eisman was to have picked up critical information in the case which was destined for Casolaro and Riconosciuto, he was found shot to death. Some of the individuals and companies Casolaro was following leads on at the time of his death are: Dominic and Bob Balsano, Gemini Industries, The Papago Indian Tribe, the Menominee Indian Tribe, the Cabazon Indian Tribe, The Primerit Bank of Nevada, BCCI and 312 other related financial institutions, Dr. Earl Brian, Peter Videnieks, Community Banking of Southern California, Home Savings and Loan of Seattle, Theodore Strand, Robert Booth Nichols, ...

Casolaro was also investigating the links between the deaths of Indians and journalist Don Bolles who was killed in a car explosion in Arizona in 1976. (In 1980, a jury found John Harvey Adamson guilty of first-degree murder in the death of Bolles). Also being investigated by Casolaro was the gold & platinum smuggling that came from Southeast Asia, through Mexico and then through the Papago Indian Reservation in New Mexico. This was done through a "clearance corridor," which, due to an inter-agency agreement, the DEA refused to patrol.

Another matter he was investigating was the IBM/Tel Aviv

connection linking the use of INSLAW's PROMIS software to Israeli intelligence. Casolaro was also in touch with Alan Michael May, the bagman for the $40 million down payment made for the Iranian Hostages. Casolaro was also in contact with Bill Hamilton of INSLAW and was scheduled to meet with Videnieks and Brian at the approximate time of his murder. He kept all six of his folders with his accumulated documents and information with him at all times. Just before his alleged meeting, he left the files locked up at his home, telling relatives he felt they were safer there than traveling with him. In a search of his house after his death, NO documents were found.

Peter Zokosky also had a close liaison with Casolaro. Zokosky had previous dealings with the Cabazon Indians at the time the INSLAW software was being converted for Canadian intelligence. He also knew about the manufacture of chemical and biological weapons for the Contras through the joint venture of the Nichols family and the Wackenhut Corp. Casolaro was in the possession of documents which detailed such things as a bank in New England which has $400 million in phony bearer bonds that are being used for collateral because the bank's money has been siphoned off. Other documents detailed another bank's multi-million dollar loans used to finance drug deals, which were based on only a few thousand dollars of collateral.

THE PROMIS PROGRAM

The PROMIS program, which was stolen by the Justice Department, was to act as a Caseload Management Program for the department's massive caseload problems. Ed Meese's associate, the aforementioned "Dr." Earl Brian, was given control of pirated versions of the PROMIS program by Meese in order to sell it back to different U.S. government agencies for a very sizeable profit. Two U.S. courts have sided with INSLAW in their case against the Justice Department and awarded them an $8 million judgment. However, a higher

court of appeal has overthrown the verdict, declaring that it was not within the jurisdiction of the lower courts.

On October 9, the case was added to the workload of the United States Supreme Court. Earl Brian owns UPI (United Press International) and FNN (The Financial News Network). The awarding by Meese of the software pirating venture was a "thank you" gift for Brian's role in arranging the October Surprise—the conspiracy by the Reagan Administration under the control and direction of vice presidential Candidate George Bush to delay the release of the Iranian hostages until after the 1980 election.

NOW TO RUSSBACHER AND OCTOBER SURPRISE

Navy Captain Gunther Russbacher was the pilot who flew the specially converted SR-71 carrying then Black Rose Chairman George Bush, CIA Chief William Casey and CIA operative Donald Gregg (among others). They met with Ali Akbar Hashemi Rafsanjani (speaker of the Iranian Parliament), Mohamed Ali Rajai (future President of Iran) and Manucher Ghorbanifor (an Iranian arms dealer with connections to Mossad). Since making allegations regarding the meetings in May of 1991, Russbacher has been in jail, convicted of a charge of impersonating a U.S. Attorney. He is currently being held at Terminal Island (Federal Prison, CA).

Michael Riconosciuto is currently in jail awaiting trial on charges of "conspiracy to sell drugs." These charges were concocted by the Justice Department to silence him until damage Control Procedures are carried out. The charges were made one week after Riconosciuto authored and signed his affidavit describing the operations, along with his personal involvement, of stealing and modifying the pirated PROMIS software. He detailed how Justice Department employee, customs official, and CIA operative Peter Videnieks threatened (over the phone) the lives of Riconosciuto's wife and children if he proceeded with his public "outing" of the operation.

Videnieks was a frequent guest of the aforementioned John P. Nichols (Tribal Manager) who was actually Riconosciuto's boss in several projects conducted on Cabazon Reservation land. The PROMIS software modification was just one of these projects.

As mentioned, the PROMIS software was modified to install a "rear entry" or "back door" (very important) which the NSA or other U.S. intelligence groups, could then at a later time access for use, or... the Black Rose. This accessing could be done without any of the prospective "buyers" being aware of it, so that files or information could be retrieved at will from any foreign country that the U.S. sold it to. The pirated software was then sold to over 90 countries as the operation known as "Keys to the Kingdom" was commenced. The countries included Iran, Iraq, Syria and Libya. Riconosciuto's expertise with computers, electronics and armaments was fully utilized.

The status of Indian Reservation land as "sovereign" enabled CIA, NSA, Wackenhut and elements of organized crime to conduct business in a totally new way, out of the sight of any government overseers or Congressional or Senate snoops. One project of the "Network" currently underway on the Cabazon Reservation involves a joint venture with Southern Califomia Edison Company. This "project'" will soon be generating electric power from Bio-mass drawn from local waste outlets. Biological Warfare projects are also under way at Cabazon.

Advanced Warfare Projects such as 'Pathogenic Viruses' (co-engineered with Stormont Laboratories) are also being conducted at the Cabazon Reservation. Enhanced "Fuel-Air Explosive" weapons are also being manufactured at Cabazon after they were created and tested with the assistance of Meridian Arms at the Nevada Testing site. These weapons are so advanced they match the explosive power of some nuclear weaponry.

This type of Advanced Weaponry gains its power from

polarizing the molecules in the gas cloud by a modification of the electric field, a technology developed from Thomas Townsend Brown's suppressed work. Riconosciuto was one of the weapons technicians who worked with this weaponry. He was familiar with it as he had worked with it previously at Lear in Reno, Nevada. Lear's father worked on anti-gravity engines. Riconosciuto worked for a time on the Fuel-Air Explosive Weapon with the aforementioned Gerald Bull of the space Research Corporation. Bull later became an arms advisor to Saddam Hussein. Hussein also now possesses the Fuel-Air Explosive technology.

The Leader of the House, Thomas Foley, announced last month that a formal inquiry into the INSLAW case will be initiated. Foley appointed Senator Terry Sanford as co-chairman of the joint Congressional panel to investigate the matter. Prior to his election as a state senator, Sanford was the attorney who represented Earl Brian in his 1985 takeover bid for UPI. Sanford was also instrumental in appointing Earl Brian to the board of Duke Medical University of which Sanford is president.

Riconosciuto is known in certain circles as a genius in almost all sciences. The so-called drug operation broken up in Washington State that Riconosciuto was arrested for was in actuality an electro-hydrodynamic mining operation using Townsend Brown technology. Government analysis of soil samples at the arrest site showed NO drug contamination but a high concentration of barium. Barium is often used in high-voltage related work.

THE YELLOW LODGE

Wackenhut is presently in the same operational mode in several other areas of the world. The "Reservation operations" being carried out by the "Enterprise" and the W.W.T. group are under the project name 'Yellow Lodge'.

The 'Yellow Lodge' project involves the infiltration and

covert operations of Advanced Chemical, Biological and, in some cases, HAT Weapon development. These activities, due to the sovereign status granted to Indian lands, can be carried out by private and covert operations without answering to the legitimate arm of the U.S. Government. This scenario is especially true of the Jicarilla Apache lands, as well as many other reservations in the American Southwest—the largest of these being the umbra-classification base known as D6 (DULCE) in the state of New Mexico. .

The INSLAW operation is one small project developed and carried out under the 'Yellow Lodge' Project. It should also be known that Bill Hamilton (of INSLAW) is an Ex-NSA operative. Therefore, one not unfamiliar with black operations.

The individual known as "Clark Gable" is in actuality the aforementioned Robert Booth Nichols. Nichols has extensive connections in both the intelligence underworld and the underworld of organized crime with contacts in not only the U.S. Mafia, but the Japanese "Yakuza" and everything in between. Mr. Nichols was one of Mr. Casolaro's sources of information. Nichols was and is a director of a company known as FIDCO (First Intercontinental Development Corporation). This is just one of the 'front' companies established by the "network." Robert Nichols' wife Ellen has extensive knowledge of her husband's involvements and should be considered dangerous. She is dedicated fully to the goals of their operations.

Associated with Bob Nichols are such individuals as: 1. Sir Dennis Kendall, a former MI-6 operative from England now residing in Southern California. 2. George Pender, a very powerful individual with extensive ties to an assortment of U.S. and foreign intelligence agencies and the Military Industrial Complex. Mr. Pender was former director of Burns and Roe, Inc. He is considered to be one of the most powerful and influential men in the United States. 3. Peter Zokosky (mentioned previously), a former boss of Nichols. 4. Kenneth

Roe, president of Burns and Roe, Inc. 5. Glen Shockley. 6. Robert A. Mayheu, former Howard Hughes associate and Chief Executive of Hughes Aircraft . He has been used extensively as a private contract operative for the CIA to act as liaison agent between the "Enterprise" and organized crime. This relationship began before the assassination of John F. Kennedy.

Robert Nichols is one of the key men in this group of individuals which holds and controls an extremely powerful interest in the events of the New World Order. Mr. Nichols himself, according to an admission by Ex-Special Agent in Charge, FBI, Ted Gunderson (ret.) was solely responsible for the removal of a "sanction" placed on Gunderson's life several years ago. It is no mystery as to why the pattern of hits (listed "suicides") continues with anyone daring to challenge or probe too deeply into the individuals and their affairs worldwide.

One of Casolaro's many mistakes included his sudden interest, shortly before his death, in the bombing of Pan Am Flight 103 over Lockerbie, Scotland. Killed on board the flight, among many others, were Ron Laviviere, Bill Leyere and Dan O'Connor—all CIA Operatives from the Beirut station. Also killed was Matthew Gannon, the Chief of Station, CIA, Beirut office. *The Toronto Star* did a story by John Picton which was right in every aspect.

The commander in charge of their team was a U.S. Army Intelligence officer by the name of Charles McKee, one of the individuals in charge of counter-terrorist operations in the Middle East. Part of the information that was in transit with these now-deceased individuals was material, which could be used to destroy the "Enterprise." Included was the connection to the Syrian Drug smuggling ring and the man by the name of Monzar Al-Kassar. Kassar was deeply involved in the drugs and arms for hostages deal with Secord, North, Poindexter, Hakim and all the others of the Black Rose Group.

McKee's operation uncovered an Aqua-Tech group (CIA-Deep Cover Operatives) which was actually the team the CIA

employed to help provide cover protection, safe routing and screening procedures for the Middle East drug-running operations. Part of their duties was to cover and deflect interest from other intelligence offices from Europe and other countries, especially U.S. agencies and, in particular, another Deep Cover Operation working somewhere within the Office of Naval Intelligence.

The ONI Group is working currently to topple the "Enterprise" and restore the intelligence community to fall back within the guidelines of their original intent. The most pertinent of their motives is a salvage operation on the U.S. Constitution and the prevention of an extreme right-wing, fascist wing within the U.S. Government and intelligence communities (known to many as Aquarius or The Fourth Reich [Order the Rose].

West German Intelligence and Mossad uncovered the fact that a bomb had been placed on board Pan Am Flight 103 detecting a different briefcase than the one regularly used by the Drug Smuggler. As mentioned, McKee's team was on board the same flight with key evidence, which would be devastating to the "Enterprise." When the bomb information was relayed to the proper sources, the CIA Cover Operations Group ordered the reporting agencies to "Disregard."

The parameters of this operation reach to the highest levels of many world governments. The Gander, Newfoundland crash is also linked, as well as the bombing of the Marine barracks in Beirut. Tensions are growing daily between many levels of the intelligence community. Sides are currently being taken. This document is only an outline briefing of an intricate and highly complicated scenario. Advisories to follow.

(End Com-12 Briefing)

13.
COMMENTARIES
& INTERVIEWS

compiled by Kenn Thomas

Robin Ramsay wrote the earliest analysis of The Gemstone File which came in a British publication called *International Times*. Robin Ramsay, now editor of *The Lobster*, wrote this review of the then circulating manuscript in *International Times*, Volume 4, Number 11, 1978 (Missing footnote numbers have been retained from the original publication.):

Aristotle Onassis arranged J. F. Kennedy's assassination then took his gun—the Pentagon—and his woman—Jackie O.—as blood tribute.

Howard Hughes was kidnapped by Onassis in 1956 and held prisoner on the island of Skorpios until his death from heroin overdose. So says "The Gemstone File", a mysterious "Skeleton Key" to which slipped into circulation in 1976 in samizdat form. *International Times* ran excerpts of "The Skeleton Key" as a comic-strip for nine months and "The Fanatic" published it in full. Here Robin Ramsay boils "The Skeleton Key" down to its bare-bones and concludes that this animal never walked the earth.

The real history of the post-war years has yet to be written. Quite what it will look like when it is …who knows? But certain elements are becoming clear and in the course or this article I hope to indicate, if not what has been going on in any detail, certainly where to begin finding out.

To readers of "IT"—little of what is to come will be a great

surprise.

Perhaps of all people in the world, the readers of the "underground" press are best equipped to assimilate this stuff. For the "real world", the Orwellian world of War is Peace, cops are thieves, the drug squad sell dope, the Rt. Hon. Member is a crook, etc., is quite familiar to us now. We take all that stuff for granted. Right? Real history is just that stuff writ large—globally. True, there is an enormous amount of reading entailed and no-one will get this together on a slow Sunday afternoon between joints. But the buzz involved in taking part in the slow destruction of the edifice of lies that have been foisted onto the Western world since the war justifies the boring hours of reading things which turn out to be irrelevant.

In the destruction of bullshit history the Skeleton Key to The Gemstone File is a contribution—but not, as I hope to show likely to be a big one. In this first piece I offer some of the results of sixteen months of reading—what began as the attempt to check the Key. How seriously the Key should be taken I leave to your intelligence.

The Skeleton Key is all over the place in this country, in America, even in Khartoum (I heard of copies being circulated round the University there last summer). The conspiratorial nature of its distribution and the warning printed in the front of it give it an aura of being "the real shit". Alas, I don't think it is.

Where It Came From

The Key was initially circulated by Stephanie Caruana, an American journalist. She was given the complete Gemstone Files by Mae Brussell, a conspiracy researcher—perhaps the conspiracy researcher of all time—who has been beavering away for fifteen years, running a radio programme for the last seven of them. (1) Bruce Roberts gave his Gemstone Files to Mae Brussell in 1972 at the beginning of the exposure of the Watergate mess. Mae passed them on to Caruana (they were co-writing an article on Howard Hughes at the time) (2) who edited them down into what is now the Key. One can only assume that Caruana's precis is an accurate account of the

complete Files. Mae Brussell certainly treats it as though it is.

(3) The original Files, 350 pages of hand-written notes and letters from Roberts to his mother have been locked away for safe-keeping and are not available. This may be no great loss as Mae describes the original as being "repetitious, giberous, libelous and unsubstantiated". (4) Notice that I say the original is 350 pages and not the 1,000 stated in the Key. This is the figure given by Mae who, while acknowledging the discrepancy in her discussion of the Key, offers no explanation of it.

(5) From that discussion I get the clear impression (confirmed by the fact that Mae had the Files for five years without ever mentioning them) that she doesn't think much of them at all and is only now commenting on them because of the wide-spread attention they have received (to understand why she wouldn't be impressed by the time she was given the Files). (6) About Roberts, the author of the Files, I have found very little as yet.

Harry Irwin of Belfast, this country's leading researcher of the JFK killing, reported that Roberts had worked for OSS during the war (OSS was the war-time forerunner of the CIA) and died in 1977 of a brain tumour, claiming, like Jack Ruby, that he had been "seeded" with cancer cells. (7) What is the Skeleton Key's status? Among the conspiracy research community, pretty low. To my knowledge, the only member of that august body to have even mentioned it is Mae Brussell, and she thinks it at least 50 per cent bullshit. (8) Both Harry Irwin and Brian Burden, this country's JFK buffs, are exceedingly dubious about it and suspect it will turn out to be a disinformation exercise. (9) For what it's worth, I don't think that: rather, that Roberts got hold of some bits and pieces of real information, thought he saw the whole pattern and extrapolated (wrongly) in all directions. As I say, for what it's worth: I'm no expert.

The Key is an extremely weird document. Roberts claims knowledge of the contents of two unpublished books, letters exchanged between other people, telephone calls (even a ship-

to-shore call) and the famous missing eighteen-and-a-half minutes of the Nixon tapes (featuring, natch!, Nixon talking about Roberts!). He offers unsubstantiated accounts of Watergate, Dallas, and Chappaquiddick quite at variance with all other research, he attributes to a group he calls "The Mafia" enormous power, without making it clear if his "Mafia" are the same "Mafia"—i.e., the Italian-American dominated section of Organised Crime—as everyone else means. And if they are, I ask, how did an Irishman (Kennedy), a German (Meyer) and a Greek (Onassis) get membership? He ignores the roles played in American capitalism and imperialism by—to pick a few examples out of the air—the East Coast Bankers, Ford, General Motors, ITT, Luce and his media empire, the Rockefellers, the Pentagon, the China Lobby, the DIA, the NSC and NASA.

To cap it all he presents himself playing a decisive role in the Watergate fiasco and hiring Gordon Liddy of the Plumbers to kill Onassis' son and LBJ. All of this without any evidence, according to Mae Brussell.

Below I list what seem to me to be some of Roberts' errors. I make little attempt to pick off Roberts' claims about Onassis one by one. It would take a lot of words and could be tedious. Some of these claims are true, some are false and some are just uncheckable. (If enough people write to "IT" demanding to see the details I will do it. Otherwise, please accept the generalities.) Roberts claims: Oswald shot Connally.

Paraffin tests on Oswald's cheek were negative that day in Dallas. Ergo, he didn't fire a rifle that day. (Yes, it really is as simple as that. No one has ever devised a way to fire a rifle, which defeats the paraffin test.) There is, in fact, almost nothing linking Oswald to the event and had the case against him ever come to trial it would surely have been rejected. This is presumably one of the reasons Oswald had to be killed. The other would be the fear of what he would tell about who he worked for and what he was doing in Dallas. (10) Even Dallas Police Chief Curry, himself almost certainly part or the conspiracy, came to admit "we don't have any proof that

Oswald fired that rifle. No one has ever been able to put him in the building with the gun in his hands". (11) Roberts claims: Rosselli, Fratiano and Brading shot Kennedy.

Every stone in Dallas has been turned and no-one, not even the fans of the Mafia-killed-Kennedy theory claim to have located Rosselli and Frattiano in town that day. The source of this idea of Roberts' is, presumably, the discovery that the CIA had hired certain Mafia members to help in attempts on Castro's life. Rosselli was a member of that group. I don't know if Frattiano was or not. It has to be said that the idea that the Mafia-CIA team was re-assigned to kill JFK, the obstacle to the hard-liners among the Cuban refugees, the Military and the Mafia who wanted the US to take Cuba by force, is not—in the absence of anything else—implausible. (12) Eugene Brading was there in Dallas.

There is even a photograph of him, despite Roberts' talk of such photographs being "confiscated". (13) But although interest has been expressed in his presence there, nothing has been found to suggest he was doing anything other than watching. (14) Significantly, Brading was never asked to appear before either the Warren Commission or any of the Senate Hearings on Assassinations. Both Rosselli and Frattiano were well-known Mafiosi in 1963 and it is, a priori, extremely unlikely that the most important assassination of the century would be entrusted to an aging Mafia administrator (Rosselli—he was 50 plus in 1963) and a gun-man using a pistol. At least four gun-men were in Dallas that day and with Oswald not involved, that means that at the very least, Roberts is one short. The identities of at least four of the gunmen has been established, their photographs published, and they were not the team Roberts had in mind. (15) Roberts claims: Frattiano's pay-off for the hit was listed in Dun and Bradstreet's credit lists.

Not so. A friend of mine, with the help of three of its assistants, checked every single Dun and Bradstreet publication with the resources of the New York Public Library. There are no such lists, and never have been. If you consider it,

lists of individual loans within the American banking system, it becomes very unlikely. Just how big would such lists be? Millions of entries per month? Per week? And all this back in the days before micro-circuitry! Roberts claims: McCone and Helms were in charge of the Dallas CIA that day in 1963.

Not so. In 1963 McCone was Director of the whole CIA and Helms Deputy Director Plans (the covert branch). Both had been appointed by JFK after the Bay of Pigs fiasco in 1961. McCone was in Washington at the time of the killing. (16) Ehrlichman, of Watergate fame, portrays Helms in his novel/history/TV programme "Behind Closed Doors" as the biggest JFK fan there ever was, as Nixon's most hated enemy. Who knows if that's true? But he certainly was not head of the Dallas CIA in 1963.

Roberts claims: Robert Kennedy knew who had killed his brother and wrote about it in his book "The Enemy Within".

Unless there was a second (unpublished) version, this is wrong. I've read "The Enemy Within". It was published in 1961, and the only remarkable thing about it is RFK's appalling prose style. It is merely an account of his (RFK's) role in the war on the Teamsters Union. Both RFK and JFK made names for themselves during the 'fifties as enemies of organised crime in general and the Teamsters in particular, at a time when, according to the Key, Onassis had control over both the Kennedy family and the Teamsters. The Key's presentation of the arrest of Hoffa, in '61 as some big innovation is wrong. It was merely the climax to years of investigation and pursuit, as "The Enemy Within" demonstrates.

Roberts claims: Onassis was Mr. Big (world controller).

This is exceedingly difficult to even approach. Some of the bits of biography of Onassis given by Roberts are correct, some uncheckable and some are wrong. To refute the claim that X is the (secret) ruler of the world is impossible. Anything offered against such a claim can be met with the argument "Well, that is faked information. The real truth is hidden". So be it. If anyone wants to believe in the omnipotent individual there's nothing I—or anyone more qualified—can do to remove such a

belief. What I can do is point out what seem to be inconsistencies within Roberts' account and make quite clear the kind of control is involved in a claim like: Onassis is world controller.

In essence, Roberts' story is this: an alliance between the Mafia and the Hughes Organisation was strong enough to dominate the whole of American government. (Here, I assume that Roberts does mean the Italian-American Mafia. It was certainly they who were at the Appalachian meeting). Two things on this. First, the Mafia were unable to prevent their boss (Capo de Capos, I think is the term) Lucky Luciano, from being imprisoned and then exiled during and after the war. (25)

This fact fits uneasily with Roberts' talk of the Mafia being able to impose news censorship as the war approached. Second, even if the Mafia and the Hughes organisation had been welded together with Onassis' shipping interests. the resulting amalgam would have been relatively small compared with, e.g., Ford, General Motor, the Rockefellers, the Morgans, etc. (All the way through the Key I have the desire to shout "For fuck's sake, why pick Onassis? Aren't there more likely candidates for the role of Big Boss? Why pick that vulgar little man?") Further, the "powerful" Onassis was unable to prevent his rival shipping boss, Niarchos, from stealing a contract Onassis had acquired to ship the Saudis oil. (26) Not only that, but Niarchos had used the assistance of Robert Maheu in the deal and, according to Roberts, Maheu was Onassis' boy. All this took place only three years before Onassis is alleged to have acquired control of the Hughes operation.

If we return to the Key's account of Onassis pre-war, we find the claim that Onassis made a secret deal with the oil companies to ship the Arab oil. But the biographies of Onassis are agreed (27) that at the time of the alleged deal, Onassis did not have the kind of tonnage to partake in such a deal. Those biographies (yes, they might be faked) portray Onassis as a bent shipping boss who, after WW2, got lucky and managed to arrange a deal to buy some surplus US Government tankers. That much Roberts has got right. He is also probably right in

his claim that Hughes lost control of his operation. Rumours to that effect have been around for years. (28) But, again, in all the complicated ramifications round the Hughes business, no mention of Onassis is found. Mae Brussell believes Hughes lost control of his business in 1946, after his plane crash, and was finally incarcerated in 1957 in the motel in Beverly Hills. (29) There is some indication that Hughes dies, finally, on Skorpios. Both Mae Brussell and two other researchers have reported these claims (30) but neither of them are then inclined to conclude that Onassis was the Big Man. A more likely explanation of Hughes' death on Skorpios would be this: the Hughes organisation became very closely linked with the Pentagon and the CIA. (31) These organisations were active in the installation of the Greek Junta in the sixties and Onassis with his interests in Greece, may have been asked to baby-sit Hughes for them. (32)

All of this is inconclusive. I am not capable of untangling the Hughes connections, and I have come across no-one else who is. At root, Roberts' claims about Onassis are simply implausible—because no single individual or organisation would he capable of doing what Roberts claims. When those claims are listed the whole scenario just looks ridiculous. Roberts would have us believe that one man had control of both political parties, the Pentagon, the CIA, the Washington Federal bureaucracies, the Press, and large chunks of the world. Really! All of this on a financial base which is mere piffle when compared to dozens of others.

Any such claims for one individual or organisation just do not survive even a little reading. Compare Roberts' account of Watergate with the essays in "Big Brother and the Holding Company". (33) Roberts' story just dissolves into nonsense and simplistic nonsense at that. I think we can see how Roberts arrived at his scenario. He probably heard the rumours that Hughes was on Skorpios, traced Hughes' last "public sighting" to 1957 and then concluded that Onassis had kidnapped him. With that as his hypothesis he simply interpreted events—(And why should this hypothesis not be just as plausible: Hughes

disappears and his organisation is taken over by the Mormons (the Mormon "Mafia"). The Mormon Church is the secret control mechanism. All its "missionaries" are agents plotting our destruction. Its computers, apparently collecting genealogical information are in fact accumulating data prior to the take-over of the world. If you need evidence look at all the Mormons around the Watergate farce—Robert Bennett, e.g., who has been accused of plotting the whole thing, of being "Deep Throat" and all manner of manipulative exercises.) The point is this: at the skimpy level presented in the Key, a dozen alternative scenarios—just as plausible—could be constructed. If any of them arrived in your local bookshop, marked "dangerous" and with the air of secret revelations like the Key, would they not be just as plausible? In fact Mae Brussell does think the Mormons took over Hughes. I have no knowledge on that. It might be true. But even if it is, it hardly suggests that the Mormon Church is the secret controller of the world.

All the way through this piece I am conscious of the fact that the Key is someone else's account of the Roberts Files. It is possible that I am doing Roberts a great injustice: his Files may be a great deal more coherent than the Key suggests. It is unlikely that we'll ever know. I doubt if Mae Brussell is going to make (what she thinks of as) mostly nonsense, widely available when there is a mountain of more solid research around.

The Key is, finally, a pricktease, promising much more and delivering mostly nothing. It is, however, an excellent hypothesis to use as a framework and guide to reading lists. And it is, in its own way, pointing in the right directions. Large roles have been played in the creation of the post-war world by the Mafia, the Gehlen/CIA link-up, by the Hughes organization, by the World Bank, by Watergate and by the Kennedys. Finally, that Roberts got the story wrong may be less important than the fact that he has roused a lot of people to interest in things of which they were previously pretty oblivious (this is certainly true in my case). It's a case of "thanks, but no thanks". But definitely "thanks".

Robin Ramsay would be pleased to receive any information on the File.

Write c/o "IT". He says "All information is welcome. The reconstruction of the history of the post-war years will be an enormous task. Many hands make the work light.

Key To The Key 1. There is a profile of Mae Brussell by Paul Krassner in the US edition of *OUI*, June 1978. Mae Brussell's programme, "Dialogue Conspiracy" is on KLRB FM, out of Carmel, California. The programmes are recorded on cassettes and can be bought from her. Write for programming list.

2. *Playgirl*, December 1974.

3. In her discussion of the Key.

4. On a letter to a friend of mine.

5. In her discussion of the Key. See (1) above.

6. Try her series of articles in Paul Krassner's *The Realist*, August and December 1972, February 1974.

7. Harry Irwin is the editor of the JFK Assassination Forum Newsletter.

8. Opinion expressed in letter (see 3 above.)

9. Brian Burden is former editor of the JFK Assassination forum Newsletter. These opinions expressed in letters to me.

10. The reading list on Oswald and Dallas is now enormous. In a sense almost anywhere is a good place to start, but avoid books by Eddowes (November 22), Epstein (*Legend*) and Macmillan (*Marina and Lee*)—all three are bullshit, the last two certainly deliberately disinforming. Eddowes I suspect is just an amateur idiot. For a recent view of the case brought by the Warren Commission against Oswald try Howard Roffman, *Presumed Guilty* (Thomas Yosaloff Ltd., London, 1976). The simplest rule of thumb is this: anyone who suggests Oswald was either a "lone nut" or working for the Cubans/Soviets is an idiot or a liar and probably working for the CIA/FBI, etc.

11. Quoted in Carl Oglesby, *Yankee and Cowboy Wars* (Sheed, Andrews and MacNeil Inc., Kansas City, 1976). Page 145 is perhaps the best of all places to start. An excellent book.

12. See Daniel Schorr, "The Assassins", New York Review

of Books, 13/10/77 and Davenport/Eddy/Hurwitz, "The Hughes Papers" (Sphere, London, 1977), pp. 51-54.

13. Photograph of Brading taken just after the shooting in Dallas.

26. Ian Macfarlane, *Proof of Conspiracy* (Book Distributors, Melbourne, Australia, 1975). Probably hard to find, but an excellent place to begin.

14. Donald Freed (co-author of *Executive Action*) has Brading in the same role in his factoid book *The Killing of RFK* (Sphere. London. 1977)

15. See photographs in Richard Sprague and Robert Cutler, "The Umbrella System, prelude to an assassination," in *Gallery* (US only). June 1978.

Sprague is former consultant to the House Select Committee on Assassination. He was fired for asking too many pertinent questions.

16. William Manchester, *The Death of a President* (Pan, 1967), 286.

25. M. Gorsch and R. Hamer. "The Last Testament of Lucky Luciano."

26. Davenport/Eddy/Hurwitz (12 above), pp. 51-54."International Herald Tribune", 3/8/78.

27. See biographies of Onassis by Frischaur (Bodley Head, London, 1968) and by Fraser, Jacobsen, Ottaway and Chester (Weidenfield and Nicholson, London, 1977).

28. E.g., Oglesby, Ch. 6 (11 above); Fay Chester and Linklater, "Hoax" (Quartet, London, 1973); see the Epilogue; and Joe Davenport and Todd Lawson. "The Empire of Howard Hughes" (*Peace and Pieces*, USA. 1975, ISBN 0914024 22 1).

29. In her radio programme (see above).

30. Mae Brussell and Davenport and Lawson (see 28 above).

31. Davenport and Lawson (see 2 above) and Oglesby (see 11 above) Ch. 6.

32. See Mae Brussell, "Whv Was Martha Mitchell Kidnapped?", *The Realist*, August 1972.

33. "Big Brother and the Holding Company; The World

Behind Watergate", edited by Steven Weissman, (Ramparts Press, USA, 1974, but available in the UK from the *Monthly Review Press*, London) An excellent book which makes UK "investigative research" look the shallow shit that it is.

34. Mae Brussell articles (see 6 above); also John Dean, *Blind Ambition* (W. H. Allen. London 1976), pp. 390-392.

Ramsay became well-known, of course, for his magazine *Lobster*, published at 214 Westbourne Avenue, Hull, HU5 3JB in the UK. His web site is located at:

www.knowledge.co.uk/xxx/lobster/ and his e-mail address is robin@lobster.karoo.co.uk. Presumably, any new information about Gemstone is still welcome at these addresses.

Lobster itself revisited the topic in 1990, with issue #19:

It says much about [Dr. Christopher] Andrew's ignorance of the history of the Kennedy assassination and the demolition of the Warren Commission Report that he should offer that, of all things, as an example of what he called this 'incurable tendency' of people—he means ordinary, non-academic people, presumably—to construct conspiracy theories.

Andrew appears to be among the tiny minority of people—spooks, state propagandists and the seriously naive—who still believe the 'lone assassin' story. For my part, I was grateful for Andrew's asinine comments, for ever since the reappearance of the 'Skeleton Key to The Gemstone File' in both *Black Flag* (August 15 '88) and *Cut* (April and May '88), I had been meaning to write a piece about conspiracy theory, conspiracy theorists and 'the conspiracy theory of history'. Andrew's display of the prejudices of the average conservative-minded academic, spurred me to get on with it.

Gemstone with its sweeping allegations about the world-wide power of Aristotle Onassis—who allegedly killed Howard Hughes, John F. Kennedy, ran the Mafia, controlled the American elections etc. etc.—The Skeleton Key to The Gemstone File (just called The Gemstone File usually) is an interesting contemporary version of the classic conspiracy

theory. As part of Gemstone's continuing appeal seems to be the mystery surrounding it, let me first digress into a short history of Gemstone.

Gemstone first appeared in the UK in 1976 in typewritten, photocopy form, attributed to 'The Jesse James Press, New York and London'. A copy reached Hull (I have heard of copies as far away as the Sudan) with the instruction that the reader should copy it and pass it on. This I duly did. Gemstone was subsequently (1977) reproduced in the now defunct *International Times*. Another London 'underground' magazine, *The Fanatic*, reprinted the same version in 1977 or 78: I can no longer remember which and there is no date on my copy. Knowing nothing at all about this area at the time—I can still remember trying to find out what the World Bank was—Gemstone fascinated me. But when I went into the library and started checking it out, I discovered it was mostly fantasy, and rebutted Gemstone's central claims in *International Times* (Vol 4 No 11, 1978). But, en route, I had found out some things about it.

The Gemstone File began as a set of letters from the author, Bruce Roberts, to his mother, copies of which were given to the recently deceased American conspiracy theorist and researcher, Mae Brussel, at the end of 1972, just as Watergate was flickering into life. In 1977 Brussel described Roberts' letters to a friend of mine as 'repetitious, giberous, libelous and unsubstantiated'; which, coming from Mae Brussel, for whom almost anything was possible, was quite a put-down. Indeed, Brussel had Roberts' letters for five years before deeming them worthy of mention on her radio programme, 'Dialogue Conspiracy'; and then, while repeating Roberts' central claims, she was critical of them. What appeared in this country in 1976 as 'The Skeleton Key to The Gemstone Files' is a précis of Roberts' allegations done by Brussel's colleague at the time, Stephanie Caruana, with whom she was working on a piece about Howard Hughes destined for *Playgirl*. There are no 'files'; nor are there the '1000 pages' referred to in the Key's introduction. According to Brussel, 300 is more like it. About

Gemstone author Roberts there are merely rumours: that he died in 1977, of a brain tumour, claiming, like Jack Ruby, that he had been seeded with cancer cells; that he worked for OSS during the war; that he had been a student at the University of Wisconsin. None of this has been checked as far as I know, for the simple reason that no conspiracy researcher has thought Gemstone (or its author) worth taking seriously.

As well as the original Caruana précis, Gemstone has appeared in the *Boston Globe* (August 12, 1980), a version taken from one put out in book form (though it would be a very thin book) by 'Fighting Tigers', a subsidiary of the CIA front company, Air America. This version contained material added to the original 1976 version. Gemstone also appeared in the American porno mag, *Hustler,* in 1979, presented as 'the solution' to the Kennedy assassination. Since then the American researcher Ace Hayes has found two other versions, little pamphlet editions in the U.S. Such pamphlets have been in circulation in London more or less continuously since 1977. (I have seen them several times in the basement of Compendium Bookshop in London.) Entering into the spirit of the thing, Ace Hayes amalgamated these different versions to produce a new synthesis—giving four, perhaps five versions in all.

Authorless, drifting around the fringes of our culture, Gemstone has become a wonderful disinformation vehicle, available to anyone to add to, modify, reprint, recirculate. The last version I saw was still about 95% Roberts, but I expect that one day, years hence, a version will appear in which Roberts' original allegations have all but disappeared.

The redoubtable Stephanie Caruana continues to champion the veracity of Gemstone and reappears among conspiracy students sporadically in its defense. In the summer of 1993, she gave the following interview to *Steamshovel Press,* the conspiracy magazine published at POB 23715, St. Louis, MO 63121, and on the web at www.umsl.edu/~skthoma:

Q: Stephanie Caruana was responsible for surfacing The Gemstone File, a behind-the-scenes documentation of various power cabals involving Aristotle Onassis and Howard

Hughes, among others, in connection with the Kennedy assassination. Thank you for being with us.

A: I'm delighted to talk to you.

Q: How did you first encounter The Gemstone File?

A: I was working with Mae Brussel. She was a conspiracy researcher in Carmel Valley, California for a number of years and I was a writer for *Playgirl* magazine. I got in touch with her because I wanted to find out more about the Symbionese Liberation Army's kidnapping of Patty Hearst and what was really behind it. So I went to see Mae and I began writing articles based on her research files. We began writing an article about Howard Hughes and Aristotle Onassis at the request of my editor at *Playgirl*.

Q: How did this grow out of your interest in the Patty Hearst kidnapping?

A: I was referred to Mae by a news editor of a radio station in San Francisco. I saw that she had so much information stashed away in her house in Carmel Valley, and I offered to move in with her as a sort of writing slave. My editor at *Playgirl* asked me to ask Mae if she knew anything about Howard Hughes. And Mae said, "Howard Hughes is dead. Onassis kidnapped him."

Q: This was well before it was officially announced that Hughes had died.

A: Yes. This was in 1974.

Q: What is the long and the short of what happened to Patty Hearst?

A: I was living in Berkeley about a mile from where Pat Hearst was living. When this happened, of course, everybody in Berkeley was quite shocked. It became clear that this was some sort of media event. I had never seen anything like it. There were these demands from the leader, Cinque, battle communiques; he wanted food giveaways in Oakland, which I watched. I felt that there was something going on that I really didn't understand. It seemed more media than anything else.

Q: Like an artificially constructed drama being played out on the TV news.

A: Yes. And that's when I went to see Mae. Mae had a great many interesting things to say, and we wrote an article about it which was terrific. Mae had done a lot of research on what was going on the California prison system, particularly at Vacaville prison, where there was a tremendous amount of mind control going on. I had a friend who had been there and they had given her shock treatments. It was something that was way beyond what was happening in other prisons. Mae's theory, and I believed her, was that Donald Defreeze, "Cinque", had been programmed at Vacaville through a series of classes in "Black Pride" and "Let's move along with the revolution," and possibly other-forms of mind control such as drugs. He was also a three-time loser. They could have kept him in jail for the rest of his life. There was no chance that he could ever have gotten out. He was what Mae called a yo-yo, which is a prisoner that these people have on a string. They can let him out of prison for their own purposes and pull him back any time they want, completely under the control of the authorities.

Q: So you went to work for Mae doing research on Howard Hughes.

A: I was staying at Mae's house and she had these enormous files. She pulled out a file on Howard Hughes with all these clippings, and a file on Onassis and all these other clippings. And it was a tremendous rush job, a very fast deadline. It was supposed to be the major article for their Christmas issue. So I started reading and reading, but Mae's theory that Onassis had kidnapped Howard Hughes—I said, "Mae, I don't see it. I see articles about Hughes and Onassis, but I don't see any cross. So where are you getting this idea from?" And at that point, she said, "Well, I have these other letters from this guy. He gave me these letters back in 1972. I read them, and I thought maybe he's just a crazy-whacko kind of person, but I have since then received some—a couple of other sources. So I tend to put more credence in it than I did originally." And she gave me a way of looking at things that I found was something I could accept. And I find myself using that. She said, "When I

hear the same story from three different sources, I tend to think it may be true." So she had the story about Onassis and Hughes from one source, and then she had this Canadian tabloid and she had another source. If you have three vectors, you can locate a point in three dimensions.

Q: So the letters were the Bruce Roberts letters? What is the connection between Bruce Roberts and Mae Brussell? Who did Bruce work for?

A: He didn't work for anybody. He was his own man. And I would say without a doubt that he was the most incredibly amazing and fantastic person I have ever met in my entire life.

Q: How did you meet Bruce Roberts?

A: I read the letters at Mae's, and I was absolutely stunned by them. I was overwhelmed by them. There was so much information and it was written in such a brilliant style. I found it believable. Maybe I was different from Mae. I read it all over the space of one night or possibly two nights, but straight. Couldn't put it down. I was at the same time writing this article. I became very curious about Bruce Roberts. I asked Mae what he was like, and she gave me her impression.

She told me that she had met him in 1972 and he had given her these letters. And she said that she didn't believe them at first, but she did now. By this time, it was 1974. After several months I decided that I didn't want to work with Mae any more; it was getting to be too dreary.

I went to San Francisco and the first thing I did was I went to Bruce Roberts' house and looked him up.

Q: The Skeleton Key to The Gemstone File is an outline that you created based on your review of all the Roberts letters.

A. He arranged for me to read some of his more recent letters, and I made notes. The Skeleton Key is a chronological outline based on my notes and my conversations with him, and whatever made sense to me.

Believe me, I left out more than I put in. It was a very dangerous situation for everybody. We were all living in a powderkeg and this man really was surrounded by murders. While I released the file, I didn't feel that I had any right to

release a great many personal details about him or his sources, and that's why I didn't. Bruce Roberts read the Skeleton Key and it seemed as though he approved of it in a way, which really amazed me. And he used to call me up sometimes and ask me to go to certain events, and bring copies along and give copies to people.

Q: When did he die?

A: He died in 1976. I would say that he was murdered. Supposedly he died of a brain tumor, but that man was so healthy and so tough that I think he was killed. They almost killed him while I was there. That's why I released the Key in the first place. I was so upset. I was just enraged and I felt that I had to get the story out. The Gemstone File is the best history we have of the Kennedy assassination and of that time.

I'm not talking about my own work. I only wish I had the original letters. I have a couple of them but I don't have the whole thing. But this man was a historian in the real sense of the word. Of course, the people that are running our country at this point, one thing they want to kill is anybody who wants to tell the truth about what's going on.

Q: I realize the Kennedy assassination is only one detail in a long story about the hidden machinations of what's happening, the thrust of which is that the international Mafia with Aristotle Onassis at its head is the group that's calling the shots.

A: Of course, they have become so ingrained in the American society, can you call them Mafia? They all wear business suits. They've all got loads of money. They're all "respectable" businessmen-men, not all of them.

The killers aren't, but the guys who tell the killers what to do and pay them, all of our big business people. I have a list somewhere of the hundred richest families or people in the country and it's probably the same people who are the Mafia. I'd like to compare notes.

Q: One of the criticisms laid at the feet of people who suggest Mafia involvement in Kennedy's death is that the Mafia couldn't do a cover-up over these thirty years. That may

not necessarily be true when you consider that the Mafia and the high-ranking members of the intelligence community are basically the same people.

A: They are now. The factor that ties them together for me anyway is Onassis because according to Bruce Roberts, who I believe, he kidnapped Howard Hughes in 1957. And Howard Hughes was an extraordinarily rich and powerful man with a tremendous empire. And Howard Hughes had already bribed Richard Nixon. So Howard Hughes had Vice-President Nixon in his pocket at that time. As I talk about this, in my mind I have this picture of the food chain in the ocean. A little fish gets swallowed by a bigger fish, who gets swallowed by a bigger fish, and a bigger fish.

And Onassis was the biggest fish in the ocean. And along came Hughes, who was so huge that he became a tiny morsel for Onassis who swallowed him up. And he got away with it. It was an imaginative stroke of genius by a man who was more powerful than Alexander the Great. He was the richest man in the world and the most powerful man in the world. And he ran the world until he died.(End of interview)

The following letter, referencing the previous interview, came from Jim Hougan, renowned author of several important books on the history of the covert intelligence world, including *Spooks* (William Morrow, 1978):

It seems to me that, as an editor who publishes some very good stuff (Timothy O'Neill comes to mind), you should know better than to lend uncritical credence to materials like the "Gemstone File." To say (as you did in SP 8) that The Gemstone File is "a behind-the-scenes documentation of various power cabals" is silly. The File is, as I think you must know, an interesting but totally fucked-up rant. As such, it may be of some literary or cultural interest, but it's only parapolitical significance would seem to be that it has misled many and discredited the few who've been foolish enough to reference it.

As an investigative reporter who's written extensively on

parapolitical issues (see *Spooks* and *Secret Agenda*), I'm depressed by the nearly transcendental gullibility of what I would like to think is a part of the audience for which I'm writing. If, to be believed, a writer need only assert something, then why should anyone bother to conduct interviews, seek out documents, or otherwise let facts stand in the way of supposition? A good example of the vacuum at the heart of The Gemstone File can be seen in the suggestion that Aristotle Onassis was at the head of an "international Mafia ... calling the shots" heard round the world. In reality, Onassis was very nearly broken by the CIA during the 1950s.

This occurred when the Agency mounted covert operations to overturn a contract that Onassis had struck with the Saudis, giving him a monopoly on the shipment of oil from Saudi shores. Key figures in this activity were Onassis's rival, Stavros Niarchos, CIA agent Robert Maheu, a spook named John Gerrity, and Edward Bennett Williams—all of whom worked against Onassis on behalf of the CIA. Maheu, as you must know, subsequently went on to represent Howard Hughes in Las Vegas, and Williams became (among many other things) a lead attorney for the *Washington Post.* Contrary to what Roberts asserts in The Gemstone File, Hughes was not kidnapped by Onassis in 1957—but was, instead, and according to Robert Maheu, kidnapped by International Intelligence Incorporated, or Intertel, in 1971. (Intertel is a Washington-based private intelligence agency whose incorporators identify politically with the Kennedy family.) The story, which was a difficult one to get, was told—in considerable detail, and with extensive footnotes—in *Spooks.*

My intention here, however, is not so much to dispute the details relevant to The Gemstone File (or any other article in *Steamshovel Press*), but to suggest instead that the parapolitical underground should consider whether or not it matters that they've got it right or wrong.

If any conspiracy theory will do, then the *Steamshovel Press* should be regarded as a literary enterprise—like *Fate* or *Granta.* If, on the other hand, it seems important to distinguish

between reality and fantasy, then I think it's up to you to establish standards of reportage (footnotes, etc.). Surely your readers need to know that Timothy O'Neill deserves to be taken seriously—while Stephanie Caruana does not.

That said, I like *Steamshovel* and I'll keep reading it. But I do think you need to distinguish between parapolitical artifacts such as The Gemstone File and "behind-the-scenes documentation" (such as Ollie North's notebooks.)

Yers,

Jim Hougan

Afton, Virginia

In 1994, Stephanie Caruana submitted two analyses of new books on Gemstone. The first examined Jim Keith's volume: *The Gemstone File*, edited by Jim Keith (IllumiNet).

Jim Keith is the kind of editor writers dread: He makes mistakes. He misunderstands. You tell him something, and he gets it wrong, Then he compounds his first mistake by "analyzing" the soup he has plunged into.

Not a pretty sight! That is my first complaint about the IllumiNet edition of The Gemstone File. There are others.

Still, I tell myself that there are compensations. The 1992 publication made the Gemstone Skeleton Key available in a renewed and slightly more "respectable" version than the bootleg copies that have circled the globe in one form or another since I wrote the Key and began releasing copies of various "editions" early in 1975. The Key itself is followed by an 'interview' (based primarily on letters that I wrote to Mike Gunderloy, former editor of *Fact Sheet Five*), which gave me some opportunity to clarify a number of questions that have been raised over the years.

Transcripts of two of Mae Brussell's *Dialogue: Conspiracy* radio programs from 1977-8 give Mae's version of how I came to meet Bruce Roberts and write the Skeleton Key. In view of a small but shrill phalanx of phonies who want to claim the credit, and the money if there is any, I am grateful for their inclusion.

A segment of the Kiwi Gemstone follows, and that is also interesting and useful. These sections take up the first 96 pages of the book. Okay so far! But then Keith, having to deliver a 200+ page manuscript, was forced back upon his own questionable resources. From his various comments scattered throughout the book, he seems to be suffering from a terminal dilemma of ambivalence about the Gemstone material. On one hand, he'd like to brand it a "hoax," thus inflating his own reputation while demolishing mine. On the other hand, any circulation the book gets will be because of the wide circulation and reputation (good or bad) of the original Skeleton Key—which had nothing to do with him, and everything to do with the richness and fascination of the Gemstone information presented. So he vacillates.

It seems he carefully selected a circle of contributors to the rest of the book, who, whatever their basic attitudes, must all have agreed to take at least one hard slam at Gemstone. None of these "researchers," including Keith, have taken the trouble to do any serious "research" on Gemstone's important premises. Yet Keith now stakes a claim to be an "expert" on Gemstone.

Of the eight contributors to the back half of the book, the selection I find most offensive is Len Bracken's short story—or perhaps it's the placement. Following directly upon the spare and somber, reality-based "Kiwi Gemstone," Bracken's ill-conceived fantasy of Bruce Roberts as a stoned hippy is like getting slapped in the face with a cold wet mackerel while listening to Pachelbel. [Editor's Note: Bracken's contribution to Keith's book was indeed fictional. Bracken is the author of a new book on expository prose on conspiracy history called *The Arch Conspirator,* published by Adventures Unlimited Press.] Equally dumb is the "Appendix: Sodium Morphate" section by Yael Dragwyla and Gary Csillaghegyi. These "experts" couldn't find "sodium morphate" in two source books, and therefore conclude that such a poison couldn't exist. I say, tell it to Lucrezia Borgia, Or "William Shakespeare" (1) Morphine is a derivative of the opium poppy, which for reasons known only

to itself, produces opium. Smoked or ingested in small amounts, opium is an addictive drug. In larger amounts, it induces coma; a very large dose will kill you. These properties of opium have been known for thousands of years—going back to the time of Pliny.

(See "opium" in the *Oxford English Dictionary*—compact edition).

Morphine, developed early in the 19th century, works even better, since it's more concentrated. If "D&C" had bothered to consult the OED, under "morphine," they would have found "morphine sulphate,'" which compound has been known since the nineteenth century, and numerous references to its poisonous effects. Also references to "morphine salts" and "morphate". Sir Arthur Conan Doyle had a medical villain prepare a fatal injection of "morphia" to bump off a victim in one of his Sherlock Holmes stories. The modern pharmacopoeia depends to a large extent on "discovering" the properties of various plants which have been known to folk medicine and folk murder for centuries. Modern chemistry may improve the potency of these plant substances by refining them, but dead is dead, and how efficient do you have to be once that objective is achieved? Unfortunately, these "researchers" have been unable to research their way out of this paper bag.

Kerry Thornley's contribution, "Is Gemstone a Hoax?" is the most outspoken in calling the Skeleton Key "bullshit." Kerry's belief was that since he has personally known so many people connected with the JFK assassination, and didn't know where the Skeleton Key came from, it had to be a hoax. However, Keith knew (it developed from my work with Mae Brussell in 1974), and chose not to share that information with Kerry before the book was published. It seems typical of Keith's shameless and reckless manipulation and suppression of information in his own self-interest. (He does it again in his "review" of Gerald Carroll's Gemstone book when he carefully conceals Carroll's professional background by cutting out the words "in journalism" from Carroll's title: "assistant professor... at the University of Iowa".) In 1992, Kerry told me

how embarrassed he had been by Keith's publication of Kerry's statement, which Kerry now disavows.

The second-half selection I liked best was "Outlaws and Inslaw," by Ben G. Price. It is well written and informative, and updates Gemstone with references to BCCI, and Danny Casolaro's suspicious death. Consistent with Price's level of information, he concedes that the Skeleton Key is "correct in most details." As far as I am concerned, the IllumiNet Press Gemstone book is a rip-off. Although I worked with Keith prior to publication, answering the questions he raised and helping him to develop his 'interview' with me, I received no compensation for my contributions from the publisher, although Keith and the other writers did. And although Keith based the entire book on information which he got from me, in the Skeleton Key itself and in additional letters, I receive no credit on the book jacket, or in advertisements of the book.

In terms of pertinent new information and informed research about the Skeleton Key and Gemstone in general (including the only published photo of Bruce Roberts that I know about), I recommend that readers buy instead Gerald Carroll's new book, *Project Seek: Onassis, Kennedy and the Gemstone Thesis.*

1. See "The Shakespeare Conspiracy," by Stephanie Caruana.

Caruana's second review concerned the book by Gerald Carroll:*Project Seek: Onassis, Kennedy and the Gemstone Thesis* by Gerald A. Carroll (America West), A Review by Stephanie Caruana.

Project Seek does an outstanding job of researching and documenting the starkly compressed statements I made in the 22-page Skeleton Key to The Gemstone File, which I released, samizdat-style, in 1975. Its 388 pages are packed solid with new information, relevant original interviews, footnoted sources, and rational analysis. It clearly documents, supports and expands upon perhaps 80% of the original Gemstone Key material. In fact, it is just the book I have been hoping someone would do, some day.

It has fulfilled its stated aim: a "determination to find out exactly how truthful Gemstone File author Bruce Roberts actually was." What I particularly like about this book is that it does not, like Jim Keith's, perch on a loft editorial peak of opinionated ignorance and take potshots at source material that neither Keith nor his "researchers" have bothered either to try to understand or study in detail, either to substantiate or deny. Carroll brings to his subject 20 years of experience as a newspaper reporter, columnist and editor with Gannett, Copley, Thomson, Hearst and McNaughton companies, including 10 years at the Hearst-owned *San Francisco Examiner.*

He has used his skills to ferret out additional biographical information about the elusive Bruce Roberts, and has even unearthed a 1952 photograph of Bruce Roberts draping a gemstone headdress on Carmen Miranda! The photo section alone is a gem, and Carroll's written text provides a rational, well-written and easily understandable exposition of the Gemstone Skeleton Key's unavoidably staccato style.

Carroll's interviewees include: Donald Neuhaus, who worked for "Hughes" guarding Jean Peters in her bungalow at the Beverly Hills Hotel during the summer of 1957; Dr. Theodore Maiman, developer of laser-beam research for Hughes Tool, who may have used some of Bruce Roberts' artificial rubies in his work in 1959; and Randy Strom, son of Al Strom, the bartender at the Drift Inn in San Francisco.

The last chapter, Shiny New Gemstones, provides a bridge from the Skeleton Key's final paragraphs, written in June, 1975, to today's events.

In its strict adherence to investigating the Skeleton Key's "Gemstone" statements in detail, the book adheres more closely to the original spirit of Gemstone, which was and will always remain a dogged search for the truth, than Jim Keith's version.

I think the lunacy of Keith's attempt to be top dog in the Gemstone manger trembles to the surface as, in his review, he refers to my "rant" at the Phenomicon Convention, which

certainly did turn out to be dueling microphones! Too bad, Jim! I wrote the Skeleton Key, and you didn't! I understand it, and you don't.

Gemstone arises occasionally as a topic on the internet, and Skeleton Key author Stephanie Caruana has also joined the discussion on rare occasion. The following appeared on alt.conspiracy from James Daughtery's discussion list for A-albionic Research a respected ruling class/conspiracy research resource of longstanding (POB 20273, Ferndale, MI 48220), December 1994:

Q: Is there any evidence that The Gemstone File is true or that parts of it is true? What is your opinion about it (if you don't mind my asking)?

Daugherty: I don't think it is true. It is even hard to find parts of it that are true! Only the names mentioned have relevance and, of course, something very weird was going on with Howard Hughes. The key insight is that there is no integration of it's narrative into known geopolitial history. However, it is something that all who would study the conspiracy theory of history must read!

On June 22, 1995, Stephanie Caruana wrote to Daugherty:

Dear Jim and everyone else:

I think I'm going to have to say goodby to this group, at least for the present.

Not that what you are saying isn't interesting! Just that there's too much of it, and I don't have time to cope with all this incoming mail, much less respond to it, at present. Still, the various messages stir up many feelings.

As some people may know, I wrote a short summary of Bruce Roberts' letters back in May 1975, to which I attached the name, "A Skeleton Key to The Gemstone File." I sent it out for free distribution, and it did go round and round the world. I meant it as information, and several serious researchers have spent years trying to determine whether the information was

good or not.

The latest, a book called *"Project Seek,"* does the best job I have seen yet of substantiating about 90% of what was said then—a compressed version of JFK, Hughes, Onassis, RFK, etc. I've taken a lot of abuse through the years, and still have people from all sides of the spectrum throwing rocks whenever I stick my head up, but who cares, really? I'm still here, and I still think the story is true.

Have learned a few more things in between.

I think the struggle for domination, and competition to the death, comes with the territory for all living creatures—vegetable, as well as animal. When the first amoeba got crowded out of its water drop, it fought back! You haven't lived until you've watched a couple of male mudskippers having at each other over a tiny, but in their view, overcrowded puddle. (2 is too many!) Higher up on the evolutionary scale, you have a male lion killing the cubs of the lion who ruled the pride before he got there, etc, ad infinitum.

Generally, with some species exceptions, the males fight each other, while the females save their strength to protect their babies, which keeps the species going. What I'm saying is that competition to the death, for available resources, is the deciding factor in all evolution. If you don't win a place in the sun for yourself, and some of your children, you become extinct. Monkey bands fight each other over territory. So do baboons. Up the evolutionary scale, blacks fight black, Indians fight Indians, Scots and Irish fight English, Serbs fight Croats fight Muslims, North fights South, blacks fight whites fight reds fight yellows, Jews fight Arabs fight Protestants fight Catholics fight Mohammedans, etcetera.

The big dance of life. You got to be in it to win it. Nobody gets excited when a couple of bull moose(s?) fight it out.

What happened here on the big blue marble was that the two-legged twerps with very little fur won big! Killed off most of the competition! Outnumbered their enemies, overflowed their boundaries, defeated even germs bigtime, and are now facing the consequences. Want to live forever? You and

everyone else.

How about playing fair, wearing out your heart and then just going away to that great big never-land in the sky? No way—gimme another heart, please! It's just "natural" to want to live forever, and actively try to kill whoever and whatever seems to be standing in your way. I think we're watching the beginnings of a big bloodbath which will continue until either the two-legged nudies kill each other off to a sustainable population level, get smart (which ain't likely), nuke themselves and this whole wonderful world to a powder, or like Steven King said in the Stand, create a germ that'll be 99% "effective," and maybe AIDS is that.

Anyway, have a nice day.

On August 22, 1995, Caruana responded to the following inquiry:

Does anyone know how Skolnick or any well-informed researcher feels about the Gemstone Thesis..how can you connect Onassis in the big picture?—Matthew Crawford Well...I don't know how Skolnick feels, or whether I would qualify in your book as a "well-informed researcher," but I did write the "Skeleton Key to The Gemstone File" which is generally circulated as the Gemstone Thesis...so I probably know more about this than most people. I think Bruce Roberts was right, although the tale he tells, being from his point of view alone, perhaps leaves out certain other factors which have been mentioned and stressed by others.

Stephanie Caruana, on August 24, 1995, returned to the discussion with James Daugherty:

Larry Stopa's summary of how the media has been coopted to conceal the truth about what is going on in the U.S. reminds me of my own experiences back in 1974-5.

I was writing articles for *Playgirl* magazine, primarily about issues of importance to women. I wrote about a new method of early abortion, at a time when abortions were only legal in

New York and California, and coat-hanger-back-room-trips-to Mexico stories were all too common. I wrote about decent nutrition and care for pregnant women as a way to avoid birth defects. I interviewed black poet Maya Angelou, and black feminist activist Flo Kennedy. *Playgirl* got off to a zooming start, probably due primarily to the male nudes, but I'd like to think that some of my articles on issues important to women helped. (This was at a time when, as now, women's magazines pretty much stick to cosmetics, diets, and how to get a better job.) The editor at *Playgirl*, Marin Milan, was interested in politics. I met Mae Brussell, the wellknown but under-appreciated conspiracy researcher, and began to work with her. We wrote an article about the Patty Hearst kidnapping, "Why Was Patty Hearst Kidnapped?" and sold it to a small Berkeley underground newspaper, the "Berkeley Barb." This article detailed the connections between the so-called "Symbionese Liberation Army", the California prison system, the use of black prisoner and petty criminal Donald DeFreeze, baptized "Cinque" by his government-funded trainers/handlers, as a hapless tool of government propaganda efforts against blacks (the so-called "Symbionese Liberation Army" with its weird "manifestoes,") etc., which would justify the civil war against the people that is now going on with even greater intensity. The very week the Berkeley Barb story appeared on the stands, threatening to blow the cover off of this story, Donald de Freeze and the "Symbionese Liberation Army" of hapless stooges were moved to a "Safe house" in the L.A. area, and a L.A.P.D. "swat team" was brought in to turn them into toast, first making sure Patty Hearst and her government-paid handlers were safely out of harm's way. The Berkeley Barb's owners received an offer they couldn't refuse, and sold out. Media control went all the way down to the smallest newspaper.

I wrote another article with Mae Brussell, entitled "Is Howard Hughes Dead and Buried off a Greek Island?" In its original form, it gave a broad picture of the manipulation of the U.S. government for private gain, including heroin traffic,

arms trading, gambling in Cuba, etc., and fingered Aristotle Onassis as a major player in the global money-power game. Although the article which appeared had been very much watered down and edited by *Playgirl's* attorneys, it still lit up some dark areas that were supposed to remain dark. Result: I was fired as a contributing editor; Marin Milam, the editor, was fired, and *Playgirl* was "bought" and subsequently changed hands a couple of times before reemerging as a magazine of no particular relevance.

I subsequently released the "Skeleton Key to The Gemstone File" after I realized that Bruce Roberts' picture of the U.S. media as being coopted beyond reason to keep these and other facts out of the awareness of the ordinary U.S. citizen, was pretty much correct. The wide popularity and constant reprinting of the Gemstone "Key" showed me that people really did want to know what was going on. I have been personally hounded for years, beginning with a personal visit to my house by an IRS representative, but there has also been a loud chorus of "journalists" who deafened the ear with their frog-like croaks about how inaccurate and absurd the "Gemstone" synopsis was. However, a couple of books have appeared giving numerous source materials that back up what was said.

None of this, of course, returns to me what was taken away by the people who called me "crazy," and still do.

I still believe that Bruce Roberts was offed by the CIA for daring to write what he did, and that Mae Brussell was also murdered because she kept on trucking. I think both of these people deserve to have a monument erected in their honor, where Danny Casolaro should also be included, as well as a long string of writers who have tried to report the truth, and who have been hounded, derided, imprisoned, and sometimes murdered because of it.

—Stephanie Caruana

One Gemstone File personality who went on to accrue some fame primarily as a foil to the great psychologist/philosopher

Dr. Timothy Leary, Watergater G. Gordon Liddy, also became known for his Washington, DC radio show on WJFK (an appropriate set of call letters). In 1992, he had as a guest the conspiracy writer Jonathan Vankin. Vankin co-authored *The 70 Greatest Conspiracies of All Time* with John Whalen, and both still maintain a web site at www.conspire.com. The program was a rare and unfortunately brief confrontation about the Gemstone thesis with one of its ostensible characters:

L: I just received a fax from a fellow who had called earlier, Mr. "U".

He said had I ever heard about The Gemstone File? Now, of course, I know about the Gemstone Plan...

V: I was going to ask you about that, actually.

L: That was my plan, see, the Gemstone Plan. But he's now faxed me something that looks like it was done on an old typewriter.

V: Hey, you bet! I was going to ask you about The Gemstone File, actually.

L: I was going to ask you about The Gemstone File. It appears to be almost like a table of contents or rough outline of what purports to be, what must be, a massive document, because this starts out in 1932 with Onassis, "Greek drug pusher and ship owner," well, "alleged" Greek drug pusher, it doesn't have any... Turkish tobacco, Joseph Kennedy, Eugene Meyer and Meyer Lansky. Then in '34 it's Onassis and Rockefeller and the Seven Sisters oil companies. And then in '36-'40, it's Eugene Meyer buys the *Washington Post*. Holy Smoke! The Bilderbergers and the *Washington Post* are in...then in '41 to '45 World War II was very profitable for Onassis, Rockefeller, the Kennedys, Roosevelt, I. G. Farben, etc. Then Onassis in '49 buys U. S. surplus Liberty ships, and this just goes on, and Senator Kefauver, and, my god, page after page of this...You know this leads me to a more general question, Mr. Vankin, and that is—it occurred to me that most conspiracy theories that I have heard of fail the test of logic, the classical test of post hoc ergo proctor hoc. In other words, because something occurred after something else therefore it

occurred because of something else.

V: Right.

L: That appears to be the rationale behind this Skeleton Key of The Gemstone File. Have you ever read this?

V: Oh, absolutely. In fact, this gives me the chance to plug another book here, a book that I didn't write but that I'll have an essay in called *The Gemstone File* and it's a collection of the many versions of that document you apparently have in your hand and a lot of other essays about it. I wrote a little piece about my reaction to The Gemstone File.

L: Could you give us a little precis of it?

V: Sure. Let me tell you a little bit about what it is, because a lot of people have confused it with the Gemstone Plan.

L: I'm getting blamed for The Gemstone File.

V: There's a lot of people out there who think that you wrote it.

L: Friends and neighbors! I did not write The Gemstone File or the Skeleton Key to The Gemstone File! I have, in fact, just received this fax and that's all I know about it. However, I am listening with fascination to Mr. Vankin, who is an expert on it.

V: The Gemstone File was supposedly written by a fellow named Bruce Roberts.

L: Who he? Who Bruce Roberts?

V: This is a good question. No one really knows exactly who he was, though he and the people who are fans of The Gemstone File claim he was a very well-connected person in the intelligence community. I have no way of verifying that one way or the other. But he wrote thousands of pages of documents, mostly handwritten, explaining this conspiracy that you just sort of outlined in the Skeleton Key. Now he hooked up with Mae Brussel, who we mentioned earlier.

L: Lord. That's quite a combination.

V: Now this was in the early 70s and there's a wild story that goes along with that.

L: I'll bet it is.

V: What happened is that Mae Brussell picked up these thousands of documents written by Bruce Roberts and she was

interviewed by a journalist from *Playgirl* magazine named Stephanie Caruana, who was at that time a San Francsico-based journalist who just fell in love with The Gemstone File. She wrote the Skeleton Key to The Gemstone File, which is a 25 page condensed version.

L: What I've got here is written by this Gennifer Kariwanga?

V: Stephanie Caruana, yes.

L: Her name does not appear on this thing.

V: If you look on the very first page, in the upper left or right hand corner, because on a lot of versions of the document, it's right there.

L: Well, it's a fax machine thing.

V: Maybe they cut that off for security reasons or something. But there's been a lot of versions of that Skeleton Key that have circulated, including one I think they call the Kiwi Gemstone File, which supposedly all takes place in New Zealand. That might interest that previous caller from Australia.

L: When I was down in Australia, I found there was quite rivalry between Australia and New Zealand. They are not by any means the best of friends. They wouldn't let me in New Zealand.

V: Oh dear.

L: In the airplane at Sydney, waiting to take off for Auckland, New Zealand, and they came on board and they said, "Mr. Liddy, you'll have to get off the airplane." And I said, "Would you mind telling me why?" And they said, "Well, because, we received a TWX from Auckland saying that if you land the plane with M r. Liddy on it, then M r. Liddy will have to stay in the confines of the aircraft. He will not be allowed to set foot on New Zealand's soil until the aircraft is refueled and has to go back." And I said, "Well is there a reason why?" And they said no they didn't. So there was a press conference afterwards and they asked me to speculate and I really didn't know, so I said that of course I had recently been released from five years in prison. Perhaps they are fearful for the health of their sheep, I wasn't sure. All that did, I'm sure, was assure

that I will never get in to New Zealand. So it does not surprise me that there is a New Zealand Gemstone File. (End of conversation.)

THE NEW YORK TIMES, MONDAY, MARCH 30, 1970

Tunney's Daughter Accused of Slaying Husband

Is Held by Police in England for Court Appearance

Special to The New York Times

LONDON, March 29 — Gene Tunney's 30 year-old daughter, Joan, was charged in Amersham today with the murder of her husband, Lynn Carter Wilkinson.

She is in custody and will appear before the Magistrate's Court in nearby Chesham on Tuesday.

The Amersham police said that Mr. Wilkinson's body, showing head injuries, had been found about 9 A.M. at his home at Chenies, a village near Amersham, which is 24 miles north of London. A police officer said Mr. Wilkinson was 31 years old and that Mrs. Wilkinson had been cooperating with the police in their inquiries today.

Gene Tunney, who is now 72 years old, was world heavyweight boxing champion from 1926 to 1928. His daughter married Mr. Wilkinson in Riverside, Calif., in March, 1961.

According to neighbors, the Wilkinsons had lived at Chenies for only a few months with their children, Alexandra, 5, and Erin, 3.

Last September Mr. Tunney announced that his daughter had been missing in Europe for more than a month and had failed to meet her husband in Hamburg as arranged.

The following month they were reunited in Marseilles following reports that she had been found wandering in the woods near that French port city.

Tunney Son Flies to London

The eldest son of Gene Tunney flew from Los Angeles to London yesterday to be with his sister, Joan, who has been charged with the murder of her husband.

Mr. Tunney, who retired as heavyweight champion in 1928, is in Arizona convalescing from serious spinal surgery last summer and, according to a family spokesman, is not in good enough health to make the trip.

Mr. Tunney and his wife said in a statement that they were "shocked and saddened" by the death of their son-in-law.

"Like all parents at a moment like this we have a deep feeling

United Press International
Mrs. Joan Tunney Wilkinson

Body, Bearing Head Injuries, Is Found at Their Home

nounced that his daughter had been found in France after having been missing in Europe for nearly two months. A source close to the family said that she had been taken to a hospital in Marseilles suffering from a loss of memory.

After Mrs. Wilkinson left the hospital last fall, she returned with her husband and two children to their home in San Francisco, where Mr. Wilkinson was a real estate property manager. The Wilkinsons had returned to England several months ago for an extended vacation, a family spokesman said yesterday.

Another brother of Mrs. Wilkinson is Rep. John V. Tunney of California, who is seeking the Democratic nomination to oppose Senator George Murphy's bid for a second term. Gene Tunney Jr. recently resigned as deputy district attorney in Alameda County to assist in his brother's campaign.

Gene Tunney Sr. and his wife have a home in Stamford, Conn., but have been there infrequently since his operation

of compassion and sorrow for our daughter, Joan, and a great desire to help her," the statement said. "Our eldest son, Gene, is en route to London to be with Joan in her hour of great need and to assist in whatever way is possible."

Last October Mr. Tunney an-

13.
BIBLIOGRAPHY.

Aide Says Hughes Signed Vote Proxy," *New York Times,* December 15, 1970.

Air Force Overruled By Elliott; General Testifies Son of President
icked Hughes Plane Despite Army Experts," *Tacoma News Tribune,* August
, 1947.

Air Probe Abruptly Put Off," *Tacoma News Tribune,* August 12, 1947.

Aircraft Builder Recites Merger Proposal But Senator Calls It False,"
acoma News Tribune, August 7, 1947.

ellet, Gerald, *The Age of Secrets,* Voyageur, 1995.

ender, Marylin, and Altschul, Selig, *The Chosen Instrument: Pan Am, Juan
rippe, The Rise and Fall of An American Entrepreneur,* Simon and
chuster: New York, 1982.

rown, Peter Harry and Broeske, Pat H., *Howard Hughes: The Untold Story,*
ittle, Brown: Boston, 1996.

arroll, Gerald A., *Project Seek: Onassis, Kennedy and the Gemstone
hesis,* Bridger House: Carson City, NV, 1994.

ate, Curtis, "The Mystery Man of the Tanker Fleet," *The Reporter,* June
, 1955.

Christina Onassis, Shipping Magnate, Dies at 37," *New York Times,* November
0, 1988.

Disputes Meyer's Story, President's Son Also Denies He ever Discussed
lughes Contract With Dad," *Tacoma News Tribune,* August 5, 1947.

Drosnin, Michael, *Citizen Hughes,* Holt; New York, 1985.

Epstein, Edward Jay, *The Death of the Diamond,* Sphere; London, 1982.

"Few Changes Are Expected in the Onassis Empire," *New York Times*, November 21, 1988.

"Fight for Hughes Holdings Emerges in his Absence," *New York Time*, Decmber 6, 1970.

Giancana, Sam, *Double Cross: The Explosive Inside Story of the Mobster* Who Controlled America, Time Warner: New York, 1992.

Hitchens, Christopher, "Nixon's Tapes and the 'Greek Connection' " *The Nation,* November 24, 1997.

Hougan, Jim, *Spooks: The Haunting of America—The Private Use of Secret Agents,* Morrow: New York, 1978.

"Hughes Accuses Brewster," *Tacoma News Tribune,* July 31, 1947.

"Hughes Is Upheld By Pepper," *Tacoma News Tribune,* August 10, 1947.

"Hughes' Parties In LA Short of Fun," *Tacoma News Tribune,* August 10, 1947.

"Hughes Plant Defied Government Closing Order," *Tacoma News Tribune* August 1, 1947.

"Hughes Takes New Crack at Brewster," *Tacoma News Tribune,* August 14 1947.

"Hughes To Bare His Papers, " *Tacoma News Tribune,* August 9, 1947.

"Hughes To Leave for Capital Monday," *Tacoma News Tribune,* August 4, 1947

"Industrialist Discloses Ship Deal but Can't Recall FDR Help on Plane Contract," *Tacoma News Tribune,* July 30, 1947.

eith, Jim (ed.), *The Gemstone File,* Illuminet: Atlanta, 1992.

lein, Edward, *Just Jackie: Her Private Years,* Ballantine: New York, 1998..

'Liar' Says Hughes of Brewster," *Tacoma News Tribune,* August 8, 1947.

otto, Jack, "The Golden Greeks," St. Louis Post-Dispatch, January 27, 1957.
Maheu Awarded $2.8 Million in Damage Suit Against Hughes," *New York
imes,* December 4, 1973.

lanchester, William, *The Arms of Krupp 1587-1968,* Little, Brown: Boston,
968.

lcClendon, Sarah, "There's A U.S. Tax Collector in Onassis' Affluent
uture," *Tacoma News Tribune,* November 2, 1968.

Meyer Tells of Big Expenses, Including Girls, Before Row Over Draft
tatus," *Tacoma News Tribune,* August 4, 1947.

Mrs. John F. Kennedy and Onassis, Millionaire Greek Shipowner, Will
larry," *New York Times,* October 14, 1968.

Mrs. Kennedy Gets Tour Of Island Onassis Owns," *New York Times,* October
1, 1963.

Onassis Buys 3 Tankers for $60 Million," *Tacoma News Tribune,* November
, 1968.

earson, Drew, "Big Names In Glamor Gal Quiz," *Tacoma News Tribune,* July
6, 1947.

amsay, Robin, "The Gemstone File," *International Times,* Vol. 4, #11, 1978.

Says Elliott Not Involved," *Tacoma News Tribune,* July 28, 1947.

Sore Over Party Girl Stories," *Tacoma News Tribune,* August 6, 1947.

Tina Niarchos Dead At 45; Wife of Greek Millionaire," *New York Times,*
ctober 12, 1974.

"Witness Says Hughes' Scheme Opposed But Contract Let Due to Kaiser's Prestige," *Tacoma News Tribune,* July 29, 1947.

Alan, Richard, *The Gemstone File: Sixty Years of Corruption and Manipulatio* Crown Publishing Co.: Columbus, OH, 1992.

Russo, Gus, *Live By the Sword: The Secret War Against Castro and the Death* JFK, Bancroft Press: Baltimore, MD,.1998.

Rux, Bruce, *Hollywood Vs. the Aliens,* North Atlantic Books: Berkeley, 1997.

Lane and Sheldon, *For Bond Lovers Only* , Dell Books: New York, 1965.

Thomas, Kenn, NASA, NAZIS & JFK: The Torbitt Document and th Kennedy Assassination, Adventures Unlimited Press: Kempton, IL., 1996.

Nichols and Moon, *Pyramids of Montauk* Sky Books: Westbury, NY 1995.

Allen, Rayelan, *Diana, Queen of Heaven: The New World Religion,* Pigeon Poi Publishing: Aptos, CA., 1999.

STEAMSHOVEL PRESS

Acharya S
Greg Bishop
Len Bracken
David Hatcher Childress
Uri Dowbenko
Wayne Henderson
Jim Keith
Jim Martin
Adam Parfrey
Rob Sterling

The names of the world's best conspiracy culture researchers appear regularly in the pages of Steamshovel Press.

Steamshovel examines parapolitical topics in the tradition Mae Brussell, Jim Garrison, Ace Hayes and Danny Casolaro, exploring the many strange dimensions of the contemporary Con. From the UFO cover up to the politics of assassination, the religious hucksters and the corporate/military nightmare, Steamshovel Press covers it all with dependable and complete documentation.

"Feed that dark feeling in the pit of your belly."
--Arcturus Books

"...on the cutting edge--and a strange place that is..."
--New Yorker

Don't miss an issue--or the Conspiracy will close in on you! $6 per sample issue; $23 for a four issue subscription.

Checks payable to "Kenn Thomas" at POB 23715, St. Louis, MO 63121

On the web at www.umsl.edu/~skthomas

LOST CONTINENTS & THE HOLLOW EARTH

I Remember Lemuria and the Shaver Mystery
by David Hatcher Childress & Richard Shaver

Lost Continents & the Hollow Earth is Childress' thorough examination of the early hollow earth stories of Richard Shaver and the fascination that lost continents and the hollow earth have had for the American public. Shaver's rare 1948 book *Remember Lemuria* is reprinted in its entirety, and the book is packed with illustrations from Ray Palmer's *Amazing Stories* magazine of the 1940s. Palmer and Shaver told of tunnels running through the earth—tunnels inhabited by the Deros and Teros, humanoids from an ancient spacefaring race that had inhabited the earth, eventually going underground, hundreds of thousands of years ago. Childress discusses the famous hollow earth books and delves deep into whatever reality may be behind the stories of tunnels in the earth. Operation High Jump to Antarctica in 1947 and Admiral Byrd's bizarre statement, tunnel systems in South America and Tibet, the underground world of Agartha, UFOs coming from the South Pole, more.
344 PAGES. 6X9 PAPERBACK. ILLUSTRATED. $16.95. CODE: LCHE

INSIDE THE GEMSTONE FILE

Howard Hughes, Onassis & JFK
by Kenn Thomas & David Hatcher Childress

Steamshovel Press editor Thomas takes on the Gemstone File in this run-up and run-down of the most famous underground document ever circulated. Photocopied and distributed for over 20 years, the Gemstone File is the story of Bruce Roberts, the inventor of the synthetic ruby widely used in laser technology today, and his relationship with the Howard Hughes Company and ultimately with Aristotle Onassis, the Mafia, and the CIA. Hughes kidnapped and held a drugged-up prisoner for 10 years; Onassis and his role in the Kennedy Assassination; how the Mafia ran corporate America in the 1960s; more.
320 PAGES. 6X9 PAPERBACK. ILLUSTRATED. $16.00. CODE: IGF

KUNDALINI TALES

by Richard Sauder, Ph.D.

Underground Bases and Tunnels author Richard Sauder on his personal experiences and provocative research into spontaneous spiritual awakening, out-of-body journeys, encounters with secretive governmental powers, daylight sightings of UFOs, and more. Sauder continues his studies of underground bases with new information on the occult underpinnings of the U.S. space program. The book also contains a breakthrough section that examines actual U.S. patents for devices that manipulate minds and thoughts from a remote distance. Included are chapters on the secret space program and a 130-page appendix of patents and schematic diagrams of secret technology and mind control devices.
296 PAGES. 7x10 PAPERBACK. ILLUSTRATED. BIBLIOGRAPHY. $14.95. CODE: KTAL

LIQUID CONSPIRACY

JFK, LSD, the CIA, Area 51 & UFOs
by George Piccard

Underground author George Piccard on the politics of LSD, mind control, and Kennedy's involvement with Area 51 and UFOs. Reveals JFK's LSD experiences with Mary Pinchot-Meyer. The plot thickens with an ever expanding web of CIA involvement, from underground bases with UFOs seen by JFK and Marilyn Monroe (among others) to a vaster conspiracy that affects every government agency from NASA to the Justice Department. This may have been the reason that Marilyn Monroe and actress-columnist Dorothy Killgallen were both murdered. Focusing on the bizarre side of history, *Liquid Conspiracy* takes the reader on a psychedelic tour de force.
264 PAGES. 6X9 PAPERBACK. ILLUSTRATED. $14.95. CODE: LIQC

ATLANTIS: MOTHER OF EMPIRES

Atlantis Reprint Series
by Robert Stacy-Judd

Robert Stacy-Judd's classic 1939 book on Atlantis. Stacy-Judd was a California architect and an expert on the Mayas and their relationship to Atlantis. Stacy-Judd was an excellent artist and his book is lavishly illustrated. The eighteen comprehensive chapters in the book are: The Mayas and the Lost Atlantis; Conjectures and Opinions; The Atlantean Theory; Cro-Magnon Man; East Is West; And West Is East; The Mormons and the Mayas; Astrology in Two Hemispheres; The Language of Architecture; The American Indian; Pre-Panamanians and Pre-Incas; Columns and City Planning; Comparisons and Mayan Art; The Iberian Link; The Maya Tongue; Quetzalcoatl; Summing Up the Evidence; The Mayas in Yucatan.
340 PAGES. 8X11 PAPERBACK. ILLUSTRATED. INDEX. $19.95. CODE: AMOE

COSMIC MATRIX

Piece for a Jig-Saw, Part Two
by Leonard G. Cramp

Leonard G. Cramp, a British aerospace engineer, wrote his first book *Space Gravity and the Flying Saucer* in 1954. *Cosmic Matrix* is the long-awaited sequel to his 1966 book *UFOs & Anti-Gravity: Piece for a Jig-Saw*. Cramp has had a long history of examining UFO phenomena and has concluded that UFOs use the highest possible aeronautic science to move in the way they do. Cramp examines anti-gravity effects and theorizes that this super-science used by the craft—described in detail in the book—can lift mankind into a new level of technology, transportation and understanding of the universe. The book takes a close look at gravity control, time travel, and the interlocking web of energy between all planets in our solar system with Leonard's unique technical diagrams. A fantastic voyage into the present and future!
364 PAGES. 6X9 PAPERBACK. ILLUSTRATED. BIBLIOGRAPHY. $16.00. CODE: CMX

24 HOUR CREDIT CARD ORDERS—CALL: 815-253-6390 FAX: 815-253-6300

EMAIL: AUPHQ@FRONTIERNET.NET HTTP://WWW.ADVENTURESUNLIMITED.CO.NZ

THE TIME TRAVEL HANDBOOK
A Manual of Practical Teleportation & Time Travel
edited by David Hatcher Childress

In the tradition of *The Anti-Gravity Handbook* and *The Free-Energy Device Handbook,* science and UFO author David Hatcher Childress takes us into the weird world of time travel and teleportation. Not just a whacked-out look at science fiction, this book is an authoritative chronicling of real-life time travel experiments, teleportation devices and more. *The Time Travel Handbook* takes the reader beyond the government experiments and deep into the uncharted territory of early time travellers such as Nikola Tesla and Guglielmo Marconi and their alleged time travel experiments, as well as the Wilson Brothers of EMI and their connection to the Philadelphia Experiment—the U.S. Navy's forays into invisibility, time travel, and teleportation. Childress looks into the claims of time travelling individuals, and investigates the unusual claim that pyramids on Mars were built in the future and sent back in time. A highly visual, large format book, with patents, photos and schematics. Be the first on your block to build your own time travel device!
316 PAGES. 7x10 PAPERBACK. ILLUSTRATED. $16.95. CODE: TTH. MAY PUBLICATION

PATH OF THE POLE
Cataclysmic Pole Shift Geology
by Charles Hapgood

Maps of the Ancient Sea Kings author Hapgood's classic book *Path of the Pole* is back in print! Hapgood researched Antarctica, ancient maps and the geological record to conclude that the Earth's crust has slipped in the inner core many times in the past, changing the position of the pole. *Path of the Pole* discusses the various "pole shifts" in Earth's past, giving evidence for each one, and moves on to possible future pole shifts. Packed with illustrations, this is the sourcebook for many other books on cataclysms and pole shifts such as *5-5-2000: Ice the Ultimate Disaster* by Richard Noone. A planetary alignment on May 5, 2000 is predicted to cause the next pole shift—a date that is less than a year away! With Millennium Madness in full swing, this is sure to be a popular book.
356 PAGES. 6x9 PAPERBACK. ILLUSTRATED. $16.95. CODE: POP. MAY PUBLICATION

Charles Hapgood
author of
Maps of the Ancient Sea Kings

IN SEARCH OF ADVENTURE
A Wild Travel Anthology
compiled by Bruce Northam & Brad Olsen

An epic collection of 100 travelers' tales—a compendium that celebrates the wild side of contemporary travel writing—relating humorous, revealing, sometimes naughty stories by acclaimed authors. Indeed, a book to heat up the gypsy blood in all of us. Stories by Tim Cahill, Simon Winchester, Marybeth Bond, Robert Young Pelton, David Hatcher Childress, Richard Bangs, Linda Watanabe McFerrin, Jorma Kaukonen, and many more.
459 PAGES. 6x9 PAPERBACK. ILLUSTRATED. $17.95. CODE: ISOA

ECCENTRIC LIVES AND PECULIAR NOTIONS
by John Michell

The first paperback edition of Michell's fascinating study of the lives and beliefs of over 20 eccentric people. Published in hardback by Thames & Hudson in London, *Eccentric Lives and Peculiar Notions* takes us into the bizarre and often humorous lives of such people as Lady Blount, who was sure that the earth is flat; Cyrus Teed, who believed that the earth is a hollow shell with us on the inside; Edward Hine, who believed that the British are the lost Tribes of Israel; and Baron de Guldenstubbe, who was sure that statues wrote him letters. British writer and housewife Nesta Webster devoted her life to exposing international conspiracies, and Father O'Callaghan devoted his to opposing interest on loans. The extraordinary characters in this book were—and in some cases still are—wholehearted enthusiasts for the various causes and outrageous notions they adopted, and John Michell describes their adventures with spirit and compassion. Some of them prospered and lived happily with their obsessions, while others failed dismally. We read of the hapless inventor of a giant battleship made of ice who died alone and neglected, and of the London couple who achieved peace and prosperity by drilling holes in their heads. Other chapters on the Last of the Welsh Druids; Congressman Ignacius Donnelly, the Great Heretic and Atlantis; Shakespearean Decoders and the Baconian Treasure Hunt; Early Ufologists; Jerusalem in Scotland; Bibliomaniacs; more.
248 PAGES. 6x9 PAPERBACK. ILLUSTRATED. $14.95. CODE: ELPN. MAY PUBLICATION

THE CHRIST CONSPIRACY
The Greatest Story Ever Sold
by Acharya S.

In this highly controversial and explosive book, archaeologist, historian, mythologist and linguist Acharya S. marshals an enormous amount of startling evidence to demonstrate that Christianity and the story of Jesus Christ were created by members of various secret societies, mystery schools and religions in order to unify the Roman Empire under one state religion. In developing such a fabrication, this multinational cabal drew upon a multitude of myths and rituals that existed long before the Christian era, and reworked them for centuries into the religion passed down to us today. Contrary to popular belief, there was no single man who was at the genesis of Christianity; Jesus was many characters rolled into one. These characters personified the ubiquitous solar myth, and their exploits were well known, as reflected by such popular deities as Mithras, Heracles/Hercules, Dionysos and many others throughout the Roman Empire and beyond. The story of Jesus as portrayed in the Gospels is revealed to be nearly identical in detail to that of the earlier savior-gods Krishna and Horus, who for millennia preceding Christianity held great favor with the people. *The Christ Conspiracy* shows the Jesus character as neither unique nor original, not "divine revelation." Christianity re-interprets the same extremely ancient body of knowledge that revolved around the celestial bodies and natural forces. The result of this myth making has been "The Greatest Story Ever Sold."
256 PAGES. 6x9 PAPERBACK. ILLUSTRATED. $14.95. CODE: CHRC. JUNE PUBLICATION

24 HOUR CREDIT CARD ORDERS—CALL: 815-253-6390 FAX: 815-253-6300
EMAIL: AUPHQ@FRONTIERNET.NET HTTP://WWW.ADVENTURESUNLIMITED.CO.NZ

HAARP
The Ultimate Weapon of the Conspiracy
by Jerry Smith

The HAARP project in Alaska is one of the most controversial projects ever undertaken by the U.S. Government. Jerry Sr gives us the history of the HAARP project and explains how it can be used as an awesome weapon of destruction. Sr exposes a covert military project and the web of conspiracies behind it. HAARP has many possible scientific and mili applications, from raising a planetary defense shield to peering deep into the earth. Smith leads the reader down a trail of s evidence into ever deeper and scarier conspiracy theories in an attempt to discover the "whos" and "whys" behind HAA and discloses a possible plan to rule the world. At best, HAARP is science out-of-control; at worst, HAARP could be the m dangerous device ever created, a futuristic technology that is everything from super-beam weapon to world-wide mind cor device. The Star Wars future is now. Topics include Over-the-Horizon Radar and HAARP, Mind Control, ELF and HAA The Telsa Connection, The Russian Woodpecker, GWEN & HAARP, Earth Penetrating Tomography, Weather Modificat Secret Science of the Conspiracy, more. Includes the complete 1987 Bernard Eastlund patent for his pulsed super-weapon he claims was stolen by the HAARP Project.
256 PAGES. 6x9 PAPERBACK. ILLUSTRATED. $14.95. CODE: HARP

MIND CONTROL, OSWALD & JFK:
Were We Controlled?
Introduction by Kenn Thomas

Steamshovel Press editor Kenn Thomas examines the little-known book *Were We Controlled?*, first published in 1968. book maintained that Lee Harvey Oswald was a special agent who was a mind control subject, having received an implant 1960 at a Russian hospital. Thomas examines the evidence for implant technology and the role it could have played in Kennedy Assassination. Thomas also looks at the mind control aspects of the RFK assassination and details the histor implant technology. A growing number of people are interested in CIA experiments and its "Silent Weapons for Quiet Wa
256 PAGES. 6x9 PAPERBACK. ILLUSTRATED. NOTES. $16.00. CODE: MCOJ

MIND CONTROL, WORLD CONTROL
by Jim Keith

Veteran author and investigator Jim Keith uncovers a surprising amount of information on the technology, experimenta and implementation of mind control. Various chapters in this shocking book are on early CIA experiments such as Pro Artichoke and Project R.H.I.C.-EDOM, the methodology and technology of implants, mind control assassins and coura various famous "Mind Control" victims such as Sirhan Sirhan and Candy Jones. Also featured in this book are chapters on Mind Control technology may be linked to some UFO activity and "UFO abductions."
256 PAGES. 6x9 PAPERBACK. ILLUSTRATED. FOOTNOTES. $14.95. CODE: MCWC

PROJECT SEEK
Onassis, Kennedy and the Gemstone Thesis
by Gerald A. Carroll

This book reprints the famous Gemstone File, a document circulated in 1974 concerning the Mafia, Onassis and the Kennedy assassination. With the passing of Jackie Kennedy-Onassis, this information on the Mafia and the CIA, the formerly "Hughes" controlled defense industry, and the violent string of assassinations can at last be told. Also includes new information on the Nugan Hand Bank, the BCCI scandal, "the Octopus," and the Paul Wilcher Transcripts.
388 PAGES. 6x9 PAPERBACK. ILLUSTRATED. $16.95. CODE: PJS

NASA, NAZIS & JFK:
The Torbitt Document & the JFK Assassination
Introduction by Kenn Thomas

This book emphasizes the link between "Operation Paper Clip" Nazi scientists working for NASA, the assassination of JFK, and the secret Nevada air base Area 51. The Torbitt Document also talks about the roles played in assassination by Division Five of the FBI, the Defense Industrial Security Command (DISC), the Las Vegas mob, and shadow corporate entities Permindex and Centro-Mondiale Commerciale. The Torbitt Document claims that the same play planned the 1962 assassination attempt on Charles de Gaul, who ultimately pulled out of NATO because he traced the "Ass sination Cabal" to Permindex in Switzerland and to NATO headquarters in Brussels. The Torbitt Document paints a d picture of NASA, the military industrial complex, and the connections to Mercury, Nevada which headquarters the "se space program."
258 PAGES. 5x8. PAPERBACK. ILLUSTRATED. $16.00. CODE: NNJ

THE HISTORY OF THE KNIGHTS TEMPLAR
The Temple Church and the Temple
by Charles G. Addison. Introduction by David Hatcher Childress

Chapters on the origin of the Templars, their popularity in Europe and their rivalry with the Knights of St. John, later to be know the Knights of Malta. Detailed information on the activities of the Templars in the Holy Land, and the 1312 A.D. suppression of Templars in France and other countries, which culminated in the execution of Jacques de Molay and the continuation of the Knig Templars in England and Scotland and the formation of the society of Knights Templar in London and the rebuilding of the Tem in 1816. Plus a lengthy intro about the lost Templar fleet and its connections to the ancient North American sea routes.
395 PAGES. 6x9 PAPERBACK. ILLUSTRATED. $16.95. CODE: HKT

THE HISTORY OF THE KNIGHTS TEMPLARS
by
Charles G. Addison

Introduction by David Hatcher Childress

24 HOUR CREDIT CARD ORDERS—CALL: 815-253-6390 FAX: 815-253-6300
EMAIL: AUPHQ@FRONTIERNET.NET HTTP://WWW.ADVENTURESUNLIMITED.CO.NZ

THE LOST CITIES SERIES

LOST CITIES OF ATLANTIS, ANCIENT EUROPE & THE MEDITERRANEAN
by David Hatcher Childress
Atlantis! The legendary lost continent comes under the close scrutiny of maverick archaeologist David Hatcher Childress in this sixth book in the internationally popular *Lost Cities* series. Childress takes the reader in search of sunken cities in the Mediterranean; across the Atlas Mountains in search of Atlantean ruins; to remote islands in search of megalithic ruins; to meet living legends and secret societies. From Ireland to Turkey, Morocco to Eastern Europe, and around the remote islands of the Mediterranean and Atlantic, Childress takes the reader on an astonishing quest for mankind's past. Ancient technology, cataclysms, megalithic construction, lost civilizations and devastating wars of the past are all explored in this book. Childress challenges the skeptics and proves that great civilizations not only existed in the past, but the modern world and its problems are reflections of the ancient world of Atlantis.
524 PAGES. 6x9 PAPERBACK. ILLUSTRATED WITH 100S OF MAPS, PHOTOS AND DIAGRAMS. BIBLIOGRAPHY & INDEX. $16.95. CODE: MED

LOST CITIES OF CHINA, CENTRAL INDIA & ASIA
by David Hatcher Childress
Like a real life "Indiana Jones," maverick archaeologist David Childress takes the reader on an incredible adventure across some of the world's oldest and most remote countries in search of lost cities and ancient mysteries. Discover ancient cities in the Gobi Desert; hear fantastic tales of lost continents, vanished civilizations and secret societies bent on ruling the world; visit forgotten monasteries in forbidding snow-capped mountains with strange tunnels to mysterious subterranean cities! A unique combination of far-out exploration and practical travel advice, it will astound and delight the experienced traveler or the armchair voyager.
429 PAGES. 6x9. PAPERBACK. PHOTOS, MAPS, AND ILLUSTRATIONS WITH FOOTNOTES & BIBLIOGRAPHY $14.95. CODE CHI

LOST CITIES OF ANCIENT LEMURIA & THE PACIFIC
by David Hatcher Childress
Was there once a continent in the Pacific? Called Lemuria or Pacifica by geologists, Mu or Pan by the mystics, there is now ample mythological, geological and archaeological evidence to "prove" that an advanced and ancient civilization once lived in the central Pacific. Maverick archaeologist and explorer David Hatcher Childress combs the Indian Ocean, Australia and the Pacific in search of the surprising truth about mankind's past. Contains photos of the underwater city on Pohnpei; explanations on how the statues were levitated around Easter Island in a clock-wise vortex movement; tales of disappearing islands; Egyptians in Australia; and more.
379 PAGES. 6x9. PAPERBACK. ILLUSTRATED. FOOTNOTES & BIBLIOGRAPHY $14.95. CODE LEM

LOST CITIES OF NORTH & CENTRAL AMERICA
by David Hatcher Childress
Down the back roads from coast to coast, maverick archaeologist and adventurer David Hatcher Childress goes deep into unknown America. With this incredible book, you will search for lost Mayan cities and books of gold, discover an ancient canal system in Arizona, climb gigantic pyramids in the Midwest, explore megalithic monuments in New England, and join the astonishing quest for the lost cities throughout North America. From the war-torn jungles of Guatemala, Nicaragua and Honduras to the deserts, mountains and fields of Mexico, Canada, and the U.S.A., Childress takes the reader in search of sunken ruins, Viking forts, strange tunnel systems, living dinosaurs, early Chinese explorers, and fantastic lost treasure. Packed with both early and current maps, photos and illustrations.
590 PAGES. 6x9 PAPERBACK. PHOTOS, MAPS, AND ILLUSTRATIONS. FOOTNOTES & BIBLIOGRAPHY. $14.95. CODE: NCA

LOST CITIES & ANCIENT MYSTERIES OF AFRICA & ARABIA
by David Hatcher Childress
Across ancient deserts, dusty plains and steaming jungles, maverick archaeologist David Childress continues his world-wide quest for lost cities and ancient mysteries. Join him as he discovers forbidden cities in the Empty Quarter of Arabia; "Atlantean" ruins in Egypt and the Kalahari desert; a mysterious, ancient empire in the Sahara; and more. This is the tale of an extraordinary life on the road: across war-torn countries, Childress searches for King Solomon's Mines, living dinosaurs, the Ark of the Covenant and the solutions to some of the fantastic mysteries of the past.
423 PAGES. 6x9 PAPERBACK. PHOTOS, MAPS, AND ILLUSTRATIONS. FOOTNOTES & BIBLIOGRAPHY. $14.95. CODE: AFA

LOST CITIES & ANCIENT MYSTERIES OF SOUTH AMERICA
by David Hatcher Childress
Rogue adventurer and maverick archaeologist David Hatcher Childress takes the reader on unforgettable journeys deep into deadly jungles, high up on windswept mountains and across scorching deserts in search of lost civilizations and ancient mysteries. Travel with David and explore stone cities high in mountain forests and hear fantastic tales of Inca treasure, living dinosaurs, and a mysterious tunnel system. Whether he is hopping freight trains, searching for secret cities, or just dealing with the daily problems of food, money, and romance, the author keeps the reader spellbound. Includes both early and current maps, photos, and illustrations, and plenty of advice for the explorer planning his or her own journey of discovery.
381 PAGES. 6x9 PAPERBACK. PHOTOS, MAPS, AND ILLUSTRATIONS. FOOTNOTES & BIBLIOGRAPHY. $14.95. CODE: SAM

24 HOUR CREDIT CARD ORDERS—CALL: 815-253-6390 FAX: 815-253-6300

email: auphq@frontiernet.net http://www.azstarnet.com/~aup

One Adventure Place
P.O. Box 74
Kempton, Illinois 60946
United States of America
Tel.: 815-253-6390 • Fax: 815-253-6300
Email: auphq@frontiernet.net
http://www.adventuresunlimited.co.nz

ORDERING INSTRUCTIONS

✓ Remit by USD$ Check, Money Order or Credit Card
✓ Visa, Master Card, Discover & AmEx Accepted
✓ Prices May Change Without Notice
✓ 10% Discount for 3 or more Items

SHIPPING CHARGES

United States

✓ Postal Book Rate { $2.50 First Item
50¢ Each Additional Item

✓ Priority Mail { $3.50 First Item
$2.00 Each Additional Item

✓ UPS { $5.00 First Item
$1.50 Each Additional Item

NOTE: UPS Delivery Available to Mainland USA Only

Canada

✓ Postal Book Rate { $3.00 First Item
$1.00 Each Additional Item

✓ Postal Air Mail { $5.00 First Item
$2.00 Each Additional Item

✓ Personal Checks or Bank Drafts MUST BE
USD$ and Drawn on a US Bank
✓ Canadian Postal Money Orders OK
✓ Payment MUST BE USD$

All Other Countries

✓ Surface Delivery { $6.00 First Item
$2.00 Each Additional Item

✓ Postal Air Mail { $12.00 First Item
$8.00 Each Additional Item

✓ Payment MUST BE USD$
✓ Checks and Money Orders MUST BE USD$
and Drawn on a US Bank or branch.
✓ Add $5.00 for Air Mail Subscription to
Future *Adventures Unlimited* Catalogs

SPECIAL NOTES

✓ RETAILERS: Standard Discounts Available
✓ BACKORDERS: We Backorder all Out-of-
Stock Items Unless Otherwise Requested
✓ PRO FORMA INVOICES: Available on Request
✓ VIDEOS: NTSC Mode Only
✓ For PAL mode videos contact our other offices:

European Office:
Adventures Unlimited, PO Box 372,
Dronten, 8250 AJ, The Netherlands
South Pacific Office
Adventures Unlimited Pacifica
221 Symonds Street, Box 8199
Auckland, New Zealand

Please check: ☑

☐ This is my first order ☐ I have ordered before ☐ This is a new addre

Name

Address

City

State/Province Postal Code

Country

Phone day Evening

Fax

Item Code	Item Description	Price	Qty	Total

Please check: ☑

☐ Postal-Surface

☐ Postal-Air Mail
(Priority in USA)

☐ UPS
(Mainland USA only)

Subtotal ➡
Less Discount-10% for 3 or more items ➡
Balance ➡
Illinois Residents 6.25% Sales Tax ➡
Previous Credit ➡
Shipping ➡
Total (check/MO in USD$ only)➡

☐ Visa/MasterCard/Discover/Amex

Card Number

Expiration Date

10% Discount When You Order 3 or More Items!

Comments & Suggestions	Share Our Catalog with a Frien